Art/Literature/Religion: Life on the Borders

Edited by
Robert Detweiler

Journal of the American Academy of Religion Studies

Volume XLIX, Number 2

Scholars Press
Chico, California

GENERAL EDITOR: Robert P. Scharlemann, *University of Virginia*
ASSISTANT TO THE EDITORS: Mary Lou Doyle

☐ The Cover _____

The intersecting lines in the graphic sign represent the action of religious reality (the vertical line) upon the world of ideas (the horizontal line) by going back to the origin (the dot) from which reality and ideas come. In a general way, this is the intention of the *Journal*'s thematic series in religious studies.

Library of Congress Cataloging in Publication Data
Main entry under title:

Art/literature/religion.

(Journal of the American Academy of Religion Studies ;
v. 49, no. 2)
1. Arts and religion—Addresses, essays, lectures. 2. Arts,
Modern—20th century—Addresses, essays, lectures.
I. Detweiler, Robert. II. Series.
NX180.R4A77 700'.1'04 82-3319
ISBN 0-89130-578-5 AACR2

Manufactured in the United States of America

For Mary Eleanor Bender and John Fisher:

extraordinary teachers

67228

Contents

Art/Literature/Religion:
Life on the Borders

Robert Detweiler

A main first impression a reader may gain from scanning this collection of essays is one of disorder, and this may distress those who think that the literature and theology, or literature and religion, or art/literature/religion enterprise should have matured by now into some sort of state marked by a clearly defined methodology or at least a clearly prescribed field of inquiry. I think, however, that the impression of disorder is, initially, as it should be. The study of art/literature/religion does not constitute a discipline—as one sees by the very unwieldiness in labeling it. It tends at its most organized toward the status of an interdiscipline, which is to say that it seeks out and addresses problems not native to a traditional area of research, and although those of us who "do" art/literature/religion criticism worry sporadically at national and regional meetings about what it is that we actually do, most of us would not really wish the issue once and for all resolved. For the excitement and vigor of the enterprise and the justification for it derive from our working at the intersections and blurred edges of the traditional areas, and from now and again breaking through into new territory. The challenges to basic assumptions, the collision of matrices (Arthur Koestler's term), the conflict of interpretations (Paul Ricoeur's phrase) are fundamental to this kind of scholarship, and the scholar who engages in it has to function as what the Germans call a *Grenzgänger*, someone who at some risk travels back and forth across borders. The risk is in being apprehended as an illegitimate traveler; the reward is in the opportunity to explore the unfamiliar, interpret it in terms of what one knows, and report the news.

The tolerance of a necessary disorder does not, however, imply a disregard for creating order. All scholarship is in some sense a systematizing and a setting straight, and even within the elastic confines of interdisciplinary writing the responsibility for ordering exists. Such tentative ordering may in fact be especially important in a context where one cannot trust the validity of the wonted paradigms. My strategy in offering this collection of essays on art/literature/religion is to present them first in a neutral format, arranged simply in alphabetical sequence according to authors' names, but then to suggest, in the following paragraphs, a number of significant ways in which they might be read in relation to each other. Even this initial neutrality is

suspect, of course, for the decisions and accidents involved in soliciting and receiving manuscripts already determine to some degree the nature of the assembled study. I believe, though, that these essays represent most of the interesting directions, and some of the best scholarship being produced by art/literature/religion scholars.

I suggest that these essays be read, among other ways, as a configuration of overlapping clusters of emphasis and concern. Seven of these clusters (there are surely many more) I will identify and comment on. They are marked by:

(1) a comparatist attitude and approach;
(2) a strong interest in story;
(3) a reaction to the influence of poststructuralist criticism;
(4) a stress on the moral dimension of art and criticism;
(5) attempts to develop a theological aesthetics;
(6) a response to recent works of art and literature;
(7) attention to the role of the Bible.

The inclusion of essays by three comparatists (Grotzer, Leiva-Merikakis, Ziolkowski) reminds us of what is often overlooked: that the study of art/literature/religion was engaged in by comparative literature scholars at least since the early years of this century, long before an awareness arose of literature and religion as a more or less distinct area of research, and that the training of the comparatist (including not least a working knowledge of foreign languages) and his/her encompassing perspective can generate fresh and valuable scholarship. Grotzer's study of the "critics of consciousness" Béguin, Poulet, and Raymond from a reader-response point of view, and Leiva-Merikakis's use of von Balthasar's thought and of Continental poetry to construct a "theological aesthetics" disclose a refreshingly different kind of scholarship to Americans, while Ziolkowski's account of another sort of reader response to his studies of the Bible reveals how sensitive we remain to the question of the privileged status of the Bible as religious scripture and cultural document. But other essays attest to the power of the comparatist approach. Scott's persuasive call for a "comparative poetics," Gerhart's impressive overview of the situation in genre studies, and Hesla's ingenious essay on tragedy all partake, one way or another, in the strategies of the comparative literature scholar and encourage us, by good example, to acquire and hone those tactics. We can even hope that somewhere among us a young Erich Auerbach may be maturing who will help us to place our endeavors in art/literature/religion in the best comparative literature tradition.

A second cluster is formed by some of our essays around a regard for story. The new respectability accorded to metaphoric language by Ricoeur and others, the emergence of "narratology" and of a "poetics of fiction," the experiments in a theology of story are all of great interest for the art/literature/religion critics and even indicate the achievement of what many

such critics have been striving for: the recognition that presentational language should be taken as seriously as the discursive form. But Nathan Scott shows that the "rediscovery of story," particularly by theological critics, is attended by questions of the ontological status of narrative language that must be addressed, and John Shea is concerned that the "poetic retelling of scriptural stories" in our new context of narrative awareness be thoroughly understood and skillfully implemented.

Autobiography and biography are varieties of story telling that are also the objects of increased attention these days. Janet Gunn argues, via the classic case of Augustine's *Confessions*, that autobiography as a story of the self seeking its place and meaning in the world has inherent religious dimensions; and Richard Rubenstein tells some of his own story as Jewish theologian and rabbi both to illustrate and qualify the potential of what he calls autobiographical theology. Daniel Noel, then, relates story and autobiography to myth in his account of how some contemporary American poets employ dreams and the unconscious to reinvest our literature with a religious involvement otherwise absent or at least unarticulated.

Much criticism nowadays is touched by the pervasive linguistically-oriented modes, and our essays are no exception. Four of them constitute a cluster that is a quite explicit response to the influence of what is now often called poststructuralism, referring mainly to the deconstructive strategies of Jacques Derrida and his advocates, but also to Michel Foucault's multi-leveled and countertraditional analyses of Western institutions. The essays by Scott and Giles Gunn are the most cautious and discriminating here—Scott's describing the dilemma of the critics who cannot or will not see beyond linguisticality, and Gunn's arguing that the "radical" critics have not successfully refuted claims to a knowledge of reality outside language but have merely restricted the boundaries of inquiry. David Seeley speaks more sympathetically for a Derridean, deconstructionist approach and applies a qualified version of it to biblical interpretation, while Gerhart integrates deconstructionist thought into her own survey of genre theory and her projection for its future. Insofar as these essays are representative, we could say that art/literature/religion critics are acquainted with deconstructionist argument and rhetoric, take them seriously and employ them, but are not overwhelmed by them.

Giles Gunn's essay also recalls for us a theme that has had surprisingly little currency in our interdiscipline—the concern for ethics—and in this he is joined by three other essayists, David Hesla, Erasmo Leiva-Merikakis, and John May. Gunn's forceful analysis of how aesthetic judgments are inevitably moral—or lacking in some key element—is underscored by Hesla's comparison of the moral universes of Greek and Christian tragedy and by Leiva-Merikakis's appeal for a criticism that insists on recognizing the ethical imperative embodied even in the style of a single short poem. May's discussion of contemporary American cinema provides a welcome nonliterary

dimension to our collection and reveals in the process how cinematic style involves a director's ethical vision that is significant because of its limitations and its tendency to confuse the powerful visual illusion of the screen with the world's reality. The lesson of all of these essays is that the neglected factor of moral criticism needs to be much more vigorously addressed, and consciously practiced, by art/literature/religion critics.

Leiva-Merikakis's interest in creating a workable theological aesthetics is shared, if less explicitly, by three other authors: by Huntley and Rebecca Beyer in their essay on music and by Grotzer in his reading of the critics of consciousness. Leiva-Merikakis's suggestion (not prescription) for a methodology of a theological aesthetics based on the three critical phases of *ekstasis*, *krisis*, and *praxis* is part of an essay that is paradoxically daring in its reliance on the classical formulations of the Christian theological tradition, and even begins to sound radical in its espousal of von Balthasar's insistence that the Christian must be the guardian of "worldly" beauty. It is a kind of writing that extends valuably the scholarship of Roman Catholic writers such as Lynch, Maritain, and more recently David Tracy. Grotzer, dealing with three important French-language literary critics of our century, treats the religious dynamics of their thought in terms of transcendence, presence, and the poetically engaged consciousness to contribute to the formulation of a theological aesthetics. Like Leiva-Merikakis's effort, it is credible because it grows out of a commitment to the search for ultimate meaning incarnated in artistic form. The Beyers in their essay on contemporary music similarly, but in addressing another medium, explore the theological implications of artistic style. They show that three styles of the new music work to increase our understanding of redemption, love, and incarnation, and do so, moreover, in ways that make us more intensely aware of the contemporary non-Western and scientific influences upon our life-worlds.

The art/literature/religion enterprise has long been marked by a special attention paid to the newer creative works, and a cluster of our essays indicates a continuing of this emphasis. Scott's rehearsal of recent American novelists and short story writers, and Noel's treatment of postmodern American poets assure us that this regard for the religious and theological dimensions of contemporary writing remains strong, while May's essay on cinema and the discussion of music by the Beyers demonstrate that this sensitivity toward the new extends to the other arts. Art/literature/religion criticism has tended, on the other hand, to neglect the older periods and works, and it is good, against this lack, to have the essay by Janet Varner Gunn focusing on a venerable document (Augustine's *Confessions*) from a very up-to-date perspective, and to have Hesla's sweeping comparison of Greek and Christian tragic drama. Finally, Rubenstein's contribution (and other works by him) points to another kind of "blurred edge." His autobiographical theology is in some ways itself an example of recent literary art, merged with analysis; this sort of mixed genre writing has already become popular in some

literary circles and needs to be recognized by art/literature/religion critics.

We do not forget, of course, that Amos Wilder some decades ago pioneered in guiding religion and literature critics to the Bible itself, and this kind of effort finds representation in our final cluster of essays. Successors to Wilder were some time in coming, but now, in recent years, they have appeared in numbers, and we have both biblical scholars with "secular" literary critical sophistication (Will Beardslee, John Dominic Crossan, Dan Via, et al.) addressing biblical texts, and literature professors (Robert Alter, Frank Kermode, Louis Marin, Herbert Schneidau, and others) applying their methods to the Bible as another literary (and literary-cultural) work. Both of these directions are illustrated in the essays here by Seeley, Shea, and Ziolkowski.

Although our essays attend to many concerns and cover considerable territory, they by no means exhaust the art/literature/religion potential. Essays are missing, for example, on the visual arts other than cinema, on feminine/feminist criticism, on Third World arts and literature, on other non-Western arts and religion, on modern theater, on dance, on ritual and liturgy, on the oral tradition. Rosemary Magee's bibliography, covering roughly the past ten years of scholarship, also gives us a fine overview of the points of emphasis in the whole enterprise and shows where the lacunae exist. It becomes clear that our life on the borders, disordered and a little risky, must tolerate more disorder and more risk, for many more crossings need to be made.

Music Informing Spirit: A Commentary on the Theological Implications of Contemporary Music

Huntley Beyer and Rebecca Parker Beyer

There is reason for Christian theologians to be interested in serious contemporary music. Throughout their history, Christian life and thought have been creatively transformed by their encounter with perspectives beyond their own circle of concern. It was through the integration with Greek thought and the response to the scientific revolution that Christian theology moved into new and vital forms in the past. At present, theology is being challenged by the encounter with cultures and religious traditions outside the Western sphere and by the encounter with post-Newtonian scientific thought. Serious contemporary music is also engaged in these encounters. Analysis shows that various styles of contemporary music are connected to the Western-Christian tradition and at the same time include impulses from modern science and/or non-Western perspectives. Integrating these new perspectives, composers discover and project new forms of feeling which disclose options for spiritual reformation.

This paper presents an analysis of three styles of contemporary music and a commentary, derived from the music, on how Christian theology might reformulate its visions of redemption, love, and incarnation. Our method of analysis and commentary has three stages. First, we begin with a musical style and examine it with an ear toward discerning the source of its aesthetic power, which we suggest is located in a "generating contrast." Particular musical elements work together in particular ways to effect a "generating contrast" which creates a sense of significant unity emerging from harmonized tensiveness. Second, we explore a connection between the generating contrast of the musical style and metaphysical categories of explanation. Third, we suggest that religious values are, like art, a particular contrasting of metaphysical ultimates. Examination of how various religious styles contrast the metaphysical ultimates shared by the music leads to the commentary on how contemporary music gives information to current theological inquiry. At the same time, this commentary helps to reveal the aesthetic nature of religious life.

The implication of our methodology is that the aesthetic power of music

is in the music itself, while at the same time the music has reference beyond itself to metaphysical facts and is, like spirituality, a particular way of feeling those ultimate facts. Our project has affinity with a structuralist approach, "a program of inquiry founded upon the nature of the work of art as a cosmic symbol or metaphor, containing within itself and in the terms proper to itself a global account of the human world which engendered it; and with a set of analytical categories corresponding to the fundamental categories of human existence" (Nodelman:91). Our analysis, however, is not guided by a knowledge of structuralist concepts, but by Whitehead's process cosmology, and perhaps differs from the structuralist approach in its emphasis on metaphysical categories, with the view that human existence is to be understood within these categories.

We will begin our analysis by examining one of the most controversial styles of new music, which we will label "pan-historical" music. This is an eclectic style in which composers quote or imitate composers from every period of music history. The aesthetic power of this music is generated by the dynamic contrast of the past and the present, whose styles and times are juxtaposed and perceived through each other.

The contrast of past and present musical material is embodied in this music in various ways. Luciano Berio in the third movement of *Sinfonia* (1968) projects a dreamlike stream of consciousness as he quotes steadily from Bach to Boulez and Stockhausen, focusing on the third movement of Mahler's *Resurrection Symphony*. George Crumb, in *Music for a Summer Evening (Makrokosmos III)* (1974) dramatically evokes a time distance when he inserts amidst his eerie contemporary sounds a portion of Bach's D-sharp minor fugue from the *Well-tempered Clavier, Book II*. George Rochberg in his compositions both quotes from past music and writes in the style of previous composers. For example, in *Ricordanza* for cello and piano, written in 1972, he uses a traditional A B A form, writes the first section in a highly romantic style, uses and develops fragments from Beethoven's *Sonata No. 4* for piano and cello in the middle section as if it were a development section in a sonata form (only here what is developed is from Beethoven, not the first section of the piece), and climaxes the return of the A section with a solo cadenza of concerto-like proportion. Rochberg muses that "each of us is part of a vast physical-mental-spiritual web of previous lives, existences, modes of thought, behavior, and perception. . . . We are filaments of a universal mind; we dream each others' dreams and those of our ancestors. Time, thus, is not linear, but radial" (1973).

The aesthetic power of this contrast of past and present has two qualities. One is the feeling of inclusive breadth; time boundaries are broken down. Mozart lambs lay down with contemporary lions. The other is the sense of compressed time, which results from the unity of the composition. All times are caught up together and enfolded into the present moment, in a kind of musical fusion.

Whitehead can be used to clarify the metaphysical references of such music through his doctrine of how the past is related to the present. His basic view is that reality is comprised of discrete, momentary "occasions" of experience. Each present occasion inherits the entire past, and it is through its inheritance that "an actual entity has a perfectly definite bond with every item in the universe" (1978:41). This relationship of past to present occurs in two ways. The most ordinary way that the past inheres in the present is as it is mediated to the present through successive, contiguous events. In this causal flow, we understand things to be near or far in time. Less ordinarily, the past can have a noncontiguous relationship to the present. It is possible for a becoming actual occasion to have a nonmediated, direct prehension of an event spatially or temporally removed. John Cobb comments, "every past occasion near or far in time might be directly prehended by every becoming occasion" (1965:53).

Whitehead commented (1978:308) that as long as physical science asserted that there can be no "action at a distance" there was not much physical evidence to support his view of nonmediated inheritance. Modern physics provides evidence that supports his view. As a result of recent experiments, physicist David Bohm questions "the ordinary idea of causal connection in past and future," saying that things are not only "locally connected so that one thing affects another nearby," and asserts that the situation in contemporary physics points to the reality of "nonlocal connection" (89).

It is now possible to comment on the spiritual implications of pan-historical music for Christian life and thought. The structure of Christian existence involves a particular, complex way of feeling the relationship of the past to the present. Christianity affirms that the past influences the present and feels this influence to be positively significant for personal identity and richness of feeling. At the same time, the past is felt to be oppressive, the source of error and sin. We cannot simply repeat the past, but need to be saved from its negative impact and move into a new present, redeemed.

Within the Christian tradition, liberals and conservatives seek slightly different forms of redemption. For the liberals redemption is transcendence of the past. The past is felt to be mediated to the present through the successive flow of events, and the work of Christ is to transform history, to move us into being more than we have been, through the gift of new possibilities. Christ, the source of creative transformation, saves. The weakness of the liberal style is that the past is felt as the defining background of progress; it has little value on its own terms.

For the conservatives redemption involves reorientation to the past. A person burdened with guilt and a sense of worthlessness gains a new, worthy identity by establishing an immediate, personal relationship to Jesus. Jesus saves. The conservative unlike the liberal view asserts that we can have a direct, nonmediated experience of Jesus, and return to original Christianity.

The weakness of the conservative style is that it tends to be narrow and naive in its appraisal of and relationship to the contemporary world.

Pan-historical music, at its best, holds the liberal and conservative perspectives together in a contrast, and presents a novel way of relating the past and present, suggesting a fresh dimension to redemption. Like the conservative perspective, pan-historical music captures the nonmediated presence of the past. The past material is presented for its intrinsic value, not only for purposes of creative transformation or interpretation. Rochberg says, "I came to realize that the music of the 'old masters' was a living presence, that its spiritual values had not been displaced or destroyed by the new music" (1973). Also like the conservative view, the presence of the past is felt to be redemptive. "Music can be renewed by regaining contact with the tradition and means of the past" (Rochberg, 1973). Like the liberal perspective there is concern for creative progress. Composers are making something new; they are not just restating beauties of the past. As composer William Bolcom says, "I sense the need to reintegrate the past with the present, to treat the musical language more like spoken language: as a constantly evolving creature always taking on new flesh and bone, yet retaining its most ancient elements" (1976). Also unlike the conservative religious perspective and more like the liberal, *all* of the past, not just one hallowed person or time, is noteworthy. Holding these perspectives in aesthetic contrast, pan-historical music provides a feeling form in which the past is valued intrinsically and yet there is newness, not in liberation from the past but in the freshness of a new, expansive integration of past and present.

Pan-historical music does not always succeed at this "almost impossible task" (Rochberg, 1973). It fails when it eliminates any contemporary reference and then seems indulgent and nostalgic, narrow and naive. Bad pan-historical music exhibits the qualities of unbalanced fundamentalism, with its sweet remoteness. But when it is successful, as in Crumb's *Music for a Summer Evening* for example, pan-historical music embodies in concrete sound the possibility that redemption means a creative advance into more poignant, immediate remembrance of things past, or conversely that the presence of the past transforms the present, giving it richness and depth.

This is a new, expanded concept of redemption. Redemption is neither a retreat to the past nor an escape from it. It is the enlivening, enriching presence of the past. This means redemption includes being able to enjoy the ever-presence of all past value. The gracious work of God is indeed to move us on into new worlds and liberate us from what we have been, but this happens not only through the influx of new possibilities but through the responsive creativity of God, who purges the dross from what has been and returns to us in immediate vividness the beauty that was achieved. The love of God for the world, says Whitehead, is that "perfected actuality passes back into the temporal world, and qualifies this world so that each temporal actuality includes it as an immediate fact of relevant experience. For the

kingdom of heaven is with us today" (1978:351). It is not irrelevant to notice that in *Music for a Summer Evening,* in the movement in which he quotes from Bach, George Crumb claims that the following lines of Rilke "find their symbolic resonance in the sounds. . . : 'And in the nights the heavy earth is falling from all the stars into loneliness. We are all falling. And yet there is One who holds this falling endlessly gently in His hands.'"

A second style of contemporary music to be analyzed is indeterminate or aleatoric music. It is music in which not all the factors are precisely determined by the composer. The techniques of this music serve to negate all traditional harmonic, melodic, rhythmic, and structural relationships between sounds, liberating each sound to be heard in its independent uniqueness. This music is totally different from pan-historical music.

There are basically two ways that this music is indeterminate. One is in the way the music is performed, and the other is in the way it is composed. In a performance many aspects of the music may be left to the spontaneous choices of the performers. For example, Earle Brown's *Twenty five Pages,* written in 1953, consists of twenty-five separate pages which may be played in any order. Each page may be played with either end up. Durations are notated only approximately. Any number of pianos from one to twenty-five may be used. In *Paintings* (1965) for recorder and piano, composer Louis Andriessen abandons all conventional notation and asks the performers to make choices based on black-and-white graphic designs. John Cage has extended the use of indeterminacy to include the compositional process. In *Music of Changes* (1951) Cage threw the *I Ching* to establish tempi, dynamics, durations, sounds and silences, and superpositions, or "how many events are happening at once during a given structural space" (Cage, 1939:58).

These techniques of indeterminacy create an interesting musical effect. The music eliminates any dramatic or gestural context for sound and thus does not demonstrate a cause or generate expectation for any sound. The present moment of sound feels like it simply arises. It sounds uncaused. It did not have to happen, and furthermore it could have happened otherwise. This effect of nonlinear, noncausal connections between moments is intentional. Sounds are to be liberated "from the inherited, functional concepts of control" (Brown, n.d.) and from "personal expression, drama, psychology and the like" (Nyman:26). Even when some of the parameters in the music are determined by the composer, they are often chosen to heighten the effects of indeterminacy. "I wrote each voice individually, choosing intervals that seemed to erase or cancel out each sound as soon as we hear the next," says Morton Feldman about his *Durations I.*

The aesthetic attractiveness of this music is in its ability to sensitize the listener to appreciate each sound as it is heard. By breaking each sound out of its participation in a larger musical context, say of phrase, melody or harmony, each sound comes to be defined by its independence rather than

by its linear, contextual relationships, as in traditional music. This breakdown of context gives emphasis to a contrast, the contrast of what something is with what else it might have been. In traditional music the relevant possibilities for each moment of the music are limited by harmonic-melodic-rhythmic-structural systems, and this limitation makes possible expectation and surprising resolution, but it narrows the relevant contrast between what each moment of the music is and what it might have been. Indeterminate music explodes limitations, and expands the relevant possibilities for each moment of the music. The uniqueness and specificity of each sound is heightened for feeling by the contrast of the vastness of what something might have been with what it in fact is.

Metaphysically this musical situation is clarified by Whitehead's understanding of determination and freedom. Each concrescing occasion is determined in that it must take account of the totality of past actualities. Past actualities are determinate, settled facts, the "ground of obligation" (Whitehead, 1978:27). But the subjective occasion is free to decide how to take account of this totality of determinate fact, and it is given a resource for creative responsiveness through the realm of novel, indeterminate possibilities. Every occasion, then, is free in that it is self-determining. Freedom is maximized as the occasion takes account of a broader range of possibilities. Indeterminate music embodies the character of maximized freedom. Each musical moment is quite independent, largely undetermined by the immediate past moments of the piece, and unlimited by obligation to any musical structure or language.

Religious traditions are shaped partly by the cultivation of different balances of freedom and determination, and these balances are manifested in distinctive structures of selfhood. In Christian existence selfhood is structured through selective acceptance and creative response to determinate facts. A Christian feels obligated to self, to others, and to God. As in traditional music, freedom is always highly relevant to a given history, a given context. This structure of selfhood supports a specific kind of love. Love is the binding of oneself to another. It requires suffering the other and seeking to help transform relationships through obedient reception of God's purposes.

The Buddhist structure of selfhood maximizes the freedom of individual moments of human experience. Each immediate moment is radically self-determining, open to a wide range of influencing data, nondetermined by habits, and spontaneous in being. For the Buddhist love is unbounded compassion. Such a structure of selfhood is a contrasting of the vastness of all possibility and actuality with the particularity and spontaneity of the immediately becoming moment. This contrast is analogous to the contrast in indeterminate music in which the expanded background of relevant possibility haunts each moment of sound and heightens its particularity.

Some composers in this indeterminate style acknowledge a conscious,

intentional connection to Buddhist concerns. John Cage, in particular, indicates his Zen Buddhist leanings. "Why is it so necessary that sounds should be just sounds?" queries Cage. "In order that each sound may become the Buddha" (1939:70). The music thus provides a resource for a Buddhist-Christian dialogue. It embodies within Western tradition Eastern ways of feeling and presents to the Western listener an alternative feeling structure. A commentary on the impact of this music on Christian theology and life would parallel comments made by theologians involved in the Buddhist-Christian dialogue.

There is special significance in this encounter for the Christian understanding of love. The aim to love has been a problematic struggle insofar as selfhood is determined by obligation to "my past," "my self," "my future." Cobb observes, "Christians . . . are aware of the problems generated by the strong personal selfhood of their tradition. Anxiety, alienation, brittleness, pride, and self-seeking are too intense to be overcome by the love and community we affirm" (1975:209). Self-giving love may be strengthened by a different, open, unbounded, radically free, immediately self-determining structure of selfhood, such as is cultivated by Buddhists and evoked by indeterminate music.

A third style of contemporary music we will analyze has been variously labeled minimalism, solid state, and trance music, images which derive from visual art, electronic circuitry and non-Western ritual, respectively (Glass:5). Composers of minimal music are influenced by non-Western sources such as the additive principles of Indian rhythmic structure and the geometric repetitions of Islamic art (Glass:5), Indian ragas (Riley), and Balinese Gamelan and African drumming music (Reich, 1978). The aesthetic force of the music derives from a contrast of massive repetition and incremental change.

Minimal music is a music created through repeating melodic-rhythmic patterns. The patterns are usually short, simple and tonal, involving a minimal amount of musical material. The music changes as one repeating pattern shifts to another. The new pattern is often similar in design to the previous one. The music gains intricacy as patterns are superimposed on each other, creating a polyphonic web of pulsating, interlocking sound.

In one technique of minimal music patterns are altered by simple rhythmic or tonal additions or subtractions, a typical technique in Philip Glass's "additive" music. In another technique a polyphony of patterns is altered as rhythmic relationships between patterns change, a typical technique in Steve Reich's "phase" music. Describing *Drumming*, for example, Reich says "two or three identical instruments playing the same repeating melodic pattern gradually move out of synchronization with each other" (1974).

The techniques of minimal music yield a music that holds together repetition and change on microsonic and macrosonic levels. With regard to

repetition, microsonically, individual melodic-rhythmic patterns quickly establish an identity or stability through repetition. Macrosonically, a matrix of superimposed patterns also effects a stability as its patterned parts repeat. Change occurs on microsonic and macrosonic levels as well. Microsonically, individual patterns are composed of very simple or minimal alterations of pitch or rhythm, giving a vibratory, pulsating core to the music. These patterns themselves change in their detail, usually after many repetitions. Macrosonically, the matrix of interlocking patterns changes its character as a result of features of the individual patterns changing at different rates, and as new patterns are introduced. The result is a buzzing, energetic music that feels intensely alive but very stable. Interlocking relationships are celebrated repeatedly in a vast, slowly changing environment.

Repetition-change can be associated with the metaphysical relationship of the mental and physical pole in any actual occasion. Whitehead asserts that in the becoming of every occasion "there is a twofold aspect of the creative urge. In one aspect there is the origination of simple causal feelings; and in the other aspect there is the origination of conceptual feelings. These contrasted aspects will be called the physical and the mental poles of an actual entity. No actual entity is devoid of either pole; though their relative importance differs in different actual entities" (1978:239).

The physical pole is basically comprised of simple physical feelings. "Simple physical feelings embody the reproductive character of nature. . . . In virtue of these feelings time is the conformation of the immediate present to the past" (1978:238). Through simple physical feelings, the present reenacts or repeats the past. The repetitive structure of minimal music expresses the character of physical feeling.

The mental pole involves conceptual feelings in response to the physical pole. It introduces emphasis, valuation, purpose, or a relevant novel contrast. Apart from the operations of mentality there is no change. The gradual change in minimal music expresses the process of emergent novelty through the operations of the mental pole. Thus, the contrast of repetition and change in this music can be understood to have reference to the contrast of the mental and physical poles of experience.

The relationship of mentality and physicality is significant for the structure of Christian existence. Both mentality and physicality are valued, unlike Hinduism, which seeks liberation from causality and sense experience, aspects of physicality; and unlike Buddhism, which seeks liberation from valuation and conceptuality, aspects of mentality. For Christianity physicality is valued in that creation is considered good, and life in this world is affirmed. Aspects of mental experience—purpose, value, creative responsiveness—are especially cultivated. These aspects are understood to be those features of life that incarnate God's aims to save us from a life of repetitious oppression and give us the opportunity for new life, transformation, and creative advance. Intensified orientation to God seems to require a

structure of existence in which mentality is valued over physicality, as "God is the infinite ground of all mentality" (Whitehead, 1978:348), and the "organ of novelty" (Cobb, 1965:161) in the world.

Minimal music contrasts physicality and mentality in a different way. It emphasizes physicality over mentality, sharing the Buddhist perspective. Its representation of mentality shows mentality as a source of neither radical transformation as in Christianity nor as a source for radical transcendence as in Vedantic Hinduism. Rather, mentality is like a spark that energizes the entire, massive realm of physical interconnectedness. Interestingly, the structure of minimal music is especially analogous to patterns in nature, and it is in this connection that minimal music contributes something unique to spirituality.

The repetition-change structure of minimal music reflects the physical world of atoms, which give the appearance of stable identity but are in fact comprised of organized, energetic pulsations. Or it mirrors the biological organization of a cell which combines the enduring continuity of its molecules, basically repeating their past through physical feelings, with a degree of novelty or change. Or minimal music suggests the large scale, stable environments in nature which sustain vital, individual lives. Minimal music lacks the traditional musical emphasis on linear, dramatic shapes and tension-resolution transformations so suggestive of personal drama and growth. Instead, its emphasis on individual patterns in relationship makes it sound like an image of the human body, a complex, enduring organism that supports the variable and vibrant life of the soul; like an image of human community with many individual lives woven together into a whole; like an image of a vast eco-system, stable but gradually evolving on the large scale, and catching within its network tiny sparks of intense life.

The aesthetic structure of minimal music, with its analogies to nature, suggests a broadened image of incarnation. The music implies two fresh dimensions to incarnation.

First, the music expresses a feeling for the way in which physicality harbors mentality or "spirit." The physical yet vibrant quality of the music suggests that incarnation is not the incredible leap of spirit into matter at a few very special points in the cosmos. Rather, incarnation is the ubiquitous conspiracy of mentality with physicality. God, the ground of all mentality, is thus incarnate everywhere in the natural, as well as the human, world.

Second, because of its nonpersonal, collective aspect, minimal music suggests a reversal of the ordinary focus of spirituality on the one-to-one relationship between an individual and God. The fruit of novelty in the music is increased vitality in the interlocking relationships between patterns. So also, the work of God in the world is to intensify and extend relationships among individuals. Incarnation is maximized not only as an individual draws closer to God, but as an individual participates more fully in lives, communities, and environments beyond itself.

Minimal music calls Christian spirituality beyond feeling the dominance of spirit over matter, mind over nature, and individual over community to a greater bodily, communal, environmental, participatory awareness. Such a reversal is especially significant in an age in which we are reaping the sickly harvests of hierarchical dualism and extreme individualism.

Concluding comments are now in order. We have described and analyzed pan-historical, indeterminate and minimal styles of contemporary music, and have suggested that these three musical styles imply an expanded scheme of redemption, an alternative structure of selfhood that enables more selfless love, and an extended and relational dimension to incarnation. These new insights represent an opportunity for Christianity to be inclusive of contemporary scientific and non-Western perspectives. The real value and importance of the music, however, is not in the insights alone, abstracted by analysis from the music. The real value is that the music gives us forms of feeling in which these insights are embodied.

Music gives us new vision founded in concrete form and calls theology beyond abstract contemplation to actualized value. The actualization of religious value is an aesthetic operation, an operation of contrast, a compositional act of feeling certain things together in a certain way.

WORKS CONSULTED

Andriessen, Louis
 1965 *Paintings*. Celle, Germany: Hermann Moeck Verlag.

Berio, Luciano
 1968 *Sinfonia*. Columbia MS 7268. Jacket notes by Luciano Berio.

Bohm, David
 1978 "The Implicate Order: A New Order for Physics." *Process Studies* 8/2:73–102.

Bolcom, William
 1976 *Open House* and *Commedia*. Nonesuch Records H-71324. Jacket notes by William Bolcom.

Brown, Earle
 n.d. *Music for Violin, Cello and Piano, Music for Cello and Piano, and Hodograph I*. Time Records 58007. Jacket notes by Earle Brown.
 1975 *Twenty five Pages*. Toronto: Universal Edition.

Cage, John
 1939 *Silence*. Cambridge: The M.I.T. Press.
 1978 *Music of Changes*. New World Records NW214.

Cobb, John B., Jr.
 1965 *A Christian Natural Theology*. Philadelphia: Westminster Press.

1967 *The Structure of Christian Existence*. Philadelphia: Westminster Press.

1975 *Christ in a Pluralistic Age*. Philadelphia: Westminster Press.

Crumb, George
1975 *Music for a Summer Evening (Makrokosmos III)*. Nonesuch Records H-71311. Jacket notes by George Crumb.

Feldman, Morton
n.d. *Durations*. Time Records 58007. Jacket notes by Morton Feldman.

Glass, Philip
1979 *Einstein on the Beach*. Tomato Music Company TM-4-2901. Inside notes by Robert Palmer.

Nodelman, Sheldon
1966 "Structural analysis in art and anthropology." In *Structuralism*, edited by Jacques Ehrmann, pp. 79-93. Garden City: Doubleday.

Nyman, Michael
1974 *Experimental Music: Cage and beyond*. New York: Macmillan.

Reich, Steve
1974 *Drumming*. Deutsche Grammophon 27 40 106. Inside notes by Steve Reich.

1978 *Music for 18 Musicians*. ECM Records ECM-1-1129.

Riley, Terry
1980 *Shri Camel*. CBS Records M 35164. Jacket notes by Hugh Garder.

Rochberg, George
1973 *String Quartet No. 3*. Nonesuch Records H-71283. Jacket notes by George Rochberg.

1974 *Ricordanza (Soliloquy for Cello and Piano)*. Bryn Mawr: Theodore Presser Company.

Whitehead, Alfred North
1933 *Adventures of Ideas*. New York: The Free Press.

1978 *Process and Reality*. Corrected ed., David R. Griffin and Donald W. Sherburne, eds. New York: Free Press.

Genre—The Larger Context

Mary Gerhart

In his brief study of the concept of "genus universum," Michel Beaujour mentions two ways in which genre as mere category has been surpassed historically. An instance of the first way of surpassing genre can be seen in the regard given *The Iliad, The Odyssey* and some Romantic texts: these texts were reputed to contain all genres. An instance of the second way can be found in the view that the Bible transcends all genres because divine revelation cannot be generic in any way. In spite of the strengths of these two surpassings—or in a curiously perverse way, perhaps because of them— genre theory today has by and large been concerned with issues of classification or, to use Mallarme's term, "universal journalism" (Beaujour:19). Because the *surpassing* of genre is so often an uncritical religious or classicist claim, genre as classification may well be a reaction against forms of traditionalism.

Classification is a derivative and possibly false issue, however. In a previous essay I argued that besides genre as category, four other considerations are intrinsic to generic criticism as suggested by recent studies in interpretation theory: the "multiple parentage" of genres (E. D. Hirsch), their theoretical as well as descriptive constitution (T. Todorov), their historicity (H.-G. Gadamer), and their praxis orientation (P. Ricoeur). These four considerations all serve to expand the concept of genre and to free it from its association exclusively with categorization.

Recent studies of the history of genre theory have now made it possible for theorists to correct further the misunderstanding of genre as mere category. The search for the origins of the tripartite division of literature into epic, dramatic, and lyric, for example, has been converted into a fascinating record of misstatements and partial understandings of genre in the history of thought from Plato to the present. Furthermore, it can been shown that the researchers themselves often fall into the archaistic fallacy of thinking that once origins have been determined, the normativeness of the historical is established.

In this essay I examine four developments in the history of genre theory: the classical dispute over the question of which genre(s) are basic to all others; the effects of the New Criticism on genre theory; the primacy of the human subject in German morphological criticism; and the ambitions of deconstructionist criticism. Throughout the study, I will understand genre as

the interplay of structural exigencies and thematic expectations which the reading of any text sets in motion. The main focus, however, is on the epistemological implications of each development. In this sense, the radicality of the question of meaning and the cognitive status of all texts in deconstructionist criticism, for example, can be seen as isomorphic to the ambitions of this essay: namely, to radicalize dead notions of genre by bringing them to the level of epistemological reflection. Finally, I will make suggestions concerning the relationship of genres to modes of thought.

I. Four Developments in the History of Genre

The Classical Dispute

In his widely cited systematic study of the history of genre theory from the classical to the present Gérard Genette shows how misunderstandings of Aristotle's *Poetics* gave rise to the traditional tripartite division of genres (narrative, dramatic, lyric). Genette understands Aristotle in effect to have ignored the lyric by restricting his poetics to mimesis. It is legitimate, therefore, to attribute to Aristotle theories only of the tragic and the epic. The context of Aristotle's argument, Genette agrees, is clear: Aristotle's argument is designed to respond to Plato's fundamentalist attitude toward poets and poetizing. But Genette goes one step further: he suggests that already in Plato's distinction between "pure narrative" (use of the poet's own words and thoughts) and "imitation" (use of the character's words and gestures instead of the poet's), there is room for the genre of lyric poetry (391). Gérard argues that although the tripartite division of genres cannot be attributed to either Plato or Aristotle, there is no good reason to question its usefulness for later theorists.

Another time it would be useful to study Genette's argument that Aristotle was not merely describing literary works already in existence. He was theorizing, leaving intellectual space for genres that did not exist in fourth century Greece but which later could be found in Rome (Genette:408). For our purpose, however, the significance of Plato's and Aristotle's work, taken together, is more important. The need to give a basis for the cognitive status of literature is paramount, first in Plato's work, and then in a different way, in Aristotle's.

According to Iris Murdoch, there may be no sufficient reason to regard Plato as completely opposed to poets. Nor need we go into the complexity of the full range of understandings which attend the meanings of "representation" and of "imitation." It is more important that we understand that the real issue in the Plato–Aristotle debate was the more appropriate way of giving a positive valence to literature. In Genette's reading, Plato's theory favors the principle of virtuous "representation" whereas Aristotle favors that of mimesis. For Plato, only pure "narrative" could be an important genre (as implied in

Plato's attitude toward pure narrative as uncompromised expression, and pure imitation—unless mixed with narrative—as dissimulation). For Aristotle, on the other hand, "pure" prose has been discussed in the *Rhetoric* and "pure" poetry is not considered. We see also in this debate that the superiority of one genre over another is directly related to the implicit epistemology of the position. Plato's preference for the dithyramb (as pure poetry) is based on his belief that nothing should come between the poet's narration and his self-manifestation. Aristotle's preference for the tragic and the epic is closely related to his appreciation of the diverse forms of persuasion in the *Rhetoric* and of imitation.

In the debate between Plato and Aristotle we recognize two polar tensions which persist in the understanding of genre to the present. The initiating moment sees poetry as holistic, as an immediate expression of self, as generic in and of itself (the Platonic argument). A similar desire to surpass all distinct and determinate genres is perhaps best exemplified in Romanticism:

> "The genre of Romantic poetry is still in the process of becoming; it is its true essence to be always only becoming and never to be capable of completing itself." . . . This inherent impossibility within Romanticism is, of course, the reason why the question [what is Romanticism? or what is literature?] is actually an empty one, and why, under the rubric of Romanticism or of literature (or of . . . "Art," "Religion," etc.), the question only comes to bear on something indistinct and indeterminate, something that indefinitely recedes as one gets closer to it. It is something susceptible to being called (almost) any name, but not able to tolerate any one of these names. . . . Romantic texts. in their fragmentation or even in their dispersion, are only the interminable answer (always approximate, neither here nor there) to the question that is really unformable, i.e., always too quickly, too lightly and too easily formulated, just as if the 'thing' worked all by itself. (Lacoue-Labarthe and Nancy:2)

In Romanticism, the determinateness of "things" is held hostage to the determination to keep all things tentative.

The second moment of the debate distinguishes among different kinds of literature, seeing each kind as mediating distinct meanings, themselves capable of being analyzed systematically (the Aristotelian argument). One who argues from this position assumes that literary forms are distinct and brings to the task of understanding literature a demand for critical interpretation, i.e., an interpretation that is species-specific and which has as its ambition an explanation of how the literary work works. Instead of asking, Whence comes the power of this work? this second kind of critic asks, How is the power of this work generated through its particular form and meaning? The first pole of the debate taken alone breeds errors such as that of regarding the speaker in a lyric poem as the poet, rather than as a persona created by the poet. The second pole of the debate taken alone results in formalism.

The New Criticism

Two kinds of formalism preside in the New Criticism. For the Neo-Aristotelians, such as Richard McKeon and R. S. Crane, the Aristotelian categories of plot, character, and imitation, of words as the "matter" of poetry are the major tools of analysis. The later, more "formalist" New Critics add other concepts to explicate the text: context, tension, ambiguity, words as images. But for all its dedication to formal analysis, New Criticism strikes one as being at odds with itself on the issue of genre. Although the New Critics are intent upon what Murray Kreiger calls "formulating a new 'apology' for poetry," they seem uninterested in exploring the continuities between ordinary language and the genres of poetry on the one hand and between non-literary genres and poetry on the other. As a consequence, literary genres, although explicit, are essentially unproblematic as an issue in interpretation. One might find R. S. Crane or Sheldon Sacks arguing, for example, over the way a particular text is best understood—whether, for example, Jane Austen's *Persuasion* is best read as a "love tale" or as serious comedy (Crane:289); whether *Emma* is best read as satire or as represented action (Sacks:15–20)—but they assume that genres are formal categories, for the most part adequately defined by the historians of criticism. As a reaction against biographical and historical usurpation of textual criticism, the New Criticism concentrates on the particular tensions within particular texts. Although genre-theory is not programmatically dismissed, it is benignly neglected insofar as it is understood as extrinsic to the act of criticism. The expectation is that if one sees the individual text clearly and precisely, comparisons of texts on the level of genre would be gratuitous. On the positive side, we might say that in New Criticism, an epochē of genre theory occurs for the purpose of testing the definitions inherited from classicism. (Notice the New Critics' longstanding inability to deal with the "new" novel.)

The German Morphological Tradition

The German morphological tradition, by contrast, is preoccupied with genre theory. German morphologists are interested in finding continuities between literary genres and subjective forms. They conceive of the human

> as a self-contained whole which unites rational understanding with the irra-
> tional unconscious and recognize in the nature of [the human] as well a
> predisposition to become integrated in the "universally human," in the totality
> of humanity. By establishing an ontology which has ultimate reference to the
> metaphysical basis of human existence, it becomes possible to understand the
> individual literary work as the synthesis of all its levels of concretization. . . .
> It is precisely this "synergetic" quality that characterizes the artistic mode of
> presentation. (Weissenberger:320)

In the morphological approach, discussion of how the literary work succeeds

is subordinated to what it can be taken to say about human consciousness.

The morphological tradition, as represented by Emil Staiger, Wolfgang Kayser, Käte Hamburger, and Walter Muschg, illustrates a major effort at "naturalizing" genres, that is, of establishing their roots in the operations of human consciousness. Muschg's poetics, for example, derives directly from his typology of poetic attitudes: the magical is correlated with the pronoun "I," the mystical with the pronoun "you," the mythical with the pronoun "it." Klaus Weissenberger has synthesized the typologies of the foregoing morphological critics and applied them to lyric poetry in an attempt to show how the morphological approach can be used to inform an understanding of lyric poetry and its subforms. He chose to do this for the lyric because it seemed to him to be most simple and straightforward. Nevertheless, even though he has no difficulty in working out the patterns of the generic sub-forms, he is unable to account for the teleological character of the lyric (Weissenberger:244–53).

A more promising attempt at showing the continuities among literary genres and ordinary experience and language—one which avoids the naturalistic fallacy—can be found in Barbara Herrnstein Smith's recent book, *On the Margins of Discourse: The Relation of Literature to Language.* Smith neither recommends nor discourages use of the distinction between nature and art (or, as she puts its, "natural discourse" and "fictive discourse"). Instead, she clarifies and refines the distinction by examining the creation of fictive objects and events on the edges of both artistic and natural discourse.

The Deconstructionist Critics

We move finally to the deconstructionist critics, who provide an interesting retrieval of generic studies. They are concerned with explicitly generic considerations, but hardly for the purpose of categorization. Consider the following deconstructionist statement by Jacques Derrida:

> The clause or floodgate of genre declasses what it allows to be classed. It tolls the knell of genealogy or of genericity, which it however also brings forth to the light of day. Putting to death the very thing that it engenders, it cuts a strange figure; a formless form, it remains nearly invisible, it neither sees the day nor brings it to light. Without it, neither genre nor literature come to light, but as soon as there is this blinking of an eye, this clause or this floodgate of genre, at the very moment that a genre or a literature is broached, at that very moment degenerescence has begun, the end begins. (1980:213)

The end begins, that is, when the act of writing or reading the text ends in the beginning of generic understanding—which understanding is also one of the "ends" of the text itself. Deconstruction has been defined by J. Hillis Miller, perhaps most succinctly, as "an investigation of what is implied by this inherence in one another of figure, concept, and narrative" (233).

In his introduction to a recent book of essays by the most prominent

deconstructionists—Harold Bloom, Paul de Man, Jacques Derrida, Geoffrey Hartman, and J. Hillis Miller—Hartman describes the focus of these critics on the question of the noncoincidence of meaning and language (viii). If the critic is able to draw only positive statements (as distinct from both positive and negative statements) from that noncoincidence, Hartman thinks, s/he merely restates what has already been revealed by literature. To modulate this tendency to restate, the deconstructionists make explicit the "intertextuality" (or intergenericity) of texts. Generic considerations are therefore intrinsic to and inevitable in their commentary, enabling them to move with rapidity and ease through poetics, semiotics, and philosophical reflection, or as they call it, "speculation."

The deconstructionists assist us in moving to the epistemological level of genre in two ways: first, by drawing defeat from the pursuit of positive meaning in literary texts; i.e., by equivocating on the issue of the referent of the text, they radicalize the question of meaning and the cognitive status of *all* texts; and second, by "untangling the inherence of metaphysics in nihilism and of nihilism in metaphysics" (Miller:230), deconstructionist criticism makes explicit the interdependency of the claims made by the text and by the commentary on the text. Miller calls the latter the inseparability of host text and parasite.

II. Genre as Epistemology

Each of the four approaches to genre we have just examined has in one way or another pointed to the need for making explicit the relationship between the generic and the epistemological. In the classical Greek, the different starting points of Plato's and of Aristotle's positions in relation to the three originary genres need to become explicit in a retrieval of the question, What is knowing? That is, in the question of genre the implicit relationships between philosophy and poetry (in Plato) and between rhetoric, metaphysics and poetry (in Aristotle) need to be drawn out. In the New Criticism, the disjunction between literature and ordinary language has the effect of breaking off literary genres from other modes and therefore other genres of thought. Such singularity of vision may no longer be desirable nor sufficient even for literary criticism. In the German morphological tradition, the major premise is that genres are rooted in the operations of human consciousness. However much we may put into question their application of this premise, the force of it is clear: it calls for an articulation of the human subject in a multiplicity of cognitive functions. In the deconstructionist approach, the act of reading is exploited for its full range of affirmation and negativity. In this respect, the deconstructionist approach, properly understood, would seem to allow for the final severing of the grip that categorization has held on the understanding of genre for so many centuries.

Yet the irony that can be seen in the wilderness of contemporary criticism

is that those critics who do attend explicitly to epistemological issues are often the ones who are least willing to do *critical* generic studies. Indeed, they more often try to surpass genre altogether in their interpretation of texts. On the other hand, those who make formal critical generic analysis of texts the center of their attention are the ones most apt to give cryptic rather than critical responses to questions pertaining to the cognitive status of the literary or of literature in general. There are some indications that deconstructionist criticism may expose this irony which, if left unappreciated, is destructive to criticism as a disciplined art. Comprehensive, if not clear, appreciation is already present in some deconstructionist criticism, such as Derrida's "Living On: Border Lines."

Recent studies of genre theory do suggest, however, that on certain vexed issues which have formerly shattered the common discussion some kind of consensus may be possible. First, there is a growing recognition that generic considerations are essential to good interpretation: they are the means by which a reader is able to handle the task of making a "whole" of the parts of a text and to relate the formal aspects of one text to another, in other words, to understand a single text in the whole galaxy of literary and nonliterary texts. This recognition is implied even in such extreme views of genre as Adrian Morino's when he declares that "each literary work can be written *only* 'in its own genre,' belongs to its own genre, and starts a *new genre*" (51).

Then there is the expectation that what has been done for metaphor in recent hermeneutical theory—in terms of shifting the focus from dead metaphors (found in the lexicon) to live metaphors (found at the edges of thought and knowledge)—might also be done for genre. When a metaphor loses its essential tension between two spheres of language, it is, for all speakers of the language, dead. Genre, too, once it has become a predictable form, once it can be located without remainder in a determinate body of literature, e.g., Greek tragedy or Spenserian sonnet, sees its demise at hand. Jacques Derrida puts the point this way:

> Every text participates in one or several genres, there is no genreless text; there is always a genre and genres, yet such participation never amounts to belonging. And not because of an abundant overflowing or a free, anarchic and unclassifiable productivity, but because of the *trait* of participation itself, because of the effect of the code and of the generic mark. Making genre its mark, a text demarcates itself. (1980:213)

In other words, a certain ambiguity attends the success of genre theory. Understood as categorization, a genre ceases to be a viable form as soon as it has been certified—once critics agree that all characteristics have been identified thematically and structurally and that a discrete body of literature corresponds to the identification. Understood as making and demarcating, however, genres are initiated and deconstructed by texts in the course of

critical reading. With the latter understanding, the confidence which critics have in genre theory can be seen in Genette's statement that

> the history of the theory of genres is completely marked by these fascinating schemes which inform and deform the often strange reality of the literary field and claim to discover a natural "system" there where they erect a forced symmetry with a lot of cracked windows. These forced configurations are not always without utility, on the contrary: like all provisory classifications, and on the condition that they are well received as such, they often have an incontestable heuristic function. The broken windows can in the circumstances give a true light, and show the importance of an unrecognized term; the empty or laboriously furnished case can find very much later a legitimate occupant. (408; my translation)

Again, as Todorov says: "It is not thus 'the' genres which have disappeared, but the genres-of-the-past, and they have been replaced by the others" (45; my translation). In this sense, genres never die, they just fade into other genres of a succeeding generation.

Finally, there is a sense in which the poetry vs. science debate and the religion vs. poetry debate have ended. I am thinking here of Plato's dismissal of the poets; Wordsworth's disdain for scientists; Kant's and Hegel's low esteem for metaphor as an intrusion on philosophical thought; the process theologians' aversion to mythos; the religion-as-story religionists' evaluation of story at the expense of theology. It is now possible to see all of these positions as exclusivist in the sense that they peremptorily eliminate the opposing position. Moreover, they fail to respect one fact: that literary genres depend on the understanding of the literary in general, presumably in relation to the understanding of the nonliterary.

III. Genre in Its Larger Context—In Relation to "Modes" of Thought

At the beginning of this study, I made reference to the notion of the surpassing of genre. This notion is operative historically in relation to both sacred texts (the Bible) and classics (*The Iliad* and *The Odyssey*). The employment of this notion within theology and religion gives rise to the distinction between sacred texts (in which revelation transcends all genres or categories) and secular texts (in which things are known by "human" genres or categories). Beaujour makes the interesting observation that once traditional religion was no longer a vital force, it became incumbent upon literature to secure biblical (i.e., beyond-genre) status. Hence we find the nineteenth century Romantics seeking to surpass genre by arguing that true literature cannot be bound by any particular form.

From this perspective, how fundamental the understanding of genre has been to the two disciplines of religion and literary criticism! It is a moot question, of course, whether there would have been only one discipline and whether the disciplines would differ if genre had not been understood

exclusively as category. It is useful, however, to examine some of the options now available to us.

Epistemological reflection on literary genres has typically gone in the direction of relating them to modes of thought, usually couched in disciplinary terms, e.g., philosophical, theological, scientific, historical. But to relate them at this point is to relate too late: genres have already been stigmatized as literary and the modes of thought appear as impositions. Revising this approach (e.g., with something like Dennis Kambouchner's "Theory of Accidents") would not necessarily remove the inclination to regard certain genres as in themselves, as for example, more "religious" than others./1/ What are the implications of arguing that certain genres, such as lyric and autobiography, are "Christian genres" (cf. TeSelle:80, 96, 130, 141, 177n). Is this to say that other literary genres are non-Christian? By what criteria? If historical, does this mean that certain literary genres such as the parable are intrinsically religious? Is it appropriate to ask whether certain literary genres are more appropriately religious than others? For a specific epoch? For all time?

These questions give rise to others. Given the tendency of originating religious texts to comprise a canon, do the literary genres of these originating texts thereby acquire a privileged status? If so, then what is the status of noncanonical, nonreligious texts? Is the secularity of texts best conceived of as over and against the religiousness of texts?

If the foregoing descriptions of the constraints which attend interdisciplinary work involving genres—constraints which result primarily from treating the modes of thought only as disciplines—are accurate, it may be useful to consider another paradigm. Let the disciplines stand as primitive theoretical and systematic efforts at organizing fields of thought. Let modes of thought correspond not to the disciplines as such, but rather to those more distinctively fundamental modes of thought which cut across several disciplines, namely, linear/hermeneutical; synchronic/diachronic; reductionist/distortionist; apodictic/polemical; theoretical/commonsensical; analogical/metaphorical; mimetic/impressionistic; exclusivist/pluralist; etc.

When modes of thought are conceived of in this way, it is possible to arbitrate the interests and antipathies now vested in disciplines and schools of thought. It is likely that a single text has not only multiple parentage in terms of genre, but that it also participates in more than one mode of thought. Moreover, since one term in the paired modes of thought is embedded in another, the discussion about modes of thought generated by a particular text is apt to be richer—that is, informed also by the negative and by opposites as well as the affirmed—than when modes of thought are conceived disciplinarily. Under this new rubric, it may even be possible for the lions of theology and literary criticism to lie down with the lambs of religious studies and religious interpretation.

NOTE

/1/ Kambouchner's theory is aimed at binding itself to a "mutation within the status of theory itself. To the degree that the principle of stability loses its absolute position, theory can no longer claim to constitute an absolutely stable generality, complete and sure" (174). However ingenious Kambouchner's theory, it may be directed against an epistemological straw-person.

WORKS CONSULTED

Beaujour, Michel
 1980 "Genus Universum." *Glyph* 7:15–31.

Bloom, Harold, et al.
 1979 *Deconstruction and Criticism.* New York: Seabury.

Crane, R. S.
 1967 "Jane Austen: 'Persuasion.'" In *The Idea of the Humanities and Other Essays, Critical and Historical,* pp. 283–302. Chicago: University of Chicago Press.

Derrida, Jacques
 1979 "Living On: Border Lines." In Bloom et al.:75–176.
 1980 "The Law of Genre." *Glyph* 7:202–32.

Genette, Gérard
 1977 "Genres, 'Types,' Modes." *Poetique* 8:389–421.

Hartman, Geoffrey
 1979 Preface. In Bloom et al.:vii–ix.

Kambouchner, Dennis
 1980 "Theory of Accidents." *Glyph* 7:149–75.

Lacoue-Labarthe, Philippe, and Nancy, Jean-Luc
 1980 "Genre." *Glyph* 7:1–14.

Marino, Adrian
 1978 "A Definition of Literary Genres." In *Theories of Literary Genre, Yearbook of Comparative Criticism,* vol. 8, edited by Joseph P. Strelka, pp. 41–56. University Park: Pennsylvania State University Press.

Miller, J. Hillis
 1979 "The Critic as Host." In Bloom et al.:217–53.

Murdoch, Iris
 1977 *The Fire and The Sun: Why Plato Banished the Artists.* Oxford: Clarendon Press.

Sacks, Sheldon
 1967 *Fiction and the Shape of Belief.* Berkeley: University of California Press.

Smith, Barbara Herrnstein
 1978 *On the Margins of Discourse: The Relation of Literature to Language.* Chicago: University of Chicago Press.

TeSelle, Sallie McFague
 1975 *Speaking in Parables: A Study in Metaphor and Theology.* Philadelphia: Fortress Press.

Todorov, Tzvetan
 1978 *Les Genres du discours.* Paris: Editions du Seuil.

Weissenberger, Klaus
 1978 "A Morphological Genre Theory." In *Theories of Literary Genre, Yearbook of Comparative Criticism,* vol. 8, edited by Joseph P. Strelka, pp. 229–53. University Park: Pennsylvania State University Press.

Literary Criticism and Religious Consciousness: Marginalia on Albert Béguin, Georges Poulet, and Marcel Raymond

Peter Grotzer

Preliminary

At a time when literary texts are being studied for the most part in connection with structures of language, societal relationships, or psychological backgrounds, I wish to raise the question, in the context of the always unavoidable considerations of the complicated reader/text relationship, of the connection between the reader's concept of the text and its religious background. I proceed from the assumption that the reading of literary texts is not mere entertainment but rather a significant experience of humankind to which belongs, as well, the inquiry into that which transcends human experience.

The performance of reading can be "existentiell" in the sense that Karl Jaspers calls a communication that rises to the level of another "self" "existentiell"—or to use a term of Gabriel Marcel, "intersubjective." This is the case with authors such as Albert Béguin, Georges Poulet, and Marcel Raymond. They concentrate on the description of their experience as readers and disclose for us, directly or indirectly, a glimpse into their consciousness. Here, too, in one form or another, the problem of transcendence is raised.

Also common to these three authors is that they address primarily the meaning of the works read; they do not depict internal linguistic relationships or purely formal criteria but search for something else. One can label it "truth," "spiritual content," and "examination of human destiny"; it is something that conditions literature minimally, yet toward which literature points.

Because this is always an individual quest, we address here the problem of the subject of reception, who is geared to the search. We know that texts to a certain degree program the manner in which they should be read. But it is at least as evident that the reader's blindness and insight determine not

only the choice of reading matter but also the actualizing, in a meta-text, of what is read. There is no single church within the realm of literary criticism that guarantees salvation—which does not mean that all judgments are equally valid.

The reader/text relationship is a dynamic process that can be grasped only partially in causal, objective, rigidly scientific categories; the actualizing of a literary text takes place in a constantly expanding intellectual arena, so that theoretically any piece of writing invites to a new encounter with all that has already been read.

It is instructive to learn that for Albert Béguin this arena is determined more by Novalis, Nerval, and Péguy (among others); for Georges Poulet by Pascal, Proust, and Amiel (among others); and for Marcel Raymond by Rousseau, Senancour, and Jacques Rivière (among others)—in every case more than by Marx, Freud, Nietzsche, and Heidegger; yet one should inquire why this is so.

Whoever questions the general validity of the "results" of hermeneutical effort in our intensely scientific age (in which everything is reduced advantageously to binary systems), or dares to introduce a discussion about texts that resembles them in its ambiguity and hence relativizes the power of articulation that language possesses, opens himself to suspicion. Something similar happens when certain literary critics, whom others would just as soon deny the title of critic, along with objective and, for the most part, historical or linguistic activity offer instead of evaluation *insights* that shake our smugness and invite us to an adventuresome journey through the world of an unfamiliar consciousness.

We live nowadays in a crisis of many dimensions: faith in language has been shaken; it is simultaneously power and weakness, truth and falsehood, an establishing of presence and a reference to what is absent. For the literary critic the "world" appears in the form of language. If we understand religion as man's response to something greater that transcends him (or even something absolute), then we can assume that the reading and writing of those literary critics open to transcendence will offer witness in some form to it.

Literature as a Quest for Salvation

Albert Béguin believes in the revelatory content of poetry and, in *L'Ame romantique et le rêve*, traces the metaphysical meaning of romantic language gestures. His point of departure is the experience of bifurcation in dreams, of metaphysical restlessness, of threatened identity. Works such as Novalis's *Hymnen an die Nacht*, Gérard de Nerval's *Aurélia*, and Balzac's *Louis Lambert* proclaim a lost paradise and direct the reader to "traces" of the Absolute. Repeatedly Béguin discovers anew that the corporeal world and analytical reason do not satisfy humankind, that the drama of human existence at last always provokes the question of eternal destiny.

Dreams and poetry reveal the fragility of human identity ("JE est un autre," says Rimbaud). The path to truth is traversed by way of metaphor to the poet's "self," who seeks via language a solution to his creaturely anxiety. As Novalis says, "The 'I' is *in* the world but simultaneously transcends it." The "inner" is such only when it confronts an "outer"; man participates in both, for that is his "presence." The concept of "presence" includes reference to what I don't see; i.e., it conveys primarily reference, in symbolic fashion. Béguin's poetic is grounded in the romantic postulate of the analogy between the microcosm of language and the universe. The literary work in this view is somehow identical with the fate of its creator; it is the medium through which he seeks to reach the zone where not only his personal history but also his destiny is played out.

Whether or not this is an "eternal" destiny (as Béguin believes it is) is not the issue here. He was persuaded that it is and hence turned to manifestly literary texts which, qua "figurations" of man, fulfill or incarnate the human struggle (conscious or unconscious) for salvation. What he had already found projected in Nerval's *Aurélia* was completed in himself: the hunger for the Absolute was transformed into a passionate participation in the fate of his fellow humans, which participation assumed distinctly concrete forms. Béguin's reading is seldom "scientific" but is far more a search for man's insight into the sense of his existence, whereby the word "sense" [*Sinn*] also connotes direction. For him the literary critic's task consists of disclosing the meaning of a text as a "figuration" of humankind; the critical reader should recognize, in the expressive language of our poets, the signs of the times and should aid the literary work in completing its most important and useful task: "un rôle d'alerte donnée aux consciences" (1973:188).

Understood thus, literature (and art in general) wishes to transmit something other than ideas or facts. It wishes to open up the reader, so that he perceives his *answer*ability in a world threatened from all sides. For Béguin this means defending man as community-oriented person against the demands of totalitarian power in the service of capital, or of a totalistic ideology, or even of the Catholic church—which he joined, incidentally, in the dark year of 1941.

For him responsibility includes a sense of community. "On ne se sauve pas tout seul," says Péguy's Joan of Arc; Béguin's activity during the war as editor of *Les Cahiers du Rhône*, one of the very few independent French-language publications, and during his editorship of the magazine *Esprit* (1950–57) shows how seriously he took this statement.

In contrast to Georges Poulet and Marcel Raymond, Béguin was oriented more and more toward texts of his own era, and his criticism is sometimes very personal (for his opponents *too* personal), especially when it concerns divergencies of religious interpretation. Since I have shown elsewhere, and in particular via the example of his reading of Bernanos, how closely Béguin approximates the intentions of this author, let me remark on the basis of an

example from a chapter of Béguin's *Pascal par lui-même* how decisively he distances himself (following Péguy, Claudel, and Bernanos) from certain Jansenist concepts that he believed marked Pascal's temporal sense and kept him from drawing all of the consequences from the mystery of the Incarnation at work in the linguistic form of the *Pensées*./1/

Pascal sketches as few others the precarious situation of humankind between hope and despair, and wishes, through rhetorical skill and an accumulation of paradoxes, to direct the reader to the central figure of Christ. Nevertheless Béguin accuses him of failing to recognize how intertwined our eternal destiny is with our temporal acts: "The totality of the living and the dead constitute together the mystical body of history which will be completed and understandable only at the very end of history, with nothing remaining outside of this total communion of souls. There is no possibility of the Christian life when it is limited in the narrowness of the isolated creature" (1952:62; the chapter is entitled "Pascal sans histoire").

The concern here is with the mediation between immanent experience and transcendent salvation, or with the ambivalence of time. In agreement with Henri Marrou, Béguin rejects any division between a profane time (which is to say a constantly evolving time) and a time demarcated by Christ (which is to say an era of revelation which must be preserved). Because man already participates in eternity through his very existence, he has had revealed to him the possibility as well as the necessity of discovering and shaping anew the secrets of faith. Béguin's "engaged" writings are permeated with an at least occasionally optimistic dynamics that is closer to Péguy than to Racine and to Port-Royal.

In Béguin's final phase, which begins in the fifties, we find certain impulses toward a shifting (as we had anticipated) of the concept of religious mediation or Incarnation into the realm of "textuality." This occurs above all in the two volumes of *Création et Destinée* and is also apparent in his unpublished notes for his Christian Gauss Seminar on Bernanos held at Princeton University (October 6–November 10, 1955).

According to the texts written between 1950 and 1957, Béguin understood the literary text as a "complex, indivisible unity, a web that not only 'translates' a thought or an inner experience but also contains it, retains it in itself," and thus, according to him, "the idea or the experience of this concrete appearance, this weave of words, this rhythmic totality, can no longer be separated, for it is enclosed forever in a veritable incarnation" (1973:220). Critical reading is therefore, according to Béguin, first of all a confrontation with human destiny, insofar as it can be articulated in words.

Literary Criticism as an Act of Consciousness

In a most revealing reflection that appeared in 1975, entitled "Lecture et interprétation du texte littéraire," Georges Poulet develops his concept of

the text out of an essay by Béguin on Charles du Bos, from which the cita-
tion above is taken. He permits himself the following declaration, which
reflects among other things the concept of Marcel Raymond: "This does not
mean that the text appears essentially as the repeating of a thought. No, the
text is, first of all, a fabric of words, a rhythmic whole, a certain verbal
body, an object which, because of the materiality of its substance, is able to
be weighted, handled and appreciated physically by a series of contacts"
(1975:64).

If this is so, then it is very much like the "lecture sensible." Poulet calls
attention to Gaston Bachelard and to Jean-Pierre Richard, whose first work,
Littérature et Sensation, Poulet introduced to the readership with a preface
in 1954. (I still recall the enthusiasm with which Poulet called our attention
to it in his first Zurich seminar on Flaubert.) .

Decisive is Poulet's statement: "However, what [this criticism] reveals is
not an object existing in itself for which it is enough to assert its own pres-
ence, but the effect produced by this object on a receptive nature which is
affected by the object's accessible qualities" (1975:65). And shortly thereafter
he writes: "It is the subject which discovers the object. It is not only the
physical properties which are discovered in the object; it is a subjective real-
ity which by means of its 'incarnation' in the object reveals itself to the
intelligence and consciousness of the reader."

The reader's subject discovers in (or beneath or behind) the text as web
of words a "réalité subjective," which is the consciousness at work in the text.
Or, in other words, the reader breaks through the "construct" to the "princi-
ple" which inhabits the construct. The concept of "subjective criticism" for
Poulet means neither subjective evaluation nor the projection of an ego-
world comparable to an "object" such as a stone or a landscape. It is not the
personal (as is often the case with Béguin), but rather the largely selfless
participation in what for him the literary text actually is: consciousness
which has assumed form. Poulet speaks most frequently of "identification."
Reading for him means the inner re-creation of the author's spiritual adven-
ture, whatever shape it may take. Whoever risks this is, in terms of con-
sciousness, simultaneously himself and the one who sees unknown worlds
unfolding within himself. One automatically recalls Marcel in Proust's
Remembrance of Things Past, for whom a whole world ascends from a cup
of tea—whereby, however, the memory of the reading and the writing sub-
ject for Proust is identical, or constitutes itself as such in the event.

Neither the historical subject of the writer, the author as person, nor the
personal views and circumstances of the reader are decisive for Poulet. A
certain kind of analogy does exist between this kind of reading and contempla-
tion: the "other" in which the observer after a fashion takes shelter is an intel-
lectual universe wherein critical consciousness (the subject!) orients itself
according to certain categories such as time and space. For Georges Poulet a
"critical" reading—he gives a special meaning to the word "critical"—appears

to be an approximation of an act of faith./2/ This is why it is so difficult to speak about him "objectively." He does not seek (as does Béguin) a confrontation of humankind with its destiny but wishes to experience, in terms of consciousness, the whole totality of discrete interior worlds. But how does a "mediation" occur—if it occurs at all—between the appearance (the form, the verbal construct) and the intentionality of the art work within it?

The interpreter of a text circles somewhat like a dancer around the magic center of the evolution of an unfamiliar subject which at least partially transcends his own subject. Albert Béguin, in connection with the spiritual content of a literary work, speaks of "wrestling with the angel" (1973:220), and this metaphor brings Georges Poulet closer to what, according to him, happens in the act of reading: his consciousness transcends the "I," projects itself abruptly into the mind of the other—a process of identification that recalls mystical experience.

A "leap" is involved here: the process has already been largely completed when Poulet begins to write. He never undertakes immanent analysis of verbal structures, which demands great patience and considerable affinity with the concrete. Because for him only the "cogito" carries decisive meaning, and because the spirit infinitely transcends the concrete manifestation, he needs to destroy, break through the form. This intelligence (which experiences its roots in existence as a barely tolerable constraint) elevates itself above the objective and the material into the purely intellectual reality of the text and fashions, via an interweaving of quotations, a path through the newly discovered world. The individual works are viewed from this perspective not as linguistic, self-enclosed artistic constructs but as the developments of a central principle which alone permits the recognition of the relationship between the themes which appear during reading at first in isolation and without manifest connection. Therefore, according to Poulet, a literary work must not only be read sequentially, sentence upon sentence, from beginning to end, but "in all directions." In this way the interpreter discloses relationships that do not emerge in a linear reading or that appear only occasionally. The temporal structure of the text is layered over by a structure of themes that the reader fuses, consciously or unconsciously, into a new continuity that has little or nothing in common with narrative progression.

This reader divides and differentiates, yet he also reunites, in individualistic fashion, the separated components. His goal is the interpretive composition that reveals in miniature the paradigm of the writer's inner world. Or does the consciousness active in the whole first disclose itself through the mutually illuminating fragments?

A presupposition to Poulet's texts is an "intersubjective" communication whereby the writing subject then speaks in the name of scrutinized consciousness: the "I" attains the "self" through reading (cf. 1971:302–14: "Consciousness of oneself and consciousness of the other").

We should now inquire whether this understanding—which has been presented for our purposes here in radically simplified form—has an approximation or any sort of foundation in religious consciousness, as is the case with Béguin. We have seen that what is essential for Poulet is not contained in appearances. He puts the lie to those who believe that he abandoned his antiformalist position with the reading of those essays we cited at the start. Poulet questions Leo Spitzer's method of an exclusively inductive analysis built on objective stylistic observations, for he believes such an analysis is based on the illusion of attaining the center (the spiritual unity) via the linguistic parts.

He clarifies his position through reference to Marcel Raymond, who, in *Le Sel et la Cendre*, characterizes the reader's sympathetic penetration of the text's reality as a process of identification: "To read," says Poulet, "is to identify oneself with the other. It is not, thus, in the sense to go out of oneself; it is to become conscious that beyond oneself, not outside but inside there is the same interior life which happens to be that of the other" (1975:72). For him only the inward experience is decisive. It is questionable from this perspective whether meaning can be generated through an unintentional combination of words, whether a linguistic analysis without prior insight into the fundamental intellectual principles can be meaningful. (In connection with Roland Barthes' literary criticism, Poulet refers to a "degree zero of consciousness.")

We have discovered a parallel in Béguin between his Christianity and his concept of the text in the decade of the fifties; however, it never became the basis of his interpretation with the degree of thoroughness and patience as in the case of Marcel Raymond. In the center of Béguin's literary theoretical understanding is the construct, the "figure," "presence," the unity of saying and what-was-said in the depiction of human destiny. His religious consciousness circles the mystery of God become man, of Christ. If our basic assumption is correct, which postulates a certain approximation between the concept of the text and religious consciousness, then we can assume, regarding Poulet's attitude toward verbal constructs and toward all forms of articulation, that he did not place the term "incarnation" in the second of our citations (1975:65) in quotation marks by accident.

A highly interesting document has recently appeared relevant to this point, without which our considerations would be lacking a foundation: the *Correspondance* between Marcel Raymond and Georges Poulet. I will address only the problem of transcendence and the possibility of mediation and select a few passages from the wealth of material. The interest of this correspondence, with a foreword by Henri Gouhier of the French Academy, is many-sided and exceeds the boundaries of literary criticism.

Interesting is Poulet's explanation that he conceives of God—as did Calvin, originally—primarily as absolute transcendence, as the patriarchal God to whom, as a result of the Fall, no natural connections exist. This

transcendence can therefore be experienced, if at all, only as the absence of God; it is apparent from this statement that for Poulet every attempt to provide the Incarnation with central meaning must be a concession, practically a kind of desertion of authentic religion. The shift from immanence to transcendence is as questionable for him as the step from the objective appearance per se to consciousness.

As a devoted reader of Pascal, Poulet naturally recognizes that along with the religion of the Father there is also the religion of the Son, yet he takes a skeptical stance toward the "passage de l'absence à la présence, de la transcendance à l'immanence." Does one detect in the bracketing of a mediator, which Poulet carries out much more radically than the ascetic Pascal, the deeper reason for his skepticism regarding all aesthetics as well as the notion that the intellectual dimension might have its roots in the existential realm? How absurd Béguin's chapter on "Pascal sans histoire" must sound to him! Absurd because in Béguin's and Péguy's world view a certain hope of salvation shines through that Poulet in no way shares. For him a literary text is no more of a "présence suffisante" (Letter 37) than is the individual creature. It is merely the "mental zone where an infinity of riches equivalent at least to those of the universe are rediscovered transposed; but, in this case, this mental locale is nothing other than the spirit itself (of the author and of the reader) having the chance to watch the show and the use of its own thought directed as God *in himself* directs the show and carries out the internal idea of his creations."

Whoever separates the structures and the forms from the consciousness which pervades and determines them loses everything, according to Poulet: "The spirit withdraws. Life gives way to inertia, the totality to the multiplicity of ingredients, sensitive and imaginative power to the powerlessness of the small beam which has taken the place of the living and transcendent God." What remains, then, is an "object," which is to say something that is no longer actually accessible to me. A bit later this sentence follows: "To admire a work of art as an *art object* is to bow before the golden calf." The gnostic position of this reader could not be expressed more radically (we will see in the final part of this essay how Marcel Raymond responds, among other authors of mainly formally oriented studies of Baroque and Mannerism). Poulet's religious understanding presupposes the Fall; for him God as "an intact being" has withdrawn once more from humankind. What remains is the "présence de l'absence." Poulet does not search for the construct, the structure, the form—this would be a "sin of idolatry"—but for transparency: the purer and the sheerer, the better—as with a diamond. As he remarks in reference to the conclusion of Tolstoy's *War and Peace*: "There is a beyond of the novel that the novel can only designate" (Letter 39).

Because pure spirit, the transcendent God (and along with him all forms of complete bliss) are so infinitely remote, yet man strives toward them in spite of his fallenness, Poulet's interest focuses on the question, among

others, of how humanity might achieve a form of permanence out of moments of insight (or forgiveness)—an endeavor that transferred to the religious sphere can be accomplished only through the intervention of the infinite. Thus we return to Pascal, whose central insight into human weakness and man's inability "to keep us in a state where by chance grace has put us" (Letter 47) is presented in the *Pensées* with great conviction. Humanity is denied a lasting grace as well as true knowledge; not by accident, and in keeping with the linguistic practice of Pascal and Racine, Poulet describes what he attains in his "identification" with the consciousness of a poet as a "dark illumination."

Just as everything within the cosmic confines discovers only its sense and purpose in the infinite creator, so also, says Poulet, are all aspects of the work of art to be grasped first in terms of the ordering consciousness. According to him, "form" should be understood only as a "trace" of the intelligence that permeates that form, yet is not comprehensible in and of itself; it is the body's soul. It is true that Georges Poulet, in the course of his long debates with Marcel Raymond, called attention repeatedly to the Incarnation, but he yields nothing of his basic attitude, which is more gnostic-oriented than christocentric—just as he cannot retreat from his basic thesis—that literary criticism is primarily the scrutiny and description of an inter-subjectively experienced interiority—without betraying himself. For this author all sensual experience is merely a point of departure on the way toward the primordial condition, not toward a condition of "pure spirituality" corrupted by this or that Fall; hence it is altogether logical that he should, following *Entre moi et moi,* be writing about his own consciousness. Therein lies for him the only form of "mediation": "But the consciousness which is mine seems to be the only place that I am able to live in and where I can rejoin the one, who, when it pleases him, stays there (or consents to let me know that he is staying there)" (Letter 200).

The Text as Incarnation and Its Beyond

Of the three authors who concern us here, Marcel Raymond is the most complex both in regard to his literary critical work (which is not limited to a single method) and to his personal (religious) development. Since some stages of his growth, and the relationship between his concept of the text and his world view, have already been sketched during the colloquium at Cartigny, I will concentrate on only two concepts which appear repeatedly in his amiable objections to the (totally coherent but extremely antiformalist) position of Georges Poulet: "Incarnation" and "the beyond."

If for Albert Béguin the literary text is mainly a stage on which destiny is played out, and for Georges Poulet the "trace" of an inner experience, for Marcel Raymond it is recognized as reality. His position appears with special clarity in a response to Georges Poulet, who had explained that "forms" exist

in order to be sucked dry—as soon as the juice, the life has been pressed out of the fruits they should be thrown away: "It is *beyond* Macbeth, Lear and even Hamlet that the truth of Shakespeare resides, which is Shakespeare" (Letter 37). A longstanding and very lively love of the concrete (mildly dulled in old age) prohibited Raymond from abstracting from the tangible appearance, from the articulation of words; for him the mutual relationship between what is said and the way it is said in the literary text cannot be altered without the generation of another meaning. Starting with "form," he searches for the inner structural principles, yet he fears losing his way in the pure "subjectivity" that is Poulet's goal as he would fear getting lost in reverie. I will select two remarks from among many by Raymond on this point of conflict.

In Letter 109, for example, we read: "In fact, I have always thought that the 'content' of a literary work is inherent in the form, that to reach the 'consciousness' which is in a work, it was necessary to question the form, which is not a garment, an object, a screen, but an organized, structured verbal mass. It is not a question of accomplishing directly or intuitively a sort of *salto mortale* which would permit penetrating the heart of the 'subject' in formulating, so to speak, an abstraction of the 'object' which is the form." Raymond distinguishes between works of a more autobiographical nature—whereby like Poulet he is more in search of consciousness—and verbal works of art, to which he grants autonomy.

Later on he emphasizes that he can consider a literary work, a picture, a monument only from the aspect of the formal: "In short an incarnate being. [. . .] In reality they are one; the 'content' is inherent in the 'form.' It is only gradually by means of a way which starts necessarily from the exterior, that I progress gropingly in the knowledge of a poet, so difficult elsewhere to penetrate, so far from us in so many respects and still so attractive" (Letter 147)./3/ According to this view the individual poetic work is "an autonomous whole bearing its own center of spiritual gravity" (Letter 156). Thus the question regarding the function of the (bodily) construct receives a different answer; like Merleau-Ponty, Raymond locates the soul in close proximity to the body, so that the "sensation" permits "communion": "I live intimately in the blue of the sky that I contemplate" (Letter 154). And thus he sees, in a child's perspective or in the flight of a bird, the glory of the beyond shining through that he has, in recent years, named God.

We recall that Poulet was the first to call attention to the analogy between the method of divine creator consciousness and that of the writer (Letter 37). Raymond follows him here, yet notes a significant difference: "But God creates his worlds *ex nihilo* and without obstacles. In any case we can imagine it; first of all, he conceives a pure idea, which then is realized in its fullness. The poet must struggle in the universe of language and against language . . ." (Letter 38).

What is thus created, not without the mediation of the poet's subjectivity,

is mundane, visible, "présence d'une présence." Raymond stresses continuously that form is "the witness and the guarantor . . . of the spirit which goes beyond it. Without it, if it were not engaged in the difficult labor of giving birth, the spirit would be only a virtuality which would never speak to us, which would be nothing more ultimately than an absence."

The utterance is the first component of the literary realm to express being. Later in the letter Raymond returns to the comparison with birth and refers to catharsis as deliverance, just as a pregnant woman experiences deliverance through a well-formed child.

Here too an inner connection between the concept of the text and religious experience gradually appears: "Let us say that I am attempting to look at the same time toward the transcendent God of 'demythologized' religion (a God who is at once Alpha and Omega, Creator and Savior) and toward a world, our world, where this God is not an absence, where he is 'present everywhere and nowhere visible'" (Letter 38).

Georges Poulet, in a 1960 study of Raymond's literary critical work (now 1971:103–28), searched to no avail for an "authentic" transcendence (in his sense) behind a Rousseauistic sense of cosmic existence. His remark that Raymond's universe is committed to immanence led Raymond to make public for the first time, via passages from a diary, his personal religious experience (under the title "La maladie et la guérison, 1950–57"; now in *Le Trouble et la Présence*). The event is given a date, as in Pascal's "Mémorial," and the recollection of it, sketched shortly thereafter, reads, "Prayer. Inexpressible joy. These words alone repeated: 'Hallowed be thy name, Thy Kingdom come . . .' Influx of life, forgiveness, joy" (1977:9).

This experience, to which Raymond refers time and again, resulted in much sharper differentiation between the religious and the poetic, and the role of Christ as mediator to the infinitely remote matches, in this worldview, the comprehension of "form" as Incarnation: "The long religious questioning which has continued in me since 1950 has changed many things in my feeling for life and the world. It is, thus, that for me today the immanent and the transcendent do not exclude each other, but, on the contrary, they need each other" (Letter 192).

Poetry itself is incarnated consciousness—not the Absolute, as Béguin and Raymond had still assumed in the thirties, but still a hint, a sign, as are all worldly things. Raymond believes that he was guided by this penetration of the immanent by the transcendent even before he was conscious of it (Letter 203).

Thus this literary critic has at last attained the recognition of God's "présence" without lapsing into any sort of illusory certainty of salvation. His religiosity is not committed in any form to an ecclesiastical system. Deeply hurt by the death of his beloved wife (Christmas of 1963), he has, in spite of a growing mistrust of the revelatory value of poetic language, published autobiographical and poetic texts along with the literary criticism which he

has continued most recently in his *Etudes sur Jacques Rivière* and *Roman-tisme et Rêverie*. The titles of the autobiographical and poetic works will have assumed more suggestive power through our comments: *Le Sel et la Cendre, Poèmes pour l'Absente, Mémorial, Par delà les eaux sombres*.

We cannot undertake a concrete examination here of Raymond's poetry, which is to be understood as articulated word *and* as reference to what remains ineffable. That which lies beyond form demands a different "mediation": "It is a case of something else which is beyond language of all kinds. Not only of myself . . . , but of a spiritual reality which goes beyond me and transcends me, but to which, all the same, I am secretly related. It is in the silence, it is in an apparent absence even that in some rare and privileged moments this Being lets us come close to him and shines a light to us—so poor and naked, so encumbered with empty words. But there, but then, it is certainly no longer a question of literary criticism . . ." (Letter 186).

NOTES

/1/ Cf. P. Grotzer, *Existence et destinée d'Albert Béguin* (Neuchâtel, Switzer-land: La Baconnière, 1977). In *Les Archives Albert Béguin* (the printed catalogue consists of 398 pages), available in the municipal library of La Chaux-de-Fonds (Switzerland), can be found, among other things, large files with letters and "stalag" newspapers from French prisoners of war, and concerning the worker-priests of Paris in the fifties.

/2/ Poulet reacts especially against evaluation as a goal of literary criticism: "The critical act seems to me to have for an indispensable condition the reduction of our conscious being, certainly not to the 'literality' of the work (otherwise the criticism would only be a simple doublet), but to that which I would call its 'mentality,' that is to say, a spiritual universe and its monad" (hitherto unpublished letter to René Wellek, October 6, 1956).

/3/ Cf. in comparison Alan J. Steele, "La question de la forme," and the contri-butions of Jean Rousset at the colloquium of Cartigny. A good illustration of Ray-mond's concept of the text as "Incarnation" is his work *Senancour. Sensations et révélations*. It is not surprising that the author dedicated this book, as a response of sorts, to his friend Georges Poulet.

WORKS CONSULTED

Béguin, Albert (1901–57)
 ²1939 *L'Ame romantique et le rêve. Essai sur le romantisme alle-mand et la poésie française*. Paris: Corti.(¹1937)
 1952 *Pascal par lui-même*. Paris: Le Seuil.
 1954 *Bernanos par lui-même*. Le Seuil.

1957	*Poésie de la présence. De Chrétien de Troyes à Pierre Emmanuel.* Neuchâtel: La Baconnière; Paris: Le Seuil. Out of print.
1973	*Création et Destinée. Essais de critique littéraire.* Paris: Le Seuil.
1974	*La Réalité du rêve. Création et Destinée II.* Préface de Marcel Raymond. Paris: Le Seuil.

For an exhaustive bibliography cf. P. Grotzer, *Les Ecrits d'Albert Béguin.* Neuchâtel: La Baconnière, 1967; Supplement 1973. No translations in English.

Poulet, Georges (b. 1902)

1971	*La Conscience critique.* Paris: Corti.
1975	"Lecture et interprétation du texte littéraire." In *Qu'est-ce qu'un texte? Eléments pour une herméneutique.* Ed. E. Barbotin. Paris: Corti.
1977	*Entre moi et moi. Essais critiques sur la conscience de soi.* Paris: Corti.

For an exhaustive bibliography see Marcel Raymond/Georges Poulet, *Correspondance, 1950 à 1977.* Avant-propos de Henri Gouhier, de l'Académie française. Paris: Corti, 1981.

English translations:

1956	*Studies in Human Time.* Baltimore: Johns Hopkins University Press.
1959	*The Interior Distance.* Baltimore: Johns Hopkins University Press.
1966	*The Metamorphoses of the Circle.* Baltimore: Johns Hopkins University Press.
1969	"Phenomenology of Reading." *New Literary History* I:53–68. (A chapter of *La Conscience critique.*)
1977	*Proustian Space.* Baltimore: Johns Hopkins University Press.

Raymond, Marcel (1897–1981)

²1940	*De Baudelaire au surréalisme.* Paris: Corti. (¹1933)
1946	*Paul Valéry et la tentation de l'esprit.* Neuchâtel: La Baconnière.
1962	*Jean-Jacques Rousseau. La quête de soi et la rêverie.* Paris: Corti.
1965	*Senancour. Sensations et révélations.* Paris: Corti.
1970	*Etre et Dire. Etudes.* Neuchâtel: La Baconnière.
1972	*Etudes sur Jacques Rivière.* Paris: Corti.
1978	*Romantisme et Rêverie.* Paris: Corti.

° ° °

1968	*Poèmes pour l'Absente.* Lausanne: Rencontre.
1971	*M*
²1976	*Le Sel et la Cendre.* [Autobiography] Paris: Corti. (¹1970)
1976	*Par delà les eaux sombres.* Lausanne: L'Age d'Homme.

| 1967 | Albert Béguin–Marcel Raymond, *Lettres, 1920–1957*. Lausanne/Paris: La Bibliothèque des Arts. |
| 1977 | *Le Trouble et la Présence. Pages de journal 1950–1957*. Lausanne: L'Age d'Homme. |

English translation

| 1950 | *From Baudelaire to Surrealism*. New York: Wittenborn, Schultz. |

For an exhaustive bibliography see *Albert Béguin et Marcel Raymond*. Colloque de Cartigny. Sous la direction de Georges Poulet, Jean Rousset, Jean Starobinski, Pierre Grotzer. Paris: Corti, pp. 281–312.

Translated by Robert Detweiler and Joan Leonard.

Moral Order in Modern Literature and Criticism: The Challenge of the "new New Criticism"

Giles Gunn

One way of gauging the health of any discipline is by determining the kinds of questions it begs. Judged by this rough standard, modern literary criticism—dare I suggest all modern art criticism?—has been notable for its lack of interest in or intelligence about issues of moral consequence. By and large the relations between art and morality, or between interpretation and ethics, have not engaged the best critical minds.

There are important exceptions, of course. Names like F. R. Leavis, Georg Lukács, Edmund Wilson, Lionel Trilling, F. O. Matthiessen, and even T. S. Eliot call to mind critics for whom moral questions were scarcely a matter of indifference, but, as I shall try to show presently, they represent something of a special case. The preponderance of critical schools and emphases in modern literary interpretation, from the New Critics and the Formalists to myth critics, neo-Aristotelians, phenomenologists, Freudians, and structuralists have all been curiously deaf to the moral claims of art and the ethical responsibilities of criticism. And even when they have overcome this insensibility, their formulations of these relationships have been disappointingly wooden or unconvincing.

This absence of moral imagination on the part of critics and thinkers would be less serious, perhaps, were it not for the depth of the cultural crisis that underlies it. "The best lack all conviction," as William Butler Yeats noted many years ago, "while the worst/Are full of passionate intensity." But the "mere anarchy" consequently loosed upon the world is conceptual as well as social, intellectual as well as political. Not only have critics lost the ability to think clearly about moral issues; much contemporary art and literature has clearly been deprived of the will or even the capacity to conceive them. What is frightening about our present predicament is not the novelty of this situation—after all, there have been other dark ages in the history of culture and criticism—but the fact that it has brought to light the collapse of so many of our previous categories of thought and former standards of evaluation.

The one group of literary critics who seem exempt from this judgment includes some of those just mentioned and others like them—Kenneth Burke,

the later R. P. Blackmur, Erich Heller, Alfred Kazin, Stuart Hampshire, Walter Jackson Bate, Harry Levin, Dorothy Van Ghent, and M. H. Abrams, or, from a later generation, Frank Kermode, John Bayley, Irving Howe, Dorothea Knook, Steven Marcus, R. W. B. Lewis, Leo Marx, and Warner Berthoff. Although this group comprises no school and can be associated with no particular approach or method, whether formalist, psychological, social, rhetorical, or archetypal, it constitutes a collection of critics who have borne much of the burden of moral concern in our culture for at least half a century. Responsive to many critical trends but captive of none, they have formulated for most us, laymen and specialists alike, the terms in which art, and most especially literature, lays claim to our sense of values and bears directly or indirectly on the way we live our lives.

Yet the presiding assumptions of this same group of critics, and of the ways they have defined the relation between art and conduct, criticism and judgment, have now been placed under severe pressure by postmodern developments in literature and criticism alike. The challenge posed by these newest modes of thought and expression is not the challenge of indifference but the challenge of disbelief. Writers like Vladimir Nabokov, Thomas Pynchon, and Jorge Luis Borges, just as critics like Maurice Blanchot and Roland Barthes, have in their later works given themselves over with increasing frequency to ironic expressions of self-parody in which all the products of individual and collective consciousness, from advertising slogans to received classics, are suffused with the light of bad faith, or, worse, of complete self-delusion. In much contemporary art and thought, we are confronted with a skepticism not only about the values of human expression but about the epistemological privileges assumed by the individual self in giving form to human desire. According to the newest wave of contemporary cultural diagnosticians, from E. M. Cioran to Michel Foucault, our very channels of verbal communication are diseased and can only be cured by a surgical procedure so radical as to reduce the self to a cipher for the sign and to restrict all signs to the representation of their own meaninglessness. In this new cultural dispensation, the more traditional modern view of the self earning its right to moral respect through its resistance to the interventions of culture is now seen as but the last in a long line of metaphysical self-deceptions or "fictions" by which Western man has attempted to evade what, in "The Snow Man," Wallace Stevens calls the "Nothing that is not there and the nothing that is."

1

It is tempting to dismiss this kind of talk as so much metacritical nonsense. Contemporary discussions about "the anxiety of influence," the hermeneutical circularity of understanding, the deconstruction of metaphors, the nihilism of signs, the fictions of Cartesianism, and all the rest seem so remote

from the less turbulent precincts of literary exegesis or cultural history, and the grim, often scientific tone of these debates sounds so alien to artistic sensibility. But if the present perturbations of contemporary critical discussion in America seem to have taken on a life of their own and one that strikes many observers as utterly removed from the life of literature, they are still close to the center of some of the more important cultural confusions of the age. Indeed, there are close parallels, as I have been intimating, between postmodern developments in many of the departments of art and the "new New Criticism," as it is sometimes called.

Evidence of these parallels is all about us. For one thing, critics and writers have in effect exchanged places, with critics taking upon themselves the imaginative license and moral subversiveness of the artist, and writers turning their art into a ritual demonstration of the treachery or impotence of their own medium. For another, critics and artists have been swept up in a new wave of cultural declamation. The culprit now is none other than language itself, which is presently regarded in more radical circles as the prisonhouse of consciousness. For still another, artists and critics seem to share what Northrop Frye would call the same "myth of concern," the myth Nietzsche designated in *The Use and Abuse of History* as the myth of criticism. Instead of preserving or idealizing the past, many contemporary thinkers and writers are committed to destroying it outright, whether in the hope of making way for something altogether new or in the belief that nothing at all is preferable to what we have had.

Underlying these shared discontents is an awareness that the genres of thought and discourse have, as the social anthropologist Clifford Geertz has recently put it, become "blurred" (165–79). The metaphors which undergird the disciplines of the mind and help us differentiate among them are now mixed, confused, and unstable. Critics are turning to philosophy, philosophers to ritual theory and linguistics, social scientists to the study of symbols, and iconographers to the methods of psychology or semiotics. One can deplore this situation as intellectually untidy, but one can scarcely deny that it has raised new and perplexing questions affecting our understanding not only of the provenance of art and literature but also of the needs to which they minister. If the current critical situation in America is less intelligible than it once was, it is also decidedly more challenging and exciting. The difference now is that the stakes have been raised. What is at issue is no longer the right to have a say about literature or art but the rites of saying as such.

It is in this context that the concerns of the older moral critics, as I will describe them, have come under fresh suspicion. But who, more precisely, are those critics? How have they defined the moral importance of art and the ethical obligations of criticism? In what ways have their presiding assumptions been brought into question by the new critical techniques and disciplines? How seriously should we take the new challenges to which they

have been submitted? And what sort of defense can be made against these challenges in an effort to reconstitute the relation between literature and morality on different grounds?

2

If we confine ourselves for the present to literary criticism and the American tradition, it is possible to differentiate between two rather different kinds of moral interest exhibited by modern critics. The first, and from my point of view less important, is represented by critics like Irving Babbitt, Paul Elmer More, and the Southern Agrarians from an earlier generation, or like Yvor Winters, Prosser Hall Frye, and even William K. Wimsatt from a later. These figures were essentially critical moralists who were interested finally in measuring all symbolic forms against a prescribed set of values and in maintaining something like an inherited cultural ideal. But where Babbitt, More, and the Southern Agrarians strove in a general way to adjust literary criticism to ethical actuality as they conceived it, Winters, Frye, and Wimsatt confined themselves to the more specific formal task of evaluating works of literature against a more or less secure moral standard.

The second kind of moral interest in American literary criticism is represented by descendants of Matthew Arnold who have accepted Arnold's view of literature's critical relation to life but have sided, whether consciously or not, with John Dewey's rather different conception of the way literature does this. To writers like Wilson, Trilling, Kenneth Burke, and others, literature does not criticize life overtly, as Arnold, Babbitt, and Winters believed, by appealing to set judgment, but covertly, as Dewey insisted, by disclosing to the imagination specific possibilities that contrast with actual conditions. Dewey captured their own more modulated understanding of literature's critical bearing upon experience when he wrote that "a sense of possibilities that are unrealized and that might be realized are, when they are put in contrast with actual conditions, the most penetrating 'criticism' of the latter that can be made" (346).

The work of this second group of critics is moral, then, not simply because it is preoccupied with values but because it is preoccupied with values in a special way. Reflecting Henry James's conviction that the greatest art effects a reconciliation between the aesthetic sense and the moral, they have assumed that literature, and for that matter all art, performs this function less by preserving or repossessing received traditions than by challenging their official sanctions and by showing how they might be revised. Like any art, literature is therefore important to culture just insofar as it constitutes that culture's commentary on itself. Its function, as E. H. Gombrich might have said, is to disturb, and even to violate, moral sets. Indeed, the history of literature, as of all art, to continue the Gombrich echo, is the history of the displacement of such sets. Hence their tendency to

value art for its insight into the way the moral life revises itself, "perhaps by reducing the emphasis it placed upon one or another of its elements, perhaps by inventing and adding to itself a new element, some mode of conduct or of feeling which hitherto it had not regarded as essential to virtue" (1972:1).

The single most important category of their criticism has been the category of experience. Literature for them is something felt as well as formed, and thus they have stressed the way literature gives form to feeling as well as feeling to form. Setting themselves in firm opposition to any critical procedures which, to adapt Max Frisch's witticism about technology, so manage our relations with literature that we don't have to experience it, they have continually asked what is involved in undergoing the experience represented in any work of art. This does not mean that they have turned their criticism into a recreation of the experiences produced in works of art. It means only that, even at the expense of personal and intellectual disruption, they have felt obliged to convert the formal properties of any work into the elements of experience that are their structural equivalent and to transform the act of criticism from a measurement of the work's fulfillment of its own conditions for being into an exploration of the possibilities and limitations life reveals when viewed from within the work's own scheme of values.

In this they have been best served not by specific techniques so much as by their own personal authority. Writing frequently from as deep within themselves as they know how to reach, they have struggled to achieve the requisite combination of perplexity and engagement before their material. Convinced in matters of thought as of art that a divided mind is often far more illuminating than a settled one, they have attempted to discern the moral difference art makes when the art of its different moral makings is placed within the circumstances of its personal, social, and cultural significance.

Yet this is already to risk becoming more specific about their assumptions and practice than most of these critics have been willing to be. Suspicious of the generalizations of theory because they seem inimical to the concreteness of art, and impatient with the specifics of method because they threaten to reduce interpretation to a formula, critics like Wilson, Blackmur, Burke, and Trilling have preferred to work at some distance from the contemporary critical wars, reserving their own energies for defining the internecine struggles within art itself. Only when theoretical disputes have insinuated themselves into the general life of cultural discourse have they felt compelled to take up arms, and then most often simply for the purpose of explaining what the debate really amounts to rather than to champion one cause over another.

The only exception to this general rule has occurred when they have perceived a threat to the basis of their own humanism. That humanism is premised on the notion that the sum of man's potentialities can never be defined solely in relation to his actual circumstances, whether biological,

economic, social, or historical, but only in relation to his effort to transcend
them. This helps explain their commitment to the life of the artistic imagi-
nation: because that life expresses the margin of transcendence that consti-
tutes man's freedom and hence the measure of his independence from those
very systems of meaning he has created to define himself. To this degree
they have shared a common belief that human beings live within culture
and, in Lionel Trilling's felicitous phrase, "beyond culture" (1965). Put more
directly, they have assumed that there is some human residue, in no sense
necessarily religious or supernatural, which, however elemental or sublime,
exists beyond the reach of cultural control. This human residue or margin of
transcendence which exists, so to speak, beyond culture accounts for the
critic's ability to place culture itself under scrutiny. It also serves as the
source of his or her belief that the noblest or more important expressions of
any culture are precisely those which contain that culture's assessment of
itself, its most searching criticism of its own potentialities and deficiencies.

By tying the creative so closely to the critical, these critics may be, and
often have been, misinterpreted as supporting an aesthetic standard that is
somehow intellectualistic and rigid. Yet the standard of critical and artistic
excellence they have upheld is as far removed from Matthew Arnold's the-
ory of classical touchstones constituting the Great Tradition as it is from an
undiscriminating acceptance of all that is, as W. H. Auden puts it in "Pre-
cious Five," simply "for being." Their belief is in a kind of this-worldly
transcendence that is often compelled to assert itself in the teeth of social
and cultural pressures of conformity, and this standard is intended to be a
highly flexible and almost infinitely various gauge of human achievement. It
is also assumed to be a standard that quintessentially expresses itself within
the tensions and resistances of form. Conceived as such, this aesthetic stan-
dard helps explain why Lionel Trilling, for example, could recommend the
essentially tragic view of life held by someone like Sigmund Freud to a
generation raised on the intellectual and moral simplifications of modern
liberalism; or why F. O. Matthiessen could find in the terrible matching of
opposites in a book like *Moby-Dick* the supreme indictment of an age like
our own which attempts to bury its ideological conflicts and contradictions
in an official version of consensus; or even why Edmund Wilson, in his later
cynicism, could perceive in the unblinkered realism and shrewd rationality
of an Abraham Lincoln, or the intellectual independence, social indiffer-
ence, and professional perfectionism of an Oliver Wendell Holmes, the
necessary antidote to a nation still awash with sentimental piety and moral
self-righteousness about the Civil War.

In each of these instances, intellectual and spiritual distinction have to do
with the way particular individuals, to borrow certain terms from Kenneth
Burke's dramatistic theory of art and criticism, not only encountered and
resisted but actually encompassed the situations that confronted them; and the
critical task, in each case, depends upon isolating, defining, and evaluating the

strategies that were employed to do so. The purpose of this critical tactic is not merely to understand those strategies but in some sense to repossess them, to realize for ourselves part of what F. O. Matthiessen once called "their still unspent potential." This, then, is the office of the moral imagination in literary and cultural criticism, and its service is in behalf of those irreducible elements of the self, of the human, that resist complete conditioning by all that culture does both to shape the experience of the self and also to stabilize and control that experience in socially approved forms.

3

The chief opposition to this position now comes from those philosophers and artists who believe that our own modes of discourse as critics, to say nothing of the scriptable or iconographic forms we study, are sedimented in a cultural matrix from which we cannot extricate ourselves and are determined by a set of linguistic protocols whose range of governance far exceeds our conscious control. These thinkers and writers would turn criticism into a science and then reduce the science of criticism to a study of the grammars of discourse that not only delimit but essentially constitute cultural experience. In its more extreme forms, in the work of structuralists like Claude Lévi-Strauss and Roland Barthes and poststructuralists like Jacques Derrida and Michel Foucault, all cultural forms are viewed as more or less arbitrary constructions of meaning which bear little or no intrinsic relation to the things to which they refer, thus making of culture itself, and all talk about it, a web of artificial and largely self-serving constructs whose mode of organization can, in principle at least, be reduced to a few simple laws. For structuralists and poststructuralists alike, this search for the laws that underpin cultural orders transforms all literary and art criticism into cultural criticism, and in the work of Derrida and his American followers—Paul de Man, Joseph N. Riddel, and J. Hillis Miller—cultural criticism has taken on an intensive kind of de-ontological religious fervor.

Derrida begins where the structuralists leave off, from the assumption that all human experience can be conceived on the model of a text and that all human activity can be regarded as a form of reading or deciphering. But poststructuralists like Derrida carry this line of reasoning one step further, by casting radical skepticism on those elemental grammars of discourse with which texts are supposedly inscribed because their mode of operation is presumed to be based on a false metaphysical assumption. This assumption is that there is a necessary, or at any rate inherent, connection between words or meanings and the things to which they refer in experience, between the signifier and the thing signified. Derrida argues that this assumption is the logocentric cornerstone of a metaphysics of substance or "presence," as he calls it, which has now been thoroughly undermined in the last several centuries. And with the collapse of the old "metaphysics of presence" and its replacement

by a new "metaphysics of absence" has also gone the notion that texts can have any core of determinate or stable meaning. All assertions of meaning in any text are, on the contrary, essentially arbitrary and unrestricted, according to Derrida, since they can be attached to any number of significations. But if no text contains any core of determinate or restricted meaning but only a field of indeterminate and unrestricted meanings, then the critic's job ceases to be the adjudication of claims between the text's latent and manifest meanings and becomes instead the submission to their endlessly various elaboration. The critic must enter into their play without coming under their sway. The point is to avoid being taken in.

Derrida's hermeneutics have carried him to the point of arguing that texts are no more than black marks on a page, marks distinguishable from one another not by virtue of any intrinsic meaning they may possess but solely because of their *différance* from one another. This *différance*, which has to do literally with the size of the marks, the spaces between them, their degree of blackness, and their shape, is what allows us to attach any number of significations to them. Yet these significations have no intrinsic relation either to the marks to which they are attached or to anything outside them. And there being nothing "behind" or "beyond" the mark or sign, it naturally follows that there is no hidden or latent meaning, as we have so often assumed in critical theory, "beneath," "beside," "within," or "in front of" the text. There is only the infinite elaboration of significations opened out by the signs of the text in whose meaningless intercourse we may participate if we are willing to join with the text in the dismantling of its own meanings. We accomplish this by locating the linguistic center or axis of any text and then by demonstrating how unstable it is, how it opens out in a variety of directions that ultimately cancel each other out. The ultimate purpose of this exercise in destabilization, demystification, or deconstruction, as it is variously termed, is, at the minimum, to prevent us from being deceived, at the maximum, to secure for ourselves perhaps some momentary glimpse of the groundless abyss that seems to underlie all meaning. The motive force behind such critical efforts is not to understand the innerness of other minds but to resist their domination. According to this theory, all human acts are masked forms of aggression, and art is reduced in whole, rather than as surely it is in part, to a subtle expression of the will to power, or at least the will to manipulate and control.

It should come as no surprise that this critical theory has now generated a stormwind of reactions. Two of the best are by Gerald Graff who, in *Literature Against Itself*, attacks it on the grounds that it deprives art of moral validity, and by Hayden White who, in *Tropics of Discourse*, exploits it because it establishes, without necessarily realizing this, new grounds for redefining the moral validity of art. Before taking up these two critical responses to poststructuralism, however, it is necessary to say something further about the cultural roots of this movement.

4

Like the structuralists before them (and the existentialists before them), the poststructuralists and their literary fellow travelers, from John Barth to Donald Barthelme, have in many respects only carried to an extreme that radical skepticism toward Western values which constitutes much of the modern legacy in all the arts and disciplines of thought. Belonging to a tradition whose intellectual roots go back at least as far as the philosophical work of Kierkegaard, Marx, and Nietzsche, structuralism and poststructuralism in its deconstructive phase have their origins in the romantic and post-romantic attempt to challenge, and where possible to subvert, all the privileged forms of Western consciousness, by getting back, as Melville once put it, to "what remains primeval in our formalized humanity." From this point of view, they have in considerable measure only continued and extended the decreative impulse of cultural modernism itself.

The word *decreation* was first used by Simone Weil and then picked up by Wallace Stevens to define a particular kind of change—not from created to nothingness but from the created to the uncreated. *Decreation* refers to the process of clearing the world of what Stevens once called "its stiff and stubborn, man-locked set," of getting back to that in experience which remains uncontaminated by the imperial designs of the self. The object of such strategies is to reach a point where one can comprehend what Stevens meant by saying, in his poem on Santayana, "It is poverty's speech that seeks us out the most." This condition of unmediated, unaccommodated simplicity can only be attained in most modern art and thought through a radical process of relinquishment and divestiture. Nonetheless, its aim is not so much repudiation as recovery. Experience is purged of its false overlay of indurated habit and inherited form so that what is perceived, or, better, felt to be its essential ground or unity can once again reveal itself. The art and thought reflective of such strategies therefore exhibits a double and not a single movement: it criticizes only so that it may conserve; it relinquishes, even renounces and rejects, only so that it may reconstitute.

There is thus in modern literature a remarkable kind of convergence between Eliot's "moment in the rose garden" and Kurtz's confession of horror from the depths of Conrad's *Heart of Darkness,* or between Yeats's devious and sometimes torturous journey back to "the foul rag-and-bone shop of the heart . . . where all the ladders start" and Ivan Ilych's discovery of the suffocating darkness of death that can sometimes inexplicably provide a tentative opening to the light. All such moments are in their way religious, not because they appeal to orthodox traditions of piety, but because, in response to the increasing profanization of modern experience, they represent an almost superhuman effort to resacralize life by locating and defining its chthonic source, its *point d'appui.* These moments are the result of an often excruciating attempt to strip nature, life, and history of the false

accretions of ego so that in the new world of the modern poem, novel, or painting we may be chastened, if not renewed, by that irreducible sense of strangeness, of otherness, which, however terrifying or sublime, will not play us false.

But like postmodern writing in general, poststructuralism, especially in the speculations of Derrida, Barthes, and de Man, dismisses this counter-thrust of modern decreative art and thought in favor of carrying its critical impulse to the absurd conclusion. This conclusion is reached as soon as one is prepared to argue that the decreated core of experience sought in so much modern art and literature is itself only another privileged perspective among others by which to assert the superiority of one form of consciousness over another. Hence, to posit, as traditional moral critics do, the existence of some elemental self, or primordial element within the self, that is somehow transcendent to as well as immanent within culture itself is, for the post-structuralists, to perpetuate the same cycle of domination and subordination that has afflicted Western metaphysics from the beginning. To Derrida and the others, all perspectives are equally illusory and thus equally meaningless, and any assertions to the contrary, either about perspectives within texts or about perspectives outside them, are "fictions" that ought to be decon-structed. Yet this only demonstrates that deconstructionism, both as a critical method and as an artistic mode, does possess something like a moral dimen-sion in spite of itself. We must deconstruct all our little fictions because they belong to a metaphysical tradition of Bigger Fictions whose purpose is always to gain power over others through spurious claims to ethical or spiri-tual pre-eminence.

The problem with this observation is that deconstructionists, as both Graff and White have noted, lack the intellectual means to recognize its validity. Even more serious, they have no way of explaining how decon-structionism itself can operate as an intellectual procedure without falling victim to the same processes of false consciousness it purportedly criticizes in others. If all standpoints are equally privileged, arbitrary, and illusory; if there is no secure metaphysical, epistemological, or linguistic ground any-where, then where, it must be asked, can the deconstructionist stand as he or she mounts an assault on our specious habits of fabrication? It is to Derrida's credit that he has recognized this problem even though he can propose no solution to it. If the metaphysics of substance or presence has disintegrated under the weight of three centuries of philosophical criticism, the fact remains that the deconstructionist can no more do without its assumption of an ontological center somewhere, of "a hard bottom and rocks in place," to quote Thoreau, than the most intransigent neo-Thomist. Derrida's attack on the metaphysical premises of logocentricity absolutely presupposes it (13–14).

To a "traditionalist" like Gerald Graff, this only demonstrates that the "radical" structuralists are caught in a hopeless web of self-contradiction which

undermines their claim that reality is solely a construct of consciousness and art its willing or unwilling victim. Graff wants to insist that reality has, and must have, an existence independent of mind, and that art remains an effective moral instrument precisely because of its ability to mediate that existence to us. The morality of art thus derives from its capacity to express "the truth" about reality. To explain how this occurs, Graff joins E. H. Gombrich's model of the artwork as a combination of "making" and "matching" with Karl Popper's view that all our knowledge of the real derives from the disconfirmation of our hypotheses and conjectures about it. As works of art try to "match" with reality those hypotheses or conjectures they "make" about it, they disclose the range of facts that our hypotheses and conjectures fail to keep in view. In this manner, they not only attest to a realm of being that exists outside of consciousnesss, but presumably convey some of the "truth" about that realm and suggest how we should relate ourselves to it.

Graff can therefore accept the Kantian notion that our minds constitute the world we perceive without accepting the corollary notion that the world is thereby imprisoned within the constructions of consciousness. As Graff puts it, the world we inhabit is considerably more and other than the world we construct out of consciousness, because experience reveals that we are constantly foiled in the attempt to impose our conscious constructions upon it. What exists outside of or beyond consciousness are precisely those dimensions of experience that resist its impositions (202–4).

The problem with this solution to the question of art's claim to truth and hence to being moral is that it never quite confronts the issues deconstructionism raises. Derrida and Blanchot, to say nothing of Thomas Pynchon or the later Wallace Stevens for that matter, might well want to ask Graff how he can know that the dimensions of experience presumed to resist the impositions of consciousness aren't just other conscious constructions? Indeed, couldn't one argue that Gombrich's schema of "making" and "matching," like Popper's theory of reality-testing through hypothetical conjecture, is itself just another "fiction," or culturally contrived way of making sense, that has perdured through time not because, in any absolute sense, it is true, but rather because, in some more pragmatic sense, it works?

This is exactly the point that Hayden White has tried to make. So far as truth is concerned, he notes, it really doesn't matter whether we take the world to be real or only imagined. The mode of making sense of it is the same in either case (98). Language provides us with only a limited number of ways of lending order to experience, and these mental configurations or "tropes," as he calls them—metaphor, metonymy, synecdoche, and irony— are inevitably figurative. This means that experience can only be made sense of through the interposing of conscious constructions; it also means that these constructions of consciousness are necessarily "fictive" or imaginative.

White draws out the implications of this seeming concession to the "radicals" in his comparison of the methods of the historian with those of the

novelist or poet. Because the historian is dealing with events purported to be "real" and the poet or novelist with events purported to be "fictional," it is generally assumed that the truth claims of the one must be different from the truth claims of the other. The historian gives us knowledge of reality, of what is true, whereas the novelist or poet merely gives of knowledge of the imaginable, or what is possible. "In point of fact," White counters, "history—the real world as it evolves in time—is made sense of in the same way that the poet or novelist tries to make sense of it, i.e., by endowing what originally appears to be problematical and mysterious with the aspect of a recognizable, because a familiar, form" (98). Each uses figurative or metaphorical strategies to confer meaning on what first appears to be without it. More than that, both use the same figurative strategies, even though these strategies encourage us to draw different inferences because of the different interpretive situations they are meant to encompass.

Historian and poet alike are confronted with the question of "what these facts mean," but they go about answering this question in different ways—the historian by organizing them into a series that attempts to determine their presumed consequences by ordering them in relation to their putative causes, the novelist or poet by organizing them into a series that projects their plausible implications from an assumption about their essential nature. But the strategies of order are imaginative or fictive in either case. To lift his narrative above the level of mere chronicle, the historian must find the "story" in it or give it a plot. Yet to emplot his narrative involves more than providing it with a beginning, middle, and end; he must also structure it in conformity with one of the basic types of story which is regarded as a plausible or credible narrative form by our culture. Following Northrop Frye, White delineates only four such types or forms of narrative emplotment—tragedy, comedy, romance, and irony—but whether there are four or four hundred is less important than what they mean. Their existence points to the fact that our culture can accept as possibly "true" only a limited number of narrative structures for encoding events.

White can therefore say of historical narratives what other critics would more readily say of imaginative narratives: "They succeed in endowing sets of past events with meanings, over and above whatever comprehension they provide by appeal to putative causal laws, by exploiting the metaphorical similarities between sets of real events and the conventional structures of our fictions" (91). Historical narratives are simply extended metaphors, White says, because they do not reproduce the things to which they refer so much as call to mind images of those things. No more than fiction or poetry does, history does not imitate or copy "real" events; "it tells us in what direction to think about . . . events and charges our thought about . . . events with different emotional valences" (91).

What, then, does this say about our response to what we perceive as true, whether in history, fiction, or any other art? It tells us, or should tell us,

that our response is never to their respective contents, distinctive as those contents may be, but rather to the culturally derived forms by which they organize those contents into meaningful configurations. Our response, in other words, is to the forms "by which consciousness both constitutes and and colonizes the world as it seeks to inhabit" (99). Therefore Graff's insistence that we base the truth claims of literature, moral or otherwise, on the existence of a realm of being independent of consciousness, creates a false issue. Though we doubtless become conscious at all only because of vexations that consciousness does not control, we become aware of those vexations and make sense of them only through the mediation of consciousness itself. What this should tell us is that the "radicals" have made too much of only one side of the coin: the point is not that the constructions of consciousness or the conventions of language have cut us off from the real, but that they have dictated that we can know the real or the actual only through the interventions of the imaginative or possible. This suggests, in turn, that the essential moral question posed by our experience of works of art is not how to get beyond consciousness but how to expand its scope or reach.

5

The answer to this last question was first outlined by Immanuel Kant in his third critique but has received fresh restatement by the social thinker and philosopher, Hannah Arendt. The clue to enlarging the scope of consciousness, she suggests, lies in the cultivation of taste. This seemingly innocuous assertion derives from Arendt's belief that the most obvious, though not always most obviously understood, aspect of experience, and particularly the experience of art, is that it elicits judgment or interpretation and that judgment most essentially involves the faculty of taste. Like Kant before her, Arendt dissociates taste from the merely subjective or narrowly impressionistic. Insofar as it pertains to all acts of judgment or interpretation, taste applies primarily to the public sphere, or world we share with others, rather than to the private sphere, or world we share only with ourselves.

Kant's great achievement, according to Arendt, was to show that taste is as much a moral category as an aesthetic because it depends not only on our ability to judge for ourselves and within our own frame of reference but also upon our ability to judge from the perspective of others. This does not mean that we can ever judge as others judge or see what others see; it only means that we cannot judge at all unless we can put ourselves in the place of others and understand what things look like to them as well as to us. To do this is not to see with their eyes but to see what their eyes see, which is a very different matter. To see through their eyes, to judge as they judge, would amount to taking their place or becoming them, which is impossible. To

perceive what is revealed from where they stand, to comprehend the significance things have from within their distinctive field of vision, is simply—and yet this is everything—to enlarge our own horizon of understanding. But this only underscores how aesthetic judgments, expressive of even the simplest kinds of preference and dislike, inevitably take on the character of moral judgments—not because they involve censure or praise, but because they eventuate in what Kant so beautifully called "enlarged mentality." "Enlarged mentality," as Arendt interprets it, is the ability to think in the place of other people without necessarily thinking the way other people do. Its motive force is the imagination, and its expression is sympathy, or the ability to think and feel with, but not as, other selves.

For Arendt, then, the faculty of taste is to be located at the opposite end of the affective spectrum from personal prejudice or a sense of cultural privilege. Its basis lies in common rather than uncommon sense, the sense we share with others of the meanings we can acknowledge together even when we interpret them according to our own lights. The purpose of taste is to help us establish with others a public world of meanings, of interpretations, of significant experience in which we can all share and to which we can commonly appeal. This world provides a space for those expressions of ordinary mortality as well as personal genius which deserve, quite apart from their social utility, to be valued for their own sake. Without the exercise of taste, this world would cease to exist. With its help, this world can be enhanced and expanded, but only because questions of taste, like all matters of individual judgment, can never be resolved through coercion or the appeal to authority, but only through moral suasion, only, as Arendt is so fond of quoting Kant to say, "by wooing the consent of everyone else" (222).

The existence of this world or space created by taste—let me call it moral space—is now seriously endangered. To the threat posed from outside by all those forces contemptuous of the creations of the intellect as well as the imagination has now been added a new threat generated from inside by all those contemporary thinkers and artists who have currently lost faith in our customary ways of making sense and the senses they have made. This pervasive, and sometimes justifiable, disbelief that colors our view of all mental forms is in important respects misplaced. While there are genuine grounds for mistrusting many of the forms made by consciousness, it is only because of the ministrations of such forms that we have learned the difference consciousness makes to experience and experience makes to consciousness. Our problem, therefore, is not to escape consciousness but to determine on what bases we can accept the world it has vouchsafed to us. It is, after all, the only world we have. The moral responsibility of the artist and critic is to make that world more capacious.

WORKS CONSULTED

Arendt, Hannah
1965 *Between Past and Future: Eight Exercises in Political Thought.* New and enlarged edition. New York: Viking Press.

Derrida, Jacques
1976 *Of Grammatology.* Trans. G. C. Spivak. Baltimore: Johns Hopkins University Press.

Dewey, John
1934; 1958 *Art as Experience.* New York: Capricorn Books.

Geertz, Clifford
1980 "Blurred Genres: The Refiguration of Social Thought." *The American Scholar* 49:165–79.

Gombrich, E. H.
1972 *Art and Illusion: A Study in the Psychology of Pictorial Representation.* Princeton: Princeton University Press.

Graff, Gerald
1979 *Literature Against Itself: Literary Ideas in Modern Society.* Chicago: University of Chicago Press.

Trilling, Lionel
1965 *Beyond Culture.* New York: Viking Press.
1972 *Sincerity and Authenticity.* Cambridge: Harvard University Press.

White, Hayden
1978 *Tropics of Discourse: Essays in Cultural Criticism.* Baltimore: Johns Hopkins University Press.

The Religious Hermeneutic of Autobiography: Augustine's *Confessions* and the *Credo ut Intelligam*

Janet Varner Gunn

> Beliefs constitute the basic stratum, that which lies deepest, in the architecture of our life. By them we live, and by the same token we rarely think of them.
>
> —José Ortega y Gasset.

Augustine's *Confessions* occupies so secure a place in the autobiographical tradition as to be a touchstone in the very definition of the genre./1/ Although I do not want to question its normative status, I do want to re-examine the *assumed grounds* of the *Confessions'* paradigmatic role, since these grounds continue so basically to guide or, as I shall argue, to *mis-guide* current thinking about the religious significance of autobiography. Since its security in the tradition has bred a certain familiarity which makes re-examination difficult, some way must be found to de-familiarize the text, some way to experience the strangeness of its questions instead of the obviousness of its answers.

To aid in the process of de-familiarization, I propose to re-examine the *Confessions* from the standpoint of what I call the autobiographical situation. The autobiographical situation is constituted by three moments: the autobiographical impulse which arises out of the effort to confront the problem of temporality; the autobiographical perspective which is informed by the problems of locating and gaining access to the past; and the autobiographical response which has to do with the relation of the reader to the text and the problem of appropriation.

All of these moments of the autobiographical situation are to be understood as levels of interpretation and as part of what Hans-Georg Gadamer calls the "hermeneutical universe," a "world" characterized by finitude and historicity. It is only within such a world that understanding can take place. Not to be overcome as a limitation on our understanding, finitude is our means of access, our *only* means, to reality itself. As Gadamer puts it, "the

finite nature of one's . . . understanding is the manner in which reality, resistance, the absurd, and the unintelligible assert themselves" (xxiii). Not simply a means of experiencing but the principle *mode* of experiencing, finitude constitutes an insight—for Gadamer, a *religious* insight—into "what is," that is, "what cannot be done away with" (320).

As I define it, the autobiographical situation establishes the direction we need to take up the questions of the *Confessions*, as well as provides the distance we require to evaluate the autobiographical status of the text. Looking at the questions of Augustine's *Confessions* as if they were unsolved, we will not so easily assume that the religious significance of the work depends somehow upon divine rescue from a time-bound and materially contaminated existence in order to achieve what a recent critic of autobiography has called "timeless wisdom" (Spengemann:1). In this case, autobiography would become the bridge that Augustine burns behind him, once his "true" self passes over the threshold to an atemporal repose. If this view is correct, we would do well to cancel the *Confessions'* longstanding membership in the autobiographical tradition, since the first-person narrative has necessarily to be aborted to accommodate a third-person and worldless knowledge of God. Cut off from the vital momentum of temporality, the work would thereby give birth to an undeveloped and lifeless self. Or to put the matter still another way, the life that was saved would not be Augustine's own.

When the *Confessions* is viewed through the lens of the autobiographical situation, it discloses the religious hermeneutic at the very heart of autobiography—namely, the hermeneutic of *credo ut intelligam* that informs and is enacted by the genre, securing its meaning within and not outside of the world of lived experience. The *Confessions* requires no passport to eternity, no extra-territorial rights beyond time, in order to gain religious significance either for its present readers or for Augustine as a "reader" of his life. The act of autobiography is finally to be understood as moving more deeply into time, not beyond it—in Augustine's words, a presenting of "man-in-his-deep."

Two issues figure centrally in my re-examination of the *Confessions*, the one having to do with the autobiographical status of the text, the other with the proper grounds upon which we can accept this or any work as religious autobiography. Relevant to both issues is the relation of discourses in the *Confessions*—in particular, the relation of the analytic and exegetical portions in Books Ten through Thirteen to the narrative section in the first nine books. Roy Pascal, among others, dismisses the final books as no more than a long philosophical footnote on the "autobiography proper" of the first nine. Even Peter Brown tends to set off these last books from the rest when he writes that "the remaining three books of the *Confessions* are a fitting ending to the self-revelation of such a man: like a soft light creeping back over a rain-soaked landscape" (180).

I would argue, however, that these last books, along with earlier passages

at the beginning that Pascal dismisses as "interjectory," are parts themselves of the autobiographical "landscape." Indeed, these books and passages are at the center of the landscape, for it is most especially in them that we find Augustine's efforts to situate his project—both the confessing "I" and the God to whom he is confessing.

The notion of placement, along with the corollary question of location, is operative throughout the *Confessions*. This notion serves not only to relate the work's variety of discourses, but it secures the autobiographical status and, finally, constitutes the religious significance of the *Confessions*, when placement or situatedness or location are understood in the operative terms of the *credo ut intelligam*. The hermeneutical principle of believing in order to understand that Augustine will make explicit in his later writings on the Gospel of John is already implicit in the *Confessions*. The "I" that confesses is the "I" that lives and has its life in believing. *Believing* and *living*: these words share a common set of roots; both of them participate in the idea of being "'sticky,'" of adhering, remaining, and especially staying alive (Partridge:353). The primary feature in this catalogue of etymological associations is the idea of locatedness. Both life and belief involve adherence— not, however, as an assent to universal principles or doctrinal formulations *sub specie aeternitatis*, but as anchorage in the particular circumstances of one's temporal existence.

Far from being "stuck" by the fact of locatedness, it is only in the acknowledgment of such anchorage that one is able to move forward. In Gadamer's terms, our finitude is our mode of access to reality; or as Ortega y Gasset might put it, "Man cannot live in radical uncertainty about himself and every one of his circumstances. . . . [E]very life has some certainty" (Weintraub:261). Such certainty is a "certainty of faith"—a "zone of stability" or a "*creencia*."

Creencias are culturally operative convictions about the way reality is put together and how, as a consequence, human beings ought to behave. In *The Modern Theme*, Ortega defines *creencias* as the "nets, provided with meshes of definite sizes and shapes which enable . . . [people] to achieve a strict affinity with some truths and to be incorribibly inept for the assimilation of others" (89). These nets become visible only when their "meshes" are strained by unexpected events, by experience that can no longer be made sense of through the "sizes and shapes" of their particular grids. As the literature of theodicy so amply illustrates, the "design" of the universe comes under question—or even into the field of our attention—only when the experience of suffering and evil puts it to the test. In this respect, we come to an *awareness* of Paradise only when it is lost.

Whether or not we want to subscribe to some Miltonic doctrine of the fortunate fall, it is true to say that experience, either personal or cultural, is available to us *as our own* only when our firm assumptions about reality are unhinged by our coming up against the unexpected and the unintelligible.

At the same time, we would be unable to "catch" any experience at all, old or new, without the assumptive reality of our nets. As. E. H. Gombrich has suggested, we need "schema" in order to "correct" them.

The Augustinian *credo ut intelligam* testifies to the fact that there is always a *place* from which the autobiographer adumbrates his or her perspective on the self. (Perspective, moreover, is an organizing, not a deforming, of reality.) This place derives from the circumstances of the autobiographer's past—not alone the "raw data" of those circumstances, but the net of *creencias* by means of which that data has been contoured into the transpersonal or cultural meanings which make it available to the experiencing self. Augustine's "I believe" does not remove him to some atemporal space where the tenses of his cultural existence are translated into God's "eternal To-day." The belief that leads to his own autobiographical understanding of his life-in-God represents an acknowledgment of the trust he can have in his own temporal existence as a vehicle of meaning.

To define *credo* as such an acknowledgment is not to say that Augustine was captive to the nets of orthodoxy which helped him to shape the meaning of his own experience. Nor is it to say that his experience was available to him as unmediated by any grids of significance whatsoever. It is rather to say that the autobiographical situation of the *Confessions* is comprised not alone by the narrative account of the first nine books where Augustine adumbrates a perspective on his past from the standpoint his conversion provides. It is comprised as well by the opening prayer and the later books which frame and respond to that account, grounding its perspective and securing its standpoint in the reality of Augustine's life as lived.

Augustine's own theory of interpretation as he employs it in his reading of Genesis in the final books of the *Confessions* provides the larger theoretical context for understanding the relation of discourses. "Take up and read": Augustine is acting once again on the child's admonition that figured in the conversion experience he recorded in Book Nine. He is turning now to the problem of origin, a problem that is not, after all, unrelated to the problem of autobiography, but this time as it is illumined in the Old Testament account of the creation. Although he wants to get his mind around the baffling notion of creation *ex nihilo* and how to imagine himself back to a time before time, Augustine's first problem is how to *read* the account before him. From the principles of interpretation he incorporates in his reading of the Scriptures, we can get a firmer grasp on the "reading" he does of his own life./2/

As is the case in Augustine's "life-reading" act of autobiography, the concept of placement is central to a truthful understanding, here of the Scriptures. It figures in his theory of interpretation in three ways: (1) in determining authorial intention, when the reader, Augustine, must imagine himself in the author's—in this case, Moses'—place: "I cannot believe that Thou gavest a less gift to Moses . . . than I would wish or desire Thee to

have given to me, had I been born in the time he was, and hadst Thou set me that office" (300). But even in the assurance that one can expect no less of Moses than one would of oneself under the same circumstances, there is no restricting the truth of the passage at issue to one thing. (2) Recognizing the pluralism of truth, Augustine's theory of interpretation takes seriously the reader's own placement in defining his or her relation to the text: "Every man may draw out for himself such truth as he can upon these subjects, one, one truth, another, another, by larger circumlocutions of discourse" (301). So long as the context of interpretation is defined by the situation the reader's life actually occupies, his or her "horizon" contributes to rather than deflects from a truthful understanding of the text's meaning. (3) Finally, there is the matter of Augustine's own placement before the text he wants to understand. Far from dismissing the "origins of self" for the "origins of the universe," as one critic wants to argue, Augustine's reading of Genesis has everything to do with his own life as lived and now confessed (Vance). In placing *himself* before the Scriptures, he brings with him his lifelong interest in language and speech as well as the larger question of location that impels his autobiographical activity throughout the thirteen books. When some critics suppose that Augustine's conversion represents a mere transference of loyalty from Mother Monica to Mother Church, they are wrong only in imagining it could be otherwise. Augustine does not jump out of his skin to be converted. The life that is converted is the life he has lived, even a life of attachment—some would say an unnatural attachment—to his mother. And in being turned around to himself, he is turned to the God who has upheld that life all along.

And now to the relation of discourses in the *Confessions* and how it is that the notion of placement which figures so importantly in Augustine's hermeneutical theory contributes to the autobiographical status of the text, even as it illumines the religious significance of the autobiographic genre.

The *Confessions* opens with one of the many impassioned prayers that will lace the entire work. This first one introduces the motifs that will concern Augustine throughout the work: "And how shall I call upon my God and Lord, since, when I call for Him, I shall be calling Him to myself? and what room is there within me, whither my God can come into me? whither can God come into me, God who made heaven and earth? is there, indeed, O Lord my God, aught in me that can contain Thee?" (1). The self making "room" for God, God making "room" for the self—the questions continue, all of them dealing with the idea of containment and the location of God and self. Since God made heaven and earth, do they not therefore contain him? And since he, Augustine, exists, does he not already contain God, because without containing God, he would have no existence? Or is it rather the case that it is God himself who is the container "since what Thou fillest Thou fillest by containing it?" If God were the contained and not the container, he would have been poured out when the vessel of creation was broken.

Having momentarily reached the conclusion that God must be the container of his creation at the same time as he is contained by it, Augustine is led to another series of speculations: since creation cannot be exhaustive of God's being, does creation then contain only a part of him? If only a part, which part? And do the different orders of creation contain "all at once the same part? or each its own part, the greater more, the smaller less?" (3). As he later and half-humorously views the matter in Book Seven, an elephant might have more of God than a sparrow.

Augustine will eventually realize that no answer to these questions is possible so long as he continues to measure God's being as though it were corporeal matter. In fact, he will come to see that questions about God are, in truth, questions about the self and the self's actual experience./3/ The clue to God lies in the fact of his own life, and this fact, not God, is the true mystery. "But where was I, when I was seeking Thee?" he asks in Book Five, "And Thou were before me, but I had gone away from Thee; nor did I find myself, how much less Thee" (73–74)! And even after his conversion, he can admit in Book Ten, "I know less of myself than of thee. I beseech now, O my God, discover to me myself" (244). Once Augustine locates himself in his own life, he will have located God who, of course, has been there all along. Something of this understanding operates towards the end of the opening prayer when Augustine concludes his long series of questions and answers with yet another question: "Who is God save *our* God?" (3; italics added).

Augustine began the writing of his *Confessions* in 397 A.D., about a decade after his conversion. From the perspective of that conversion he turns the spotlight on his past life in the first nine books whose narrative begins with his infancy and ends with the death of Monica. He finds no moment free of sin in that spotlight, even the playful moments of his boyhood, since the direction of his life was other than towards the God he now confesses. His life before conversion was misdirected, a life lacking true orientation, a life whose vagrancy led him as far from himself as it did from God.

Augustine's questioning, however, does not end with the *metanoia* of Book Nine. With as much urgency as we find in the opening prayer, he turns once again in Book Ten to the question of location. In the books that follow the account of his conversion, Augustine is in the process of more explicitly bringing himself up-to-date in that "middle place," as he calls it, between remembering and anticipating. Having explored the "present of things past" in the first nine books, he is trying in the final books to explore the "present of things present" or "what now [he is] at the very time of making these confessions" (206).

Augustine's conversion has turned him around to himself, disclosing such pattern in his life as to rescue it from formless vagrancy. In turning to memory and time in Books Ten and Eleven, he will examine the means by which the narrative of his past has been available to him. He will take a phenomenological look, in other words, at the experience of this experience.

Even for access to the present self, Augustine must turn to the memory without which, as he says: "I cannot so much as name myself." All of his life—past, present, and imagined future—is stored in the memory, even the past he has forgotten.

The room in the self for God, the room in God for the self is memory. God's memory, we might recall, preserves the time of Augustine's infancy, the time before speech and therefore predating Augustine's own memory. As a result, even that unconscious time is accessible to Augustine's autobiographical recovery of his past. Past time is never *temps perdu*. In the surety of that faith, he can dare to announce in Book Ten, "I will confess then what I know of myself; I will confess also what I know not of myself" (208). But he continues nonetheless to call on God to "slay my emptiness" (231).

The books on memory and time are together a companion-piece to the opening prayer in Augustine's continuing effort to locate God. He shifts from the outer cosmos of creation to the inner cosmos whose "manifoldness" is "deep and boundless." In this "vast cavern" the ingredients of the created world are translated, combined, and—since the memory is "the belly of the mind"—digested. And it is here that Augustine meets up with God: "See what a space I have gone over in my memory seeking Thee, O Lord; and I have not found Thee, without it. Nor have I found anything concerning Thee, but what I have kept in my memory" (226). Since Augustine must conclude from this negative evidence—the fact that God cannot be found outside the memory—that this memory is the container of God, he re-engages the logic of his earlier questioning about God's location, asking now what place God occupies in his memory. But when he puts the problem of location in this way, he must conclude that there is "no place" that lodges God: "Place there is none; we go backward and forward, and there is no place" (227). Just as he will be unable to explain time when he is asked to define it, he is unable to explain to himself where God can be found in his memory for there is nowhere he can step back. Any "where" he can imagine is already in time and memory. The question, then, still remains: "And how shall I find Thee, if I remember Thee not?" (220).

The question is a rhetorical one, we might conclude, but it is not merely rhetorical, since in itself the question constitutes the only answer that is true to Augustine's actual experience. His knowledge of God can follow only from his experience of Him. Although the self is not coextensive with the being of God, that being is finally inaccessible outside of the self that remembers. Augustine can seek only what he already in some sense knows, as the opening paragraphs of the *Confessions* make clear: "For who can call on Thee, not knowing Thee? for he that knoweth Thee not, may call on Thee as other than Thou art" (1). The antecedent knowledge of God that makes it possible for Augustine to call upon Him is not to be construed as an emanation of Ideal Form eternally stored in some universal memory. Rather it is the particular knowledge of a God who has insinuated Himself in

Augustine's life, turning and twisting that life and finally discovering him to himself. To be sure, we find the ghost of Plato in the conception of God as the unchanging container of the universe, a conception that had become a theological cliché by the time of the *Confessions*. But that static view of God's perfection is held in tension with the living God of history, a tension that reflects the all but seamless coexistence of Greek and Hebrew thought in the classical Christian culture of the fourth and fifth centuries.

It is a tension, moreover, that is grounded in the experience of Augustine's life as lived, an experience that is as much a part of the last books of the *Confessions* as it is of the narrative recollection in the first nine. When critics, either literary or theological, argue that Augustine must relinquish hold on the ropes of his own experience-in-time in order to float free in some realm of timeless wisdom, they are reducing the *sapientia* of autobiographical standpoint to the *scientia* of worldless knowledge./4/

There is no way Augustine can get behind or outside his experience to posit God's existence, just as there is no way he can step outside of time in order to define it as an object. The passing of time is, finally, the irreducible fact of experience. Far from relinquishing his autobiogaphical standpoint in order to free his knowledge of self from historical time and space, Augustine secures that standpoint in the phenomenology of experience that Books Ten and Eleven comprise. Time is not the adversary of the self, as so much autobiography theory and substantialist theology assume. Time is the very medium of selfhood, since it makes possible the interrelatedness of experience which makes self-knowledge possible at all.

Who is God save *our* God? What is time save *our* time? God "is," but as the God who is remembered; time exists, but as the time that measures our lives. Without the first-person possessive—a first-person *plural* possessive, I hasten to add—the words have no meaning, since meaning is always a product of understanding, and understanding is grounded in and made possible by commitment: *Credo ut intelligam!*

In what is surely the most familiar line of the *Confessions*, Augustine declares, "Our heart is restless, until it repose in Thee." He returns to the idea of rest at the end of Book Thirteen, this time as an attribute of God's being: "Thy rest is Thou Thyself." Augustine reaches his goal of repose, but not a static repose of god-like perfection. "Our rest is our place"—so Augustine writes near the end of Book Thirteen. As if to make clear the fact that "place" is residential in the time-space of bodily human involvement, he immediately introduces the force of gravity to which any "spiritual" notion of human being would not be subject: "The body by its own weight strives towards its own place" (315). Augustine does not hover over his life in some timeless space above it. He comes to a landing in a life with its own particulars—a pear tree, a protective mother, a bastard son, a rhetorician's interest in language—and with its specific involvement in a world of conflicting allegiances and orthodoxies. A docetic flight to the Everywhere and

the All-time would deprive him, after all, of the very life that has brought him to himself and God. The reality of his life as lived and confessed—this autobiographical experience is the "weight" that pulls and holds him to his place. Only by acknowledging the anchorage of this place is the autobiographer free to move on. In Augustine's words: "My weight is my love; thereby am I borne, whithersoever I am borne" (315).

NOTES

/1/ Georg Misch, for example, the earliest historian of autobiography, regarded the *Confessions* as "the first great specimen of the *genre*" (17). In his still widely influential *Design and Truth in Autobiography*, Roy Pascal holds Augustine's narrative of vocation as prescriptive for "true" autobiography. And, in a recent typological study of autobiography, William C. Spengemann treats the *Confessions* as the prolepsis of the forms that the genre has come to have over the course of its historical evolution.

/2/ Understood as a cultural act of reading rather than a private act of writing, autobiography can tell us a good deal about what is operative in all of our interpretive activity. To develop this point would require more space than I have been allotted on this particular occasion.

/3/ The "self" to which I refer is the self that belongs to a world, a self whose *belonging* is prior to (and, therefore, conditions) its believing. This is what I take to be the Augustinian understanding of the self. It is an understanding which stands in sharp contrast with the concept of the self which is operative in much autobiography theory. According to the latter, the self is divided between an inner core—hidden, private, unchanging, and finally ineffable—and its outer display which serves more often than not to compromise, even to distort the inner core. For certain theorists, the ones who argue for the impossibility of autobiography, distortion of the inner self (which for them is the Real Self) is inevitable when language inscribes it. To speak (or write) the self, in this view, is to lose it. The self is ultimately accessible only to itself—or to a correspondingly transcendent and essentialist God-concept which strikes me as a fitting projection of this privileged view of selfhood.

/4/ What is lost in this reduction is the "conative" side of faith which has to do with the *relation* of the individual to the content (or "cognitive" side) of faith. While Augustine's hermeneutic of *credo ut intelligam* maintained a vital relation between these two sides of faith, the balance was lost by the late Middle Ages when "the dynamic interplay between faith and reason in the *temporal* experience of the individual was replaced by a distinction of spheres in an essentially *spatial* analogy. Faith is set above reason as its completion, and the two are related in tandem fashion; the sense that they interpenetrate in the experience and life of the believer is obscured" (Smith:4).

WORKS CONSULTED

Augustine, Bishop of Hippo
 1907 *The Confessions of Saint Augustine.* Trans. Edward B. Pusey.
 New York: E. P. Dutton. (I have taken the liberty of removing
 Pusey's italics.)

Brown, Peter
 1967 *Augustine of Hippo, A Biography.* Berkeley: University of
 California Press.

Gadamer, Hans-Georg
 1975 *Truth and Method.* Translation edited by Garrett Barden and
 John Cumming. New York: Seabury Press.

Gombrich, E. H.
 1972 *Art and Illusion: A Study in the Psychology of Pictorial Rep-
 resentation.* Princeton: Princeton University Press.

Misch, Georg
 1951 *A History of Autobiography in Antiquity.* Trans. E. W. Dickes
 and the author. Cambridge: Harvard University Press.

Ortega y Gasset, José
 1961a "History as a System." In *History as a System and Other
 Essays toward a Philosophy of History.* New York:
 W. W. Norton.
 1961b *The Modern Temper.* Trans. James Cleugh. New York: Har-
 per & Row.

Pascal, Roy
 1960 *Design and Truth in Autobiography.* Cambridge: Harvard
 University Press.

Smith, John E.
 1973 *The Analogy of Experience: An Approach to Understanding
 Religious Truth.* New York: Harper & Row.

Spengemann, William C.
 1980 *The Forms of Autobiography: Episodes in the History of a
 Literary Genre.* New Haven: Yale University Press.

Greek and Christian Tragedy: Notes Toward a Theology of Literary History

David H. Hesla

For Preston T. Roberts, Jr.

I

The Greek universe may be represented as a gigantic picture puzzle./1/ Everything that is—sun, moon, and stars, oceans and mountains, plants and animals, empires and city states, mortals and immortals—everything is a "piece" and has a place where it fits in the cosmic puzzle of being. The place where a piece belongs, its lot or portion or share of being, is its *moira*, its destiny. The principle which determines where it fits, where it belongs and where it does not belong, is *dike*, justice. The *moirai* are not all of one size, of course. The share of being that belongs to a ruler is larger by far than that of a commoner, and in a sense the *moira* of Oedipus, say, is coextensive with the *moira* of Thebes, the city he rules: his destiny is the city's destiny. The gods themselves are subject to this ordering. Zeus's *moira* is the heavens, Poseidon's the sea, and Hades' the underworld (or afterlife). The god's *moira* is (to change the metaphor) his territory, and he reigns supreme over it. While Odysseus is at sea he belongs to Poseidon's *moira*, and not even the mighty Zeus can intervene on Odysseus's behalf, for that would require him to violate the *dike* that distinguishes his *moira* from Poseidon's. (The jargon of urban street gangs is exactly right: the sea is Poseidon's "turf," and he will not allow anyone else to trespass on it.) The city of Thebes is also a territory, and its inhabitants live in accordance with certain *nomoi*—customs, habits of behavior, particular laws. Even individuals are territories and have certain habits and rules—laws—which they obey as they live their lives. In theory the laws which govern one individual or one city should be identical with the laws which govern all individuals and all cities, for in order to be valid these laws must be in accordance with *dike*. The cosmos would be truly and beautifully ordered—the puzzle would be complete—if every entity (every individual "piece" or "territory") were to occupy fully its own *moira* and observe the limits set by *dike* and not overlap or trespass upon the *moira* of another.

The fact is that individuals do not observe these limits. When Paris abducts Helen he steals (or trespasses upon) a portion of Menelaus's *moira*. Thyestes violates the *dike* that distinguishes his *moira* from that of his brother Atreus by seducing Artreus's wife. In the most famous instance of all, Oedipus appropriates totally the portion of being allotted to his father, Laius, by murdering him and taking both his public or political place as ruler of Thebes and his private or domestic place as husband to Jocasta.

The usual way of accounting for the fact that one person harms another by trespassing upon his (or her) *moira* is to say that he is guilty of *hybris*, overweening pride. This word, however, like several others to be encountered, has been misunderstood. In its typical usage in the texts *hybris* names an act—rape would be a good example—in which one person wantonly does violence to another. An act, of course, has a motive, and later interpretations of *hybris* have shifted the emphasis from the act itself to the motive, "pride" or "arrogance."

Much the same has happened to the word *hamartia*. It literally means "to miss the mark," as when an archer shoots at a target and misses it. (Hamlet's apology to Laertes uses just this idea: "I have shot mine arrow o'er the house/And hurt my brother.") *Hamartia* is frequently used in the New Testament, and is translated as "sin." This usage perhaps explains why critics have used the word to mean "tragic flaw" or "weakness of character" or some other reprehensible trait which merits punishment. As used by Aristotle and the Greek playwrights, however, *hamartia* designates an act that is committed in ignorance of the true circumstances which surround it and of the consequences it entails.

That horrific deeds result in disaster for the doer has led some commentators to interpret *nemesis* as a principle of divine retribution which works almost mechanically to ensure punishment for wrong-doing. The primary meaning of the word, however, is simply that of a feeling of shock or outrage which an act of *hybris* would arouse in an ordinary human being.

The interpretations of *hybris* as pride, *hamartia* as tragic flaw or sin, and *nemesis* as divine retribution are the result of bringing Christian concepts and patterns of thought to bear on Greek tragedy. The result has been to obscure some of the fundamental differences between the philosophical and theological premises that inform Greek tragedy and those that inform tragedies written during the Christian period of Western culture.

The heroes and heroines of Greek tragedy are members of the aristocracy—members, that is, of the class of persons who are devoted to the pursuit of *arete*. The word means "nobility," "excellence," even "bestness." A true aristocrat is one who has won honor for himself by achieving excellence through a wide range of human skills. In an *agon*—a struggle or contest—he has proved that he can run faster, throw the javelin farther, kill more enemies, compose better poetry, argue more convincingly, and reach better decisions than his competitors. The pursuit of *arete* requires a contest with

one's chief competitors to prove who is best. It is a probing for the limits of one's *moira*. To live moderately within those limits is *sophia*, wisdom; to live and act to the extreme boundaries of one's moira is *arete*.

The danger involved in the pursuit of *arete* is of course that one will exceed the limits set by *dike* to one's own *moira* and encroach upon the *moira* of another. There is an important and valid sense in which Agamemnon's sacrifice of his daughter Iphigeneia is an act which demonstrates his *arete* as a military commander, just as Oedipus's conquest of a stranger and his retainers is an act which demonstrates his courage and prowess as a fighter and is something he can rightfully be proud of. At the same time, these are acts of *hybris*: they violate the *dike* which distinguishes one *moira* from another, and they result in misery and suffering, in *ate*—ruin or disaster.

In the sense of ruin, the word *ate* points to the result or effect of certain behavior. It has another sense, however, which points to the cause of a person's behavior. The deeds which Ajax, Orestes, and others perform are so dreadful that it seems impossible to believe that decent, intelligent persons could perform them. The concept of *ate* accounts for the fact that they do, for *ate* is a delusion or infatuation or frenzy sent by a god or *daimon* and which takes possession of an individual and drives him to do what in ordinary circumstances he would not do. Much of the *Libation Bearers* depicts the process by which Orestes and Electra work themselves and each other into the preternatural state of frenzy which alone enables them to commit murder. It is *ate* which drives Ajax to run amok. Confronted by the self-blinded Oedipus, the chorus asks him what spirit (*daimon*) urged him to do such a dreadful thing to himself.

The story (*mythos*, argument) which provides the plot of a Greek tragedy typically begins when a member of the aristocracy performs an act of wanton violence upon another member or members of the same class. The act may result from *dianoia*, thought, as when a person is confronted with a problematic situation, thinks it through, and decides upon a course of action: Creon's decree prohibiting the burial of Polyneice's body is an example. Or it may result from *ethos*, character, fundamental habits or patterns of behavior: Agamemnon's vanity, Oedipus's anger, Medea's jealousy. Or, finally, the action may be taken in obedience to divine urging, whether that urging is in the form of an explicit command (Apollo's command to Orestes to slay Clytemnestra) or in the form of *ate*, a god-sent delusion or frenzy. In any event, the act is done in *hamartia*, in ignorance of the circumstances and consequences which it entails.

From this original event certain consequences follow, and they follow, in Aristotle's language, according to necessity or likelihood. Aristotle wants to exclude from tragedy the merely possible as well as the unlikely and the impossible, for in his view tragedy is more philosophic than history, and it speaks of universals whereas history speaks of particulars. Ten thousand Greeks did in fact drive off fifty thousand Persians at Marathon, so such an

event must be possible. But it is neither likely nor necessary, the philosophic principle or universal being that an army outmanned five to one will be defeated.

It may even be appropriate to understand likelihood and necessity in terms of the two dimensions of tragic personages that Aristotle recognizes, *dianoia* or thought, and *ethos* or character. Given the predicament of Thebes at the beginning of the *Oedipus Rex,* and given the vaunted intelligence of its ruler, it is likely, though not necessary, that Oedipus will think through the problem and arrive at the decision to discover the identity of Laius's murderer. Actions that issue from character, however, from deeply ingrained habits of behavior, are of the order of the necessary, and exhibit certain universals:

All irascible men, when thwarted or frustrated, will strike out in anger.

Oedipus is an irascible man.

Oedipus, when thwarted or frustrated, will strike out in anger.

This universal is particularized four times; in Oedipus's reaction to being thwarted or challenged by Laius, Teiresias, Creon, and the herdsman. Again, given Oedipus's character and Creon's, it is inevitable, necessary, that they will get involved in a furious argument; and, given the *ethos* of Jocasta, it is inevitable that she will enter the scene and terminate the argument by chastising Oedipus and Creon as if they were two little boys.

The conclusion of a tragedy, Aristotle tells us, involves recognition and suffering, as well as the catharsis of pity and fear. The object of pity is undeserved misfortune, the object of fear a future misfortune. If the catastrophes which befall the characters of Greek tragedy deprive them of family and friends, of honor and dignity, even of life itself, those same events also strip away the vanity, pretensions, and illusions which mask the truth of existence. To the extent that this is so, misfortune carries with it a compensatory fortune, and so effects the catharsis of pity and fear. Pity will also be catharted if the undeserved misfortune is seen to be in some sense deserved. The murder of an old man and his retainers is not, in Oedipus's view, an act that deserves punishment. It is only when the identity of the old man is recognized that Oedipus's misfortune seems to be deserved. Fear will be catharted if the future misfortune becomes a present misfortune. When that happens the catastrophe need not be feared but endured, suffered through. Recognition catharts pity, suffering catharts fear.

That wisdom comes from suffering is a common theme in Greek tragedy, especially in the earliest of the playwrights. Aeschylus could hardly have meant, however, that Clytemnestra intended to teach Agamemnon a lesson by killing him. The meaning of the phrase seems rather to be that wisdom, the understanding of oneself and of one's relations to others, cannot be acquired at a distance from disaster. Other kinds of learning— mathematical and scientific truths, the skills and techniques of artisans, the practice of trades or professions—do not necessarily entail suffering in their

acquisition. Wisdom, however, cannot be learned at second hand, a priori, through apprenticeship. Being finite and ignorant, mortals cannot know in advance the limits that *dike* has set to their *moirai*. It is not until one has transgressed the limit, trespassed upon the *moira* of another, and endured the consequences, that one can know the share of being one has been allotted, and where it belongs and does not belong in the puzzle of the cosmos. Wisdom is the knowledge of justice, but the nature of justice is not something that can be known beforehand. It can be known only as a result of the experience of injuring those whom one does not want to injure—oneself, one's wife, one's father, one's daughter. If wisdom belongs to anyone at all it belongs to those who have suffered and survived. It is, perhaps, the lesson Aeschylus himself learned at Marathon.

At the same time, it must be noted that the acquisition of wisdom is the only good (if that is the correct way to put it) that can emerge from Greek tragedy. Wisdom is a function of *dianoia*, thought, or *nous*, mind, and thinking is one of the three sources or causes of action. The other two are character and divine impulse or urging. With respect to the last there is nothing a mortal can do: he must obey the oracle, he must act out the frenzy the god has sent. The actions that issue from character are also something over which a mortal has no control, for an angry man will do angry things, a vain man will do things that display his vanity. In Greek tragedy a person's character is not changed by the events which occur, not even the suffering he must endure; and Oedipus at the end of the play is as irascible as he was at the beginning. Suffering can change the way a person thinks, however, and with the increase of wisdom there may also come a greater degree of control over one's moods and passions and habits.

The world of Greek tragedy is not organized for the purpose of promoting human happiness. To be a mortal is to suffer, and again and again it is to suffer from the incompatibility of one set of laws, values, duties, and responsibilities with another set. Agamemnon cannot be both a good commander-in-chief and a good father, and being a man he subordinates his paternal and domestic duties to his military and political duties. Clytemnestra cannot be a good wife as well as a good mother, and being a woman she chooses the ties of blood over the ties of marriage. Antigone cannot be both a good sister and a good citizen, and being an idealist she refuses to obey a law which prohibits her from performing her sororal duties and which she considers to be incompatible with true justice.

But both Antigone and Creon appeal to the law and to justice to support their opposing decisions and actions. Clytemnestra defends her murder of Agamemnon by calling it her child's *dike*; Orestes dismisses his murder of Aegisthus as being no more than is called for by *nomos* and *dike*. In fact, any tragic hero or heroine can justify his or her decision and action, no matter how heinous, by asserting that they are in conformity with justice or done at the instigation or behest of "the god." The contest or struggle, the

agon, in Greek tragedy is, therefore, never a struggle of good with evil, right with wrong. It is always a struggle of one version of *dike* with another. For this reason it may be said that there are no villains, no really evil persons, in all of Greek tragedy (the one possible exception is, ironically, the Zeus of *Prometheus Bound*). There are persons who act foolishly because they are infatuated by envy, rage, or lust. There are persons who act out of habits of anger or jealousy. Everywhere we find persons who have good intentions, who strive for excellence, and who act out of a concern for honor and justice. Nowhere, however, do we find a person who knows what *dike* is and who deliberately defies it.

The reason that justice is many is of course that the gods are many. From the quarrel among the gods described in the first book of the *Iliad* through the theomachies of Hesiod's *Theogony*, the contest of Apollo and the Erinyes in the *Oresteia*, the *agon* of Creon and Antigone, and the destruction of Hippolytus by Cygnis, the truth, wisdom, and justice supported by one god meet with challenge from another. It is most completely demonstrated in the *The Eumenides*, where it is made clear that what had appeared to be a chain of human acts of vengeance is nothing less than the working out of the contest between the values of the old, chthonic, matriarchal, and rural gods who supported the primacy of blood and family (the Eumenides) and the new, Olympian, masculine, and urban gods who support the primacy of reason and citizenship in the *polis* (Apollo).

There are four moments in the logic of Greek tragedy. First, the gods are many, they sponsor different and opposing sets of values and laws and versions of justice, and they enforce these values in the affairs of human beings. Second, the nature of human existence is such that it challenges mortals to be excellent, and does so by presenting them with questions to answer, problems to solve, ills to remedy, imbalances to restore, injustices to rectify; and in order to do these things it is necessary to make decisions and take actions. Third, mortals are well-intentioned, and seek to please the gods, obey the laws, live in accordance with justice, pursue excellence, and do well by their family and friends; but they are also finite, and their knowledge is limited by ignorance, their judgments skewed by passion and infatuation. Finally, given the plurality of gods, the need to prove one's excellence, maintain one's honor, and strive for justice, and given also the finitude and ignorance of mortals, it is not possible for human beings to solve one problem without creating another, to answer one question without asking another, to do justice to one without doing injustice to another.

In Greek tragedy action as such is morally ambiguous. The one who acts does so in the belief that what he does is right, in accordance with *dike*. To others, or to himself at a later time, the act is recognized as having worked an injustice, one that is greater, more incompatible with *dike*, than the original injustice. This second injustice now calls out for rectification, but the second act of rectification is just as ambiguous as the first, and results in a

third injustice. The process whereby an act of intended justice results in injustice extends into the indefinite past, though it may be given an arbitrary origin in a curse or a prophecy; and it extends into the indefinite future, though it may be brought to an end by the intervention of a god. The typical Greek plot is a plot of revenge, and an act of vengeance is succeeded by an act of re-vengeance, with the necessity (or probability) of that process in nature whereby a cause has an effect which in turn becomes a cause having an effect which in turn . . . ; or of a syllogism, wherein the conclusion follows necessarily from the major and minor premises.

And in all of this, no one is to blame. The protagonist of Greek tragedy does what he must do and knows how to do in behalf of justice. He or she is not at fault if an act which is aimed at the good misses the mark and causes woundings and death to those who are dear. To do the unambiguous good does not lie in the capacity of mortals, not even—especially—in the best of them.

The scene or event which Aristotle calls the *anagnorisis*, the recognition, is always accompanied by the *nescivi*, the "I did not know." Agamemnon did not know that in sacrificing Iphigeneia he was offending Artemis; Clytemnestra did not know that in murdering Agamemnon she was offending Apollo; Orestes did not know that in murdering his mother he was offending the Erinyes; Hippolytus did not know that in honoring Artemis by leading a life of chastity he was offending Aphrodite. Creon did not know that in sending Antigone to her death he was also sending his son and wife to theirs. Ajax did not know it was only animals he slaughtered, not the Greek high command. Oedipus did not know it was his father he murdered, his mother he married.

The "I did not know" testifies to a discrepancy between the opinion the protagonist has of himself and the real truth of the matter. It says, "You are not who you thought you were. You are not wise but ignorant, you are not invincible but weak, you are not just but vindictive, you are not glorious but vain, you are not without limits, but finite." The feeling that accompanies the recognition of this discrepancy is that of an adult who has soiled himself in public, and has thereby revealed that he is not an adult but an incontinent infant. One has the sense of being smeared with one's own stinking filth, that one's filthy self can be seen and smelled by everyone, and that they are all overcome by a nausea and loathing (*nemesis*) for what they see and smell. The soiling is felt to become an indelible stain, the stain a pollution (*misama*) that will contaminate the world. The sudden recognition of the discrepancy between one's megalomaniacal opinion of one's self as like unto the immortals in respect of wisdom and righteousness and the truth of one's being as ignorant, mistaken, and the cause of suffering and injustice gives rise to the feeling of shame.

Shame is the destiny of ignorance in action. It is the fate that awaits those who would be truly great, for in the world of Greek tragedy it is not

possible to be both great and good. Shame is the curse of finitude, for to be is, sooner or later, to be ashamed. It is also a pollution, and threatens to infect all those in the neighborhood. Shame therefore wants to disappear; it wants not to be. It can do so in one of two ways. It can go into exile and there, far away from one's neighbors, it can wash away the pollution; or it can commit suicide.

II

In the epistle to the Romans St. Paul writes, "I know that in me (that is, in my flesh) dwelleth no good thing: for to will is present with me; but how to perform that which is good I find not. For the good that I would I do not: but the evil which I would not, that I do" (7:18–19, AV). Unlike the protagonist of a Greek tragedy, Paul knows perfectly well what the good is. He knows what it is, moreover, because he has been told what it is by the Lord God. In Paul's view, as in the view of all Jews and Christians, the name of the good is Torah, the Law, revealed of old to Moses and the people of Israel at Sinai and set down in detail in the Pentateuch.

Paul's problem is not that of knowing the good but doing it. He also knows why he does not do it: there is a second law to which man is bound: "I delight in the law of God after the inward man; But I see another law in my members, warring against the law of my mind, and bringing me into captivity to the law of sin which is in my members" (Rom. 7:22–23). The law of God is holy and just and good (Rom. 7:12) and to this law the "inward man" and the "mind" give assent. There is a second law, however, the law of sin, and this law is at war with the first, governs the "members" of Paul's body (his "flesh"), and prevents him from obeying the law of God.

Paul's inability to obey the law of God is not different from the inability of the people of Israel to live up to the terms of the convenant. Those terms were that Yahweh was to be the sole God of Israel, Israel was to be his chosen people. They were to obey his law, he in turn would watch over them, protect them, and make of them a mighty people. The history of Israel, however, is the history of its failure to hear the word of the Lord and do it. Throughout the Old Testament the law is figured in tropes of "the way": "Blessed are the undefiled in the way, who walk in the law of the Lord" (Ps. 119:1). Israel's disobedience consequently figures in tropes of straying and wandering: "All we like sheep have gone astray; we have turned every one to his own way" (Is. 53:6). Inevitably the prophets call on Israel to return to the way of the Lord: "Even from the days of your fathers ye are gone away from mine ordinances, and have not kept them. Return unto me, and I will return unto you" (Mal. 3:7).

Given the terms of the convenant it is irrational of Israel not to walk in the way of the Lord. When the prophets attempt to account for Israel's disobedience they speak of the people as stiff-necked and hard-hearted, a

"perverse and crooked generation" (Deut. 32:5). When Paul explains his failure to do the good he does so by saying that his flesh is subject to the "law of sin." At the same time, both the prophets' call to return to the way of the Lord and Paul's preaching the necessity of faith in Christ crucified seem to suggest that human beings have the power to alter their behavior. If Israel is perverse and crooked, it can become straight; if Paul is in bondage, a captive to the law of sin in his members, he can become free.

What the Old Testament writers and Paul are both working toward is a concept which will make sense of the religious, ethical, and psychological facts which compose their experience of living under the law of God. In fact, it is not until the third, fourth, and fifth centuries after Christ, when Christian theologians become acquainted with the concepts and terms of Roman law and Stoic philosophy, that the tradition finds what it needs. It is the concept of the will (*voluntas*), the power of free choice (*liberum arbitrium*), the principle of human freedom. Using these concepts, Augustine and others are able to resolve a perplexity that Paul himself raised for Christian thought. In his letter to the Romans and elsewhere Paul comes dangerously close to asserting that the "law of sin" is the equal of the "law of God." The equality of the law suggests either that God created the law of sin, or that there is a second God, and it is he who is the creator of evil. Both are unacceptable to Christian thought. Paul also nearly equates the "flesh" with sin. To do so, however, would be another way of saying that God created evil, and would deny a fundamental premise of the Judaeo-Christian tradition, namely, that as created, both man and the world are good. By positing in man a will that is free, Christian theologians can preserve the unity and goodness of God, for it allows them to assert that sin enters into the world when man in his freedom turns away from the holy, just, and good law of the One God, and elects to obey some other law. The concept of the free will makes man responsible for sin and for guilt under the law, and makes him liable for punishment for guilt.

There are two ways for the will to go wrong. These lines, spoken by Edmund, the bastard son of the Duke of Gloucester, provide an example of the first way:

> Thou, Nature, art my goddess; to thy law
> My services are bound.
>
> (*King Lear* 1.2.1–2)

This is defiance. Edmund knows that the law of primogeniture is a just society's way of ensuring that the crisis of power provoked by the death of the parents of a numerous issue will be negotiated in a peaceful and orderly fashion. By invoking the values of a "natural meritocracy" he flaunts the law of God as it is reflected in the law of society.

The second way for the will to go wrong is set out bluntly by Milton's

Samson in his lecture to Dalila:

> . . . if weakness may excuse,
> What Murtherer, what Traytor, Parricide,
> Incestuous, Sacrilegious, but may plead it?
> All wickedness is weakness. . . .

<div align="right">(Samson Agonistes, 831–34)</div>

In defiance man deliberately rejects the law of God and sets up his own law; in weakness he accepts a law established by another. In defiance man tries to be more than a human being, in weakness he becomes less. Both result from temptation, but defiance is tempted to pride, envy, anger, and covetousness, weakness to lust, gluttony, and sloth. Both are idolatry, but in the first man makes an idol of himself; in the second he bows down to what is neither God nor himself but a third, called "the world." Both are versions of hate, but where defiance tries to destroy God's law, weakness turns away from it and loses itself in the world. Both are perversions of love, for rather than loving the law of God defiance loves itself, weakness loves another. The Freudian terms for the two are aggression and sex, and the paradigmatic acts are homicide (especially regicide and parricide) and fornication (including adultery). Their personifications are Lucifer and Adam, their slogans *Non serviam* ("I will not serve") and *Mulier dedit mihi* ("The woman gave me [of the tree, and I did eat]").

These two misuses of the will also are associated with certain cultural traditions and patterns. The concept of defiance needs the support of an intellectual tradition that speaks of the power of the will, whether for good or evil, and finds it in the tradition of Thomistic theology and Aristotelian voluntarism. Literary instances include Dante's Satan frozen in ice at the root of Hell, the usurpers and avengers of Elizabethan tragedy, Milton's own Lucifer, Blake's protean and many-faceted challengers of old Nobodaddy, Dostoevski's atheists and anarchists, Nietzsche's Zarathustra, and—in its inevitably secularized version—Joyce's Stephen Dedalus, who takes Lucifer's motto for his own. This tradition, it should be noted, is most comfortable in a society in which episcopacy and monarchy are the accepted modes of governance of church and state—notably Elizabethan England.

The interpretation of sin as resulting from the weakness of the will finds its intellectual support in Pauline, Augustinian, Lutheran, and Calvinistic discussions of the bondage and servitude of the will. Dante's Paolo and Francesca begin the long list of couples—including Lancelot and Guinevere, Tristan and Isolde, Faust and Marguerite, the Rev. Mr. Dimmesdale and Hester—who weakly succumb to the lusts of the flesh and pay for it in agonizing remorse. The definition of sin as weakness tends to prevail in societies in which strict adherence to many laws is required by a group of elders or all the members of a congregation, and which lack a king to overthrow—notably eighteenth- and nineteenth-century America. With the

stupendous exception of the captain of the *Pequod*, American sinners are guilty of weakness, not defiance.

The ideas and values which inform Christian tragedy are therefore fundamentally different from those that inform Greek tragedy. In the Greek view murder and adultery, pillage and theft are not wrong in themselves but only if they offend some god or harm those whom one would not desire to harm. Oedipus has no qualm about having slaughtered an old man and his retainers over a question of right-of-way. Agamemnon parades his paramour Cassandra before the eyes of his wife and people. Vengeance is not only condoned but demanded by Apollo as Orestes' duty. But Claudius and Macbeth know the word of the Lord that says, "Thou shalt not kill." Iago knows it is wrong to bear false witness. Edmund knows it is wrong to covet his brother's property, just as he and Goneril and Regan know they should honor their father and mother. And Hamlet, the Wittenberg scholar, knows the Song of Moses, part of which reads, "To me belongeth vengeance and recompence; their foot shall slide in due time" (Deut. 32:35).

Moreover, as created, both man and his world are good. Evil enters into the world by way of human acts issuing from a will that is free to obey or disobey God's law. There is no curse on the house of Lear, no oracle has prophesied Macbeth's doom. The fault lies not in the stars or with the gods but in Iago's perverse will, in Macbeth's weak will. The act which disrupts the established order does not lie in some distant past, as in Greek tragedy, but in the present, and it can therefore be represented on the stage as clearly, explicitly, and unambiguously as Eve's temptation of Adam or Cain's murder of Abel.

The action of a Christian story begins, then, when a character possessed of a free will, and knowing what he ought and ought not to do, is tempted to defy the law of God or weakly to submit to a law other than God's. Iago and Edmund are instances of the first, Macbeth of the second. Claudius is tempted by both for he possesses his brother's throne and his wife. Hamlet's temptation is more subtle, as the play as a whole is more subtle and ambiguous than the others: he is tempted by the ghost's plea for justice to usurp God's providential rule of the world and take upon himself the responsibility of avenging his father's murder. In succumbing to the temptation each of the characters falls from grace, and through that fall introduces disorder into an orderly situation. The temptation is represented on stage, and (with the possible exception of the ghost's appearance to Hamlet) is morally unambiguous. The *agon* in Christian tragedy is a struggle between right and wrong, and not, as in Greek tragedy, between two different versions of justice.

Through the middle of the story the consequences of the initial event are worked out. But whereas in Greek tragedy the sequent events follow one another necessarily or probably, in Christian tragedy there is always a vestige of the possible—that is to say, of freedom and grace. In Greek tragedy the act of *hybris* lies in the past. It is not possible for Agamemnon not to

sacrifice Iphigeneia, for Ajax not to attack the Greek leaders, for Oedipus not to kill his father and marry his mother, for these deeds have already been done. In a Christian story the acts of murder, treachery, and so on lie in the future and are yet to do. There is therefore a possibility that they will not be done.

Possibility is function of character as well as plot. Given the unchanging and unchangeable *ethos* of a Clytemnestra, it is inconceivable—impossible— that she will not murder Agamemnon. Given the doctrine of "free will," however, there is a possibility that Macbeth will not murder Duncan, Claudius will confess to the murder of King Hamlet, that even Iago will repent and cease tormenting Othello. If in the event these possibilities are not actualized, it is because the evildoer's will has been hardened against the will of God. Free to choose, the sinner chooses to persist in his sin. He alone is responsible for it. He is guilty under the law.

The conclusion of a Greek tragedy involves recognition and suffering, and the catharsis of pity and fear. Recognition plays a part in Christian tragedy as well, but it is less a re-cognizing of the identity of persons ("The man I killed was my father") than the dis-covery of the culpability of persons ("The King's to blame"). In scenes of judgment and condemnation the guilt of sinners is proved or confessed, and the innocent are exonerated. Suffering in Greek tragedy is of the body (wounds, death) and of the mind (the mental anguish that accompanies ignorance and shame); Christian tragedy adds to these the spiritual or moral suffering of contrition and repentance. Othello, Gertrude, Lear, Lady Macbeth, and even Claudius all suffer from conscience as a result of being forced to acknowledge their misdoings. In the extreme case remorse leads to madness and even to suicide.

Madness in Greek tragedy takes the form of *ate*, a divinely sent infatuation or delusion. It drives persons (Ajax, Phaedre) to do things they would not ordinarily do, and to bring harm and suffering to themselves and others. Because they do these things in a god-sent frenzy, however, they are not completely responsible for their actions. The sufferings they bring about are not deserved, therefore, so they engender the emotion of pity. Suicide is a way of "disappearing," and is a course of action taken by those (Ajax, Jocasta) who cannot continue to live with the shame they have brought upon themselves and those who are dear to them.

Madness in Christian tragedy occurs toward the end of a work, not the beginning, and is a consequence of sin, not its cause. Iago, Edmund, and Macbeth are not mad. They are envious, covetous, and ambitious—they are evil. If they were mad they would not be free, and if not free they could not be held responsible for their actions. Because they are free to do good or evil, and choose to do evil, the suffering they cause arouses the emotion of indignation rather than pity. Ophelia, Lady Macbeth, and Lear all become mad. Ophelia's insanity is attributable in large measure to Hamlet's brutal treatment of her, and because her suffering is undeserved she is pitiable.

Lady Macbeth's madness is the result of a classic "double bind": she both must and must not confess her guilt. She is her own persecutor and victim, and the anguish of her madness is punishment for her sin. Lear's madness is not final punishment but a temporary penance for sin, and when he emerges from his purgatorial experience his fierce pride and petty vanity have been burned away, though his spirit remains indomitable.

In the Christian tradition suicide is both sinful and futile. It is sinful because it issues from unbelief: it denies that God is loving and merciful, and capable of forgiving even the worst of sins. It is futile because it provides an escape from judgment only in this world and not in the next. Suicide, therefore, tends to be reserved for those who are not wholly responsible for their actions or not entirely Christian. Othello's honor and nobility are "natural," even "pagan" virtues, and whether he was a baptized Christian may be mooted. Horatio attempts suicide, but he is less a Christian than a Roman Stoic philosopher. Both Ophelia and Lady Macbeth are mad when they take their own lives (though whether Ophelia "commits suicide" is questionable), and so are not responsible for their deaths.

In his analysis of the piteous and the fearsome Aristotle notes that there is nothing piteous about the change in fortune from good to bad of an "equitable" man (i.e., of a man who possesses the highest and best of moral virtues) or of an exceedingly "villainous" man. The first is "repulsive" (or "odious"), the second lacks both pity and fear. He concludes that the reversal in fortune must occur to a person of virtue who makes a mistake of judgment. In fact, none of the extant Greek tragedies concerns persons at the extremes of virtue, extremely good or extremely bad.

Christian tragedy includes both extremes, however, and the emotional quality or affective meaning of such works is different from its Greek counterparts. On Aristotle's premises the suffering of such innocents as Desdemona, Ophelia, and Cordelia would indeed be repulsive, for it so far exceeds what they deserve that it becomes unjust and unintelligible. In the Judaeo-Christian world, however, a world in which the contest is between good and evil, the fact is that the unrighteous cause the righteous to suffer. The Crucifixion— that is, suffering innocence—is unjust, but it is intelligible, and it arouses not only emotions of pity and compassion for the victim but of indignation and righteous anger with respect to the perpetrators of injustice.

The change in fortune from good to bad of sinners such as Iago, Edmund, Claudius, and Macbeth arouses neither pity nor fear, but a sense of justice accomplished. It brings to a satisfying conclusion the emotional expectations aroused by the suffering of the innocent. Christian tragedy is punitive tragedy for it depicts a world in which the contest between good and evil is supervised by the providence of a just God. In such a world innocence and righteousness are not necessarily rewarded (that is the pattern of comedy), but evil is surely punished.

Aristotle says that fear concerns the "similar," and by this I understand

him to mean that, given the condition of necessity and likelihood, the future is apt to be similar to the present, and the misfortune which is potential in present circumstances is more likely than not to be realized. In Greek tragedy fear is catharted when the misfortune actually occurs and is suffered through. Suffering catharts fear.

Suffering does not cathart suffering, however, and when desperate Oedipus looks to his own future life he can see only misery and shame. Again, in tragedies of revenge, the act of vengeance only gives occasion for a succeeding act of re-venge. In Greek tragedy the future is not significantly different from the past and present.

In Christian tragedy fear of a future misfortune is accompanied and qualified by hope in the ultimate triumph of justice and the restoration of the order disrupted by sin. The basis of hope is faith in "the possible." Possibility, as I have noted, is a function of plot, in the sense that events which will cause suffering lie in the future and not in the past; and is a function of character, in the sense that wrongdoing is the result of a will which, if it is perverse or weak, can still be straightened or strengthened.

The plot of a Christian tragedy does not allow for the possibility of introducing late in the story persons or incidents which will rescue the innocent as well as punish the guilty, for Christian tragedy is still tragedy. In Christian tragedy as in Greek, fear is catharted when future misfortune becomes present, is endured, and passes into the past. But it is catharted completely. If the curtain does not come down upon a new heaven and a new earth, it comes down on a new beginning, a second chance. Evil and its power for future ill have been purged, and a new and just order has been established.

One way to purge evil is to destroy it, as Macbeth, Claudius, and Iago are destroyed, and Goneril and Regan destroy one another. Another is to change it from evil into good. Awakening from the purgatory of his madness, Lear acknowledges his ill treatment of Cordelia and asks her forgiveness. Dying of wounds they have inflicted on one another, Hamlet and Laertes forgive one another of the suffering they have caused each other. Following the trial by combat, Edmund and Edgar exchange charity; then, when Edmund sees the bodies of Goneril and Regan and realizes for the first time in his life that he was lovable and beloved, he performs an act of compassion that goes against his "natural" self-centeredness and attempts to save Lear and Cordelia from the death to which he himself sent them.

As rigid in its perverseness as it may be, the human will is still malleable. Suffering can break it, forgiveness can soften it, and love can shape it anew in conformity with the will of God. The possibility that the will of man can be converted from its old way of idolatry and selfishness to the new way of charity and compassion means that evil and suffering are not a necessary or essential ingredient in human existence, that the future need not be like the past but can be different, and that it can be faced with hope and confidence and not—as

Oedipus must face it—with despair and fear.

The differences between Greek and Christian tragedy are many and important, but in one respect there is an important similarity between them. Othello, Lear, Hamlet, and Macbeth are all unequipped intellectually and by experience to deal with the situation that confronts them. They are human beings, and are therefore finite and ignorant. Othello is by training a soldier: he has no idea of the complexities of the human psyche, the workings of jealousy, or the façade of trustworthiness deceit can display. Macbeth too is a soldier, and knows that to defeat the enemy is to bring to an end the disruptions in the state caused by rebellion: he is totally unprepared, therefore, when he learns that the murder of Duncan is not the end but the beginning of a train of events that leads from horror to horror. Hamlet's youth, idealism, and legalistic frame of mind (he must have been studying law at Wittenberg, while Horatio was reading classics) have not prepared him to deal with the realities of murder, lust, betrayal, and court intrigue. Moreover, he is his father's son, and has sworn to avenge his father's murder; but he is also a Christian, and knows that vengeance is God's responsibility, not man's. Lear, finally, knows that his authority as king and the order and stability of his kingdom rest on the inviolability of the oath of allegiance which his vassal lords have taken to him. He foolishly supposes that he can transfer these political procedures to the domestic realm, and can ensure his authority as father and the order and stability of his family by requiring his daughters to pledge their love to him. He does not know that love cannot be coerced.

The ignorance that is ingredient to finitude is not itself sinful, however, and is not the principal cause of evil. Othello's gullibility, Lear's naivete and foolishness, Hamlet's scrupulousness and ambivalence, and Macbeth's effeminate curiosity make them easy marks for persons who are truly wicked and perverse. Othello is, as it were, Oedipus translated into a Christian cosmos: everything he does, including the murder of Desdemona, he does out of honor, for the sake of *arete*. The emotion that accompanies his discovery of what he has done is more that of Greek shame than Christian guilt—a fact which helps account for his committing suicide. But he is the victim of the malevolent Iago, not of his own ignorance. Lear's foolishness alienates him from Cordelia and puts him into the hands of his untender daughters. In the suffering that ensues, however, he becomes for the first time in his life a man of sorrows and acquainted with grief, both his own and that of poor naked wretches everywhere. Kings do not suffer, fathers do; and in the end the humility he has learned in consequence of his suffering allows him to be reconciled with Cordelia.

Neither Macbeth nor Hamlet are "good" persons the way Othello and Lear are, however. Macbeth's unsexed, Clytemnestra-like wife pushes him to find out what it would be like to be king, but she cannot push him entirely against his will, and her ambition is only a larger and more daring version of

his own. Hamlet's ambivalence about the ultimate justice or rightness of his cause allows him to be manipulated by Claudius, and he has the idealism and scrupulousness of inexperienced youth, but he is also ruthless. He is Shylock with a sword. He is merciless with Ophelia and his mother; having caught the conscience of the King he sings with vindictive joy; he murders Polonius and sends Rosencrantz and Guildenstern to their deaths without any remorse whatsoever. The reason he offers for sparing Claudius at his prayers is an expression of the utter mercilessness of the *lex talionis* in a Christian context. It is Laertes, not Hamlet, who initiates the exchange of forgiveness; and even then Hamlet cannot find enough mercy in himself to forgive Laertes but must pass on the responsibility to "Heaven." His cruelty and ruthlessness do not disqualify him for serving as an agent of God's providence, however, for Providence can use a merciless Hamlet as well as a compassionate Edgar for re-establishing order and justice in the world.

In its fullest sense, guilt requires four conditions: there must be a law; there must be knowledge of the law; there must be freedom to obey or disobey the known law; and there must be a violation of the law. Greek tragedy knows nothing of the first three conditions. To ask whether Oedipus, say, is guilty is therefore to ask a meaningless and irrelevant question. It is to impose the theology of one culture upon the theology of another.

The Greek emotion comparable to guilt is shame. Shame is the feeling that accompanies the recognition of the discrepancy between the goal or ideal of *arete*, excellence, and the actuality of one's shortcomings. To be a mortal is to be a finite body and finite mind. The stains of finitude upon the body are ugliness, illness, decrepitude, and death; the stains of finitude upon the mind are infatuation and ignorance. It is not possible to be a mortal and not be stained. Shame is the embarrassment of being finite, and more particularly of being mistaken. Only the gods—and the Phidian sculptures of mortals—are without the stain of finitude. Shame therefore wants to disappear, wants not to be.

If shame results from the discrepancy between what one is and what one believes one is, guilt arises from the discrepancy between what one is and what one ought to be. One's life and actions mark the "is," the law marks the "ought," and conscience determines the distance or difference between the two, notes by how much the "is" has fallen short of the "ought." Within the ought, however, is the "you owe," and the "you owe" says the shortfall is a debt one owes to the law. To be in debt to the law is to be owned by the law, to be in bondage to it, as every debtor is in bondage to his creditor. A debtor is a slave, a creditor a master, and the debt is felt to be chains and shackles, a weight, a load, an intolerable burden. The weight of debt bends the sinner's back, pushes him down, crushes him to earth, while the creditor-master is exalted and lifted up to the same degree, by the same amount.

The law is never violated in the abstract, however. It is violated in the ordinary intercourse of living, when one fails to pay what is owed to those

who are next, near. Those who are near are in one another's neighborhood, and they belong together. They belong to one another, they yearn to fit with one another, like the pieces of a puzzle, like the voices of harmonious music, like partners in a dance, holding each other by the hand, or the arm, which betokeneth concord. They long to be with one another like words in a poem, where every word is at home, taking its place to support the others, the complete consort dancing together.

The law is the pattern of the puzzle, the rhythm of the dance, the meaning of the poem. It is the ordering of the neighborhood of those who belong together. The longing of belonging is love, and those who belong together are those who love to be with one another. In the neighborhood of love there is neither Jew nor Greek, neither bond nor free, neither king nor vassal, neither master nor slave, for all are equal.

To violate the law, then, is to disrupt the pattern, interrupt the dance, corrupt the neighborhood. Sin transforms the partners in the dance to debtors and creditors, slaves and masters, bond and free. It introduces the inequality of indebtedness, and separates those who ought to be near. Love cools, friendship falls off, brothers divide, the bond between parent and child cracks. Sin ruptures the neighborliness of those who love to be together, and alienates those who belong to one another.

Sinful guilt, therefore, does not want to disappear. It wants to be forgiven, for through forgiveness it is restored to the neighborhood where it belongs. It prays for the forgiveness of the debt it owes to its neighbor and through the neighbor to the law. It wants to be rid of the burden of sin, the burden that weighs down the debtor even as it raises up the creditor. It wants to exchange charity, for only love can restore the harmony, the balance, that sin disrupted. In remembrance of the neighborliness of those who love to be with one another, it wants to be reconciled with those who ought to be near. It wants to be at one with her whom folly had exiled, and in that atonement to be restored to the minuet of mutuality, the holy, see-saw rhythm of benediction and absolution:

> When thou dost ask me blessing, I'll kneel down
> And ask of thee forgiveness.

NOTE

/1/ In preparing this essay I have borrowed terms, interpretations, and information from J. M. Bremer, F. M. Cornford, Tom F. Driver, David Grene, Reinhard Kuhn, Paul Ricoeur, Paul Tillich, Brian Wicker, and others. As his students will recognize, however, Preston T. Roberts, Jr., is the one to whom I owe the most.

Of Ecstasy and Judgment: Three Moments in the Approach to Beauty

Erasmo Leiva-Merikakis

For Arthur R. Evans, Jr.

1. Point of Departure

"If the philosopher cannot take his departure from the idea of beauty, . . . should not the Christian precisely for that reason take it up as *his* first word? . . . When the authentic form of the world becomes questionable, the responsibility for form really lies with Christians" (15–16, 24)./1/ This is the startling principle the Swiss theologian Hans Urs von Balthasar proposes at the beginning of *Herrlichkeit*, his six-volume work on theological aesthetics. It does indeed appear that, in the view of many, Christianity has to do primarily with other-worldly realities, having the minimizing of temporal realities almost as a solemn duty. But von Balthasar, far from assigning to the Christian a merely apologetical task oriented to the beyond, rather makes him responsible for salvaging the genuine beauty of *this* world, a beauty paradoxically lost precisely to those who cling too ardently, but also too exclusively, to the forms of creation. In a world increasingly bent on absolutizing the finite, von Balthasar calls for the restoration of created beauty to its ancient place in the hierarchy of Being, where, without losing its uniqueness, it shines most brilliantly when it becomes the transparent medium for the uncreated Light.

The present essay is intended as a contribution to the interdiscipline which, in the subtitle of his work, von Balthasar calls "theological aesthetics." My main objective shall be the clarification of issues in that particular area of aesthetics where the theologically informed Christian conscience encounters the volatile sensibility of modern poetry. The theoretical clarification of these issues will thus prepare the ground for practical criticism.

Although I shall necessarily have to deal with many an abstract concept, undue vagaries will be avoided by focusing primarily on modern poetry. It is only to be hoped that some of the conclusions and methods derived from this paradigm of literature may be applied to other kinds of literary statements. But, in this narrowing of the horizon, I am consciously reacting

against a type of criticism which is forever formulating strategies for approaching literature "theologically," yet never goes beyond the speculative stage. For this reason, too, I am solely concerned with the encounter between specifically Christian theology, on the one hand, and literature, on the other.

I endeavor, then, to explore and articulate as far as possible the principles that govern the encounter of a particular theology (and theology has always been particular, at any rate until the deism of the eighteenth century) with a particular form of literature. This calls for something like the sketching of a system. Now systems are always insidious—in the etymological sense: "full of traps." The guiding principle of one system, of necessity inflexible, will determine the whole nature of the edifice, which will be essentially flawed if treated as absolute "model of reality." No system can adequately "cope" with reality in the sense of totally incorporating it for understanding, not even all systems put together. And this is the trap: to imagine you have "covered" reality when you have perfected your system at last. But the point is that, although Christianity itself is not a system or an ideology, Christian theology, when applied, must take on the semblance of a logical construction of thought, as must any methodological project of human reasoning./2/

What kind of "system," then, do I have in mind? The last thing I intend to propose is a series of do-it-yourself steps which may be applied to a literary text and which would have as its result *the* Christian verdict on the poem in question. Nothing could be more useless and perverse. This point is worth emphasizing, because some such thing is generally understood whenever one mentions "Christian theology" and "literature" in the same breath. Such a tendency has at times been the motivation of zealous Christian critics, who then proceed either to canonize or to anathematize their critical object, leaving us in perfect ignorance as to the real worth of the poet's efforts. The late Tolstoy of *What Is Art?* is an example of intransigent Christian criticism in this vein. One reason for the fiasco of such theological criticism (in which theology, rather than judging, *uses* works of art for purposes of self-vindication) is that, in the past, Christian theological criticism has almost exclusively been preoccupied with questions of content, assuming that it can be separated from the form of a work.

Such criticism has dealt primarily with either the narrative or the dramatic genre, or with the poetry of a Dante and a Milton, but only insofar as this poetry reduplicates pre-existent notions of either Catholic or Protestant Christianity. This is understandable, since the most natural thing to do in determining an author's "worldview" is to examine the thought content of his creations. Being conceptually reducible, this content may then be transposed to other linguistic modes. For instance, we may abstract the "philosophy" of an existentialist novel by isolating its more categorical utterances, and then distill and condense these into some coherent "existentialist philosophy"; and it is all

the better if the novelist also has produced works of a purely philosophical nature, because then the task of interpreting the "meaning behind" his images is greatly facilitated. The result is countless books of criticism bearing titles such as "The Philosophy of Sartre" or "The Thought of Dostoyevsky," which may in addition accept or reject the author's view from a Christian perspective. Although the case of existentialist novels is perhaps the most glaring instance of works which lend themselves to such reductive criticism, the same approach is possible with all works containing even a minimum of conceptually transposable statements. Those which do not (as is mostly the case with St-John Perse, Trakl, and J. Guillén, for instance) are infallibly declared to be "hermetical," accessible only to the quantitative analysis of sound and color patterns, and so forth.

While the relative merits of such a method are not here contested, I ask why it is that the lyrical genre has so blatantly been neglected by theological critics. The answer is the reverse of what was said for the "long" genres. Critics have forgotten that, because beauty resides in forms rather than in ideas, there exists such a thing as a *theology of form* which should be the main focus of theological-critical endeavors. Lyric poetry, especially in modern times, exhibits a peculiar lack of such conceptually transposable statements as we spoke of. The extreme of this dearth is achieved by the so-called Symbolists, especially a Mallarmé and a Valéry, but the syndrome is generally true even for "confessional" poets—one thinks of G. M. Hopkins, Max Jacob, Konrad Weiss, Elisabeth Langgässer, and Thomas Merton. It so happens that in good lyrical poetry, more than in any other genre, the "content" is so intrinsically bound up with the "form" as to be practically identified with it.

If we would endeavor, then, to apply a theological critique to lyric poetry, we can see that a primary task will be to examine the nature of language itself, and the poet's own conception of the function and uses of poetry. To say this is to establish the fact that poetic activity and "creation," like any other human action, are subject to ethical judgment, even when that activity formally falls into the realm of aesthetics. It is helpful to remember in this connection that a poetic symbol may be called an "image" only metaphorically, since poetry's matter is words, and words, unlike stone, paint, and sound, have not only sensual body but also meaning. The poet's ability to assign new meanings and combinations of meanings to his words does not exempt the poetic deed from ethical judgment. The axiom that the beautiful is the *splendor veri* (the "radiance of truth," according to Aquinas) establishes a hierarchy of significations. While the specific beauty of a given form reveals to us something of the essence of that form, the more elemental (and gratuitous!) mystery of its very *existence as beautiful form* points to the one who created and bestowed it on the world, whether this creator be an artist or God. Thus, the ultimate meaning of aesthetic meaning itself is the manner of relationship between finite form and the infinite Creator and giver of the existence and the beauty of form. And this fundamental relationship is "lived" as the act of discerning

between truth and falsehood, which in ethical terms is the discernment between good and evil. The meaning of the images borne by poetic words has its effect beginning in the memory, and it is there that the will of the recipient becomes engaged in choosing the manner in which images will be concatenated to other images, these in turn to emotions and, finally, to thoughts and actions. Poetic images, therefore, necessarily bear good or evil fruit in human thought and action.

A poet's conception of the nature and function of language will logically determine his poetic doctrine, and will finally crystallize in the particular poem. That Mallarmé, for instance, saw language as a negation of reality, as the substitution of reality by the poet's symbols for it, resulted in his practice of attempting to create the world anew in each poem, according to criteria of his own. In his essay *Le livre comme instrument spirituel*, he goes so far as to say that everything that exists does so only in order to find its perfection as part of a book. (It is interesting to note that Sartre, so far otherwise from the aestheticism of Mallarmé, coincides with him in the view that the aesthetic image "abolishes" the empirical reality.) This philosophical view and this poetic practice are eminently subject to, and even demand, moral theological criticism in addition to aesthetic evaluation. And it is very telling that, in the past, the phrase "literary criticism" has quite naturally implied *aesthetic* criticism and nothing else, as if art were granted a special dispensation and autonomy within the realm of human activity.

It is often forgotten that this view was itself conditioned by peculiar cultural and philosophical circumstances in the nineteenth century and is not older than, at most, the Renaissance. The persuasion that immanent or intrinsic textual criticism (*explication de texte*) comprises the whole of literary criticism is itself the critical manifestation of the prejudices of the art-for-art's-sake aesthetic, although it may appear at face value to be a more "scientific" and objective way of doing criticism. Theological criticism is, in fact, the more "objective" approach, in the sense that it confronts the whole reality of the poem with the whole reality of the critic; the true subjective "sin" is to be selective in reducing these realities to one or another of their aspects. Here I take objectivity to be wholeness of perception (in the subject) and of existence (in the object itself). In this respect, the theological criticism here proposed offers to more traditional criticism what T. E. Hulme called a "critique of satisfaction" (12ff.): to show that the way things have been is only one among many possibilities, and that what are taken to be self-evident axioms are, in fact, but one method's eyeglasses.

The ethical imperative I envision is the preservation, within the realm of literary criticism, of the whole reality of man, a reality which, according to our premises, is fully and adequately accounted for only by the full range of Christian revelation. I mean that criticism, even of the smallest poem, should exhibit that unifying universal *élan* with which theology attempts to integrate cosmic reality. Paradoxically it seems that such universality can be

accomplished only by taking a very specific standpoint from which to "move the world," the perspective which Vladimir Soloviev described when he remarked that only that which is authentically individual coincides with what is authentically universal (168).

The charge of anachronistic provincialism, by now the standard reaction from self-consciously "modern" or "postmodern" quarters, must be borne by the Christian critic for the sake of achieving authenticity of vision. It is presumed that no one with heightened aesthetic sensibility can actually (i.e., literally) believe what Christianity has traditionally taught—whether the immutable dogmas common to all orthodox Christians or, in particular, the claim of the Catholic church to direct historical continuity from Christ and the Apostles. Even a great poet, this trend of thought goes, might make use of traditional Christian symbols as convenient images, but . . . —and so forth. This familiar mode of thinking with regard to religion itself has a complicated history, but much of it seems to be resumed in the fact that for a long time the cultured élite has substituted art for religion, with varying degrees of awareness. It is not so much modern areligiosity which is to be deplored; rather, the task presented to critics who "still" hold to the premises of the Christian faith is to clarify issues, and, by bringing theology into dialogue with literature, at least to affirm the difference between them. Only after real distinctions have been established can there be any hope of showing where authentic unity lies. The monistic tendency of the modern sensibility, that would collapse all values into one, is the shortest path to personal and cultural disintegration.

The secular humanistic attitude, by proclaiming each individual to be his own legislator, has consistently yielded a maelstrom of ethical and philosophical relativisms whose repercussion in the field of literary criticism has been (a) the idealistic conception that art is a revolt against reality, (b) that this reality must be spurned as mediocre, and (c) that art creates a superior world because the creative imagination is supremely autonomous and, in fact, creates new truth *ex nihilo*. On a philosophical plane, the habitual confusing of distinct realities must be traced to the abandonment of the trancendental imagination, which seeks the unification (not the fusing or the con-fusing) of the good, the true and the beautiful. Unification must be the union of distinct entities; otherwise we are actually speaking of a monistic collapse of identities. For T. S. Eliot, who in many ways inaugurated modern theological criticism, secularism is the chief instance of the fracturing of vital distinctions. In his critical essays, Eliot wishes to alert those who supposedly should be aware of the existence of a supernatural order to the fact that much of modern literature explicitly or implicitly gives the lie to this aspect of the Christian tradition. Unless Christianity is to be reinterpreted beyond recognition, those who call themselves Christians must take note of this event and its implications: "Man is man because he can recognize supernatural realities, not because he can invest them" (351).

The realistic basis of theological criticism, finally, is the Christian aware-
ness of man's radical imperfection, commonly termed "original sin." The
poet is an imperfect man writing for imperfect men, and some third criterion
is essential to stabilize their relationship. This third criterion is the Christian
tradition, especially as embodied in Christian theology. The negative insight
into man's radical imperfection, however, has a positive counterpart in the
conviction about the transforming capacity of literature. Literature affects
people wholly, whether the poet and his reader know it or not. We will see
how, in its conclusion, theological criticism should determine the correct
moral relationship between the reader and the poet in the context of man's
radical imperfection but also of man's innate ability to know and to love the
truth.

2. Method

The monism of the secularistic attitude reappears in the pseudoscientific
claims of so-called "objective criticism." Often it would seem that literature
is viewed as a product fabricated by computers for the purpose of being
analyzed by other computers. It would appear, rather, that in the humani-
ties the only valid approach is the "subjective," given the nature both of the
object of criticism and of the critic. The word "subjective," as used here,
must be correctly understood, however. In his preface to *The Disinherited
Mind*, Erich Heller recommends an abandonment of inflexible methodolo-
gies that points the way for us: "The literary scholar would be ill-advised to
concentrate exclusively on those aspects of his discipline which allow the
calm neutrality of what is indisputably factual and 'objective.' His business
is, I think, not the avoidance of subjectivity, but its purification" (vii).

In the specific terms of theological criticism, the approach Heller
recommends may be translated into a process with three phases, which will
constitute for us a paradigm for the encounter between the horizon of the
poem with that of the critic.

A. Initially, the subjective approach allows the poem *to be* in its own
space and time. We are drawn into its world. The critic stands before the
poem in the relationship of an ecstatic admirer and participant, who goes
outside himself and is overpowered by the reality and the beauty of the
poem. The psychological "magnetism" of great poetry draws one out of
oneself, and to this movement we will assign the classical name of *ekstasis*,
developed in greatest detail by Dionysius the Areopagite in his *Divine
Names*. For a brief instant a total unification between subject and object is
effected. This is the first manner of approaching the poem: to consider in its
expressive and captivating value the manifestation flowing from within it.
This movement has as formal object the *pulchrum*, the attribute of Being as
beautiful, and it primarily engages the sensorium, consisting of both the

physical and the spiritual senses. This phase also corresponds to the literal level of interpretation in the medieval fourfold scheme. The best poems are, at this stage, archetypal and revelatory of the interior of their author and of the cultural context within which they were produced. We approach the poem as a spiritual landscape, as the microcosm that reveals the secrets of its parent cosmos. Here what enraptures us is an impulse of amazement before the shock of beauty, such as is to be experienced by reading most any poem of Mallarmé, many a poem of Rilke, and every poem of Lorca. This is also the properly aesthetic moment of immanence within the world of the poem. The initial movement of awe before the phenomenon of beauty that invades us, however, must eventually yield to a critical movement of distancing from the beautiful object. Already the dialectic interior to this first, or "ecstatic," movement contains within it a secondary curve of critical reflection: the aesthetic reflex that seeks to determine the inner workings of the work of art, the reasons for it to have such an ecstatic effect. Poetry of the first rank always has such an effect; but there are ecstasies of horror, of delight, of melancholy, of praise. . . .

But, before proceeding with our analysis, an all-important clarification must here be made. A misunderstanding of why this first movement is called "initial" and "properly aesthetic" will inevitably lead to a deformation of the intentions of the present paradigm.

"Judgment" in no sense transcends "ecstasy," as if the analytical work of the intellect were intrinsically superior to the perception of beauty. In fact, a ruling feature of von Balthasar's work, on which we here base ourselves, is his incessant return to the *form* of revelation, his insistence that God does not reveal himself *behind* but *within* the humanly perceivable form of salvation history, culminating in the person of Christ. Nothing could be more illustrative of this necessity of finding God *in form* than the famous passage in St. Augustine's *Confessions* (X, 6) where, after asking what it is that he loves when he loves his God, he affirms in the mode of cataphatic theology that he loves a certain "light, voice, perfume, food and embrace," and it would destroy the aesthetic basis of Augustinian realism to dismiss the statement as an instance of metaphorical euphoria. If God is found and loved also with the (spiritual) senses, then, in a Christian sense, the sensorium is active at both the beginning and the conclusion of even the most transcendental experience. This is the decisive difference between the religion of a Plotinus and that of even the most Neoplatonic Christian.

Now, form is form wherever it may be found, whether in the "divine art" of revelation, or the human art of the poem, and the first task of a theological aesthetics is to heal the arbitrary dichotomy between "form" and "content" that made these appear to be mechanically separable parts of the single phenomenon of beauty. Therefore, the ecstatic moment in the perception of any beautiful form is initial in the radical sense of being the genetic and, thus, permanent locus that will contain and condition *all* subsequent

stages in the encounter between the critic and the poem. The judgment brought to bear on the form of revelation presented by God to man, however, is qualitatively different from that practiced on any form proposed by man to man, given the nature of the artists involved in each case.

B. In the second phase of criticism, a crystallization begins to take place in which the critic becomes aware of an explicit or implicit theological center from which the poetic utterance derives its meaning. This center consists of the presuppositions upon which the poem is founded. The theological center is the locus of a constellation of values (a sphere or periphery around the center) which frames and provides the context in which the poetic statement has its being: the microcosm that makes the poem possible and within which the poem exists. The insights of phenomenological criticism as practiced, for instance, in Georges Poulet's *Les métamorphoses du cercle* are here of the greatest value in determining the interior space of the poem./3/ Specifically theological criticism, moreover, brings to the poem a world of its own, only in this case it is not the purely personal microcosm of an individual, but the world of values founded upon the Christian tradition. This is the second movement of theological criticism, a movement of judgment in which the critic necessarily appraises the poem according to "objective" criteria, that is, principles not of his own making. It is important to note that such criteria are based upon a living tradition rather than upon quasi-scientific principles, and they are thus "objective" in a dynamic sense, which is very different from what is meant in the exact sciences by "objectivity." This enables the critic/poem encounter to remain within the realm of vital dialogue.

In the persona of such theological criticism as I here describe, the resurrected Christian tradition emerges in the midst of long-forbidden territory. Its first task is to identify "creative" departures that choose random elements from this tradition's storehouse of symbols and dogmas, which can have life only in their totality and organic unity. The frequent appearance of themes and fragments from Christian tradition in writers who are not Christian may generally be attributed to the transfer of divine attributes from God to man after God has been banished from the vital cosmos. Thus we have the themes of humility and prayer in Rilke (whom von Balthasar accurately describes as a "Franciscan Nietzsche"), of redemption in Shelley (*Prometheus Unbound*), of interpersonalism in D. H. Lawrence. A probing into the precise significance of these concepts will show that each time they are being used "heretically," that is, eccentrically or illegitimately, since an originally Christian theological concept, having its life in a particular context and within the organism of a total view of reality, has been excised from its matrix and used to build a private mythology founded on non-Christian premises. The contemplative, unitive vision has been supplanted by the dissecting techniques of the autopsy, and the usual result of such

mythopoiesis-by-montage is the solipsism attendant upon a "private vision of the world."

We will give the name of *krisis* to this second phase in the approach to the poem, which adds the element of judgment to the initial undifferentiated response of awe. This movement corresponds to the allegorical manner of scriptural interpretation, that is to say: it determines the *quid credas* of the literal sense—what one ought to think and believe of the object before one. The movement, governed by intellectual reflection, introduces normative criteria by bringing the *pulchrum* into relationship with the *verum*: something cannot be beautiful unless it is, precisely, the "radiance of the truth." This manner of approach distances the critic from the aesthetic object after *ekstasis* recedes as dominant response.

This kind of judgment would lead us to conclude, for instance, that T. S. Eliot's *The Waste Land* is surely not a celebration of the spiritual state of Western culture in the early twentieth century. Rilke's *Duino Elegies*, on the other hand, will be found at radical variance with this judgment, since here the German poet intends to conduct just such a celebration, in the sense that cultural disaster and disintegration are welcomed as making possible existence on a wholly interior level. In this contrast we see the fundamental importance of point of view in the poet, and the theological critic must develop the acumen to discern it. Rilke constructs a new myth that explains the world to him, whereas Eliot judges an existing reality by the very images of his poem. Here Rilke reveals himself as a gnostic, and Eliot as a realist. In this connection we may perhaps go so far as to assert that the very aesthetic structures of a poem are indicative of whether the poem is founded upon an exalted lie or whether, instead, it structures the poetic elements around a sound intellectual insight. Rilke's whole poetic ethos consists in the apotheosis of the individual will, which in its moments of highest intensity succeeds in transforming the world interiorly by making it invisible. Concrete reality is worthwhile for Rilke only to the degree that it becomes invisible—that is, to the extent that it ceases to have worldly concreteness. In this we recognize him as a faithful heir of Shelley and Mallarmé. Rilke's ethos must finally be judged to be fallacious in that he posits two extremes of the same spectrum—visibility and invisibility—as religious criteria for judging intrinsic worth, while for Christians the crucial distinction must lie between the divine and the natural. (The human soul, for instance, is invisible and yet natural, in the sense of created and finite. Conversely, the flesh of Christ is truly the flesh of the second person of the Trinity.) Eliot, by contrast, does not not seek salvation where it is not to be found. He does not turn from exteriority to interiority, or from the seen to the unseen. In fact, in *The Waste Land,* salvation is nowhere to be found. In this poem Eliot depicts man abandoned to his own resources. In Rilke's case, lack of a sound intellectual principle of discrimination leads him to the grandiose deceit of an autonomous Kingdom of Interiority, where every human faculty is

deprived of its natural object: one waits for the sake of waiting (and joyously!), young ladies love their beloveds' absence more than their presence—the apotheosis of the love of love.

C. The purpose of the second phase of criticism constitutes the third and concluding movement: the uses of literature. To this synthetic movement we will give the name of *praxis* because it deals with the practical application of the properly critical movement and focuses on the faculty of the will. Returning to the *ekstasis* with the conclusion of the *krisis*, we now seek to integrate the two by appraising their relationship to one another. The work's relation to the truth will determine its particular manner-of-being in the world and will, therefore, define the work's final relationship to the reader as a thinker and a potential doer of the good. For instance, if the *Duino Elegies* are judged to be founded upon an exalted and heroic lie, it is simply because they rest on erroneous metaphysical presuppositions which no poetic license can excuse. *Praxis* seeks foremost to determine the relationship between the author's work and his life (as a sort of apocalypse *in nuce*) in order to make a forecast as to the probable effects of the work on a generation of readers.

The *praxis* is a combination of the moral and the anagogical levels of medieval interpretation: the eschatological concerns of theology lead the critic to seek out the implications of the type of poetic statement under consideration. This necessary transition from the allegorical *krisis* to the moral-anagogical *praxis* is succinctly summarized in Bernard of Clairvaux's formula: *Aedificata est fides, instruatur vita; exercitatus est intellectus, dictetur actus*: "Now that our faith has been shaped, let it instruct our life; now that our intellect has been trained, let it determine our acts" (Leclercq:103). For our purposes this "faith" should be understood not in the exclusively religious sense, but as referring to what we "ought to believe" about any reality we confront.

Such a methodology as I have here outlined is complete only as a paradigm. It represents an ideal pattern of theological criticism which attempts to describe an exhaustive approach. In applied criticism, which will realize the paradigm only in varying degrees, it is essential to remember the insidious nature of systems in order not to destroy the wholly free phenomenal quality of a given poem. It is true to say that the continuity between thought and poetry is what, to a large extent, makes theological criticism possible, since one could hardly make much critical advance with an absolutely impermeable aesthetic entity. But this is not to say that poetry gives an aesthetic cast to an a priori thought. The polyvalence of the poetic symbol, which for Goethe and Coleridge synthesizes an idea and an image, gives poetry an irreducible character which forever eludes total analysis. Hence, the kind of "judgment" here envisioned is not intended to rectify the initial ecstasy at the shock of beauty. Rather, the task of the judgment is to

identify the type of ecstasy involved and, thus, to describe its effects.

We must again emphasize that the three movements of aesthetic encounter, as here portrayed, are not successive in time or priority, but genuinely distinct in their nature and ordered according to a logical sequence. Moreover, no critic is infallible; a responsible critic must constantly review his judgments and must continually be educated by the experience of poetry. For these two reasons, the three distinct moments in no way cancel one another out, but rather delimit and deepen personal awareness in one's relation to the poem. Thus, *ekstasis* both precedes and follows *krisis*, since the intensity of the ecstatic experience generates the erotic energy that makes *krisis* at all worthwhile in the first place. *Praxis* is the lasting fusion and reconciliation of the other two moments, and it carries the dialogue between them back into life, not abolishing but containing them both. Thus, the relationship among the three moments is dialogical rather than dialectical, since dialectics points to an inevitable deterministic succession of reactions, while dialogue refers to the participation of different perspectives in each other's universe.

The general goal of the theological critic is integral criticism—a person as a whole confronting a poem as a whole. The specific content of his approach would be the application of the tripartite process I have just described. The three primary human faculties (the sensorium, the intellect, and the will) perceive their corresponding objects (the beautiful, the true, and the good) as found in a given work of art. The mediation is respectively provided by the discipline that governs each of the three immanent faculties—namely, aesthetics, metaphysics and ethics. Such a method is specifically called *theological* because, while theology is not one of the three transcendental disciplines which together comprise philosophy, it is outside of them and subsumes them as the *regina scientiarum*, the "queen of sciences" which has as its proper object subsistent Being itself and which is, therefore, the foundation of all knowledge, just as God is the foundation for the existence of all created Being. If theology concerns itself with an understanding of God the Creator both for himself and in his relationship to creation, then professional rigor itself demands that theology enter into dialogue with works of art as parts of God's creation: what man, as the image and likeness of God, has "created" with the good things God has given him. The desire for fullness of truth, as well, demands of literary criticism that it be enlivened by such a theological perspective. The result is a critical position which is transcendental and, therefore, "liberated" in the most profound sense, and this for two reasons.

Because it seeks to integrate the poem into man's universe of meaning, the approach proposed goes beyond the work of art in itself and also beyond the realm of aesthetics as such. The basic tenet of revelation is that God first created the world and, in the redemption, re-created it out of love. The world, it follows, participating in the life of God in Christ, is not a machine.

It has an ethical meaning, which is the restitution of love's integrity through justice. A theological aesthetics, according to von Balthasar, here following Aquinas, must see beauty as the *splendor veri*, and the typical nineteenth-century heresies of aestheticism (beauty without content), moralism (action without contemplation) and scientism (the world as brute fact) each derived from a miserably impoverished view of the nature of man and creation. Viewing the world as God's creation leads to a respect and a reverence for it that no humanistic or "planetistic" philosophy, be it ever so vital, has ever attained with such thoroughness, resulting in such genuine liberation of the individual./5/

3. Outlook

We have seen that the main difference between a structuralist and a theological approach is that the first is descriptive, a thorough statement of the realities present in the poem and of their functional dynamics. Such a procedure is by nature ethically neutral. The theological approach, on the other hand, is marked by a deep eschatological concern, in the sense that it probes and draws out the implications of the work of art that lie beyond the realm of pure aesthetics: it strives to provoke each poem and poet to their own inevitable apocalypse. Of course, it is possible to deny the objective existence of a divine level of reality; in this case such apocalypticism could be construed as the symptom of religious hysteria, since the realm of man and nature will be seen not only as autonomous but as all-inclusive. Radically secular critics, for instance, could find no serious meaning in Berdyaev's aphorism to the effect that "humanism destroys man, but he is born again if he believes in God" (75). The theological critic, however, might be of value even for the partisans of a pan-human cosmos in the sense of introducing distinctions within the area of aesthetics whose absence would impoverish the understanding of the work of art itself. For this reason, the theological critic is not so much concerned with censuring the exaltation of the human to infinity as with analyzing the uses that humans make of the divine. In this way he enunciates the actual difference such use or abuse makes with regard to the form of the poem and its spiritual implications. Not proselytization but clarification is the objective, as was stated initially.

The crux of the matter is not whether a poet "believes in God" or "makes room for God" in his worldview (much less whether we can "prove" a Baudelaire or a Trakl to have been Christian poets . . .), but to determine what use the poet makes of the sacred and the numinous, to what extent he may make the divine a predicate of the natural human sphere (Rilke, Nietzsche, George, Shelley, Perse), or how he strives to relate but not confound the identity of each (Dante, Hopkins, Claudel, Eliot, Lorca, Thomas, the German Expressionists), making real dialogue between them possible (cf. Blanchet:172–76, on Perse; cf. Rothe on Expressionism). It may not be too

far off the mark to attribute a *gnostic* sensibility to the first group of poets, in the sense that they construct private myths for themselves and find their salvation in them (cf. Jonas: appendix, on gnosticism). The latter group would then be described as exhibiting a *symbolic* sensibility, since they perceive the world as a reality which, while itself possessing real being, simultaneously reveals and announces an independent absolute reality, which I have been calling "the divine." If we were to compare Shelley and Claudel, for example, we would have before us two irreconcilable conceptions of the literary symbol; and the fundamental distinction between them is perhaps the basic principle of a theology of form. While Claudel's transitive symbol is both a part of the natural order and, simultaneously, epiphanizes the invisible, transcendental order, the intransitive symbol of Shelley, conceived in a purely aesthetic fashion, must compete with the reality of the empirical object serving as symbol and derives its "magnetism" from the destruction of the symbolic object itself. The inability to exercise a polysemous, or truly symbolic, vision of reality appears as one of the earmarks of the modern sensibility. Or the same categories may be transposed to another level. That eros which does not avail itself of an efficacious mediation, an effective transitive symbol able to receive the erotic drive and carry it forward, transforming it into *agape*, condemns itself to what ultimately must be judged to be a self-contained love of one's own image. When expressed in the aesthetic medium, this attitude may be characterized as possessing a symbolism which is ineffective because it is intransitive, and its mythical figures are interconvertible because they derive their existence solely from the poetic imagination and have no counterpart in transsubjective reality. On a theological level, such intransitive symbolism can aspire to redeem a subject only in an auto-efficient manner, and self-redemption is, theologically, a contradiction in terms. This category of transitive and intransitive symbolisms is here mentioned at some length because it may give an idea of what is meant when we speak of a "theology of form."

This essay, too, should conclude "eschatologically," with a view towards tasks to be done. My only claim to originality has been to make explicit and harmonize in some manner principles of theological criticism which are at least as ancient as the fourfold method of scriptural interpretation. Perhaps I have proceeded a little too explicitly: no one is ever going to tackle a poem beginning with conscious *ekstasis* (it would then not be such!) and then "go out and put the poem into practice." However, the issues involved are crucial in themselves and deserve being brought into the light. The critics I have mentioned, as well as many others, have formulated categories of theological criticism that need to be explored in depth. Besides the category of transitive and intransitive symbolism, other similarly helpful categories might be: Allen Tate's distinction between the angelic and the symbolic imagination; contradictory conceptions regarding the nature of Being itself, with some (Rilke, Heidegger) alleging that it is continuous and spherical,

and others (Kierkegaard, T. E. Hulme, Léon Bloy) claiming that Being is discontinuous, like a cup with a crack in it (fallen creation, "ironical" model); Eliot's category of orthodoxy and heresy at a literary level; and, finally, the different apotheoses of the human and the divine (what might be called linear and circular hypostases).

Hans Urs von Balthasar had startled us initially by making Christians responsible for safeguarding the form of *worldly* beauty, which can grow to perfection only if it has its life from the Creator. Now, at the conclusion of our inquiry, we are perhaps in a better position to understand what may at first have appeared to be an arbitrary riddle on von Balthasar's part. We again listen to his words:

> Every beautiful form is perceived as the expression, frangible within space and time, of a more than temporal beauty. . . . The whole mystery of Christianity . . . is that form does not stand in opposition to infinite light. . . . The form itself must participate in the process of death and resurrection, and thus it becomes coextensive with God's Word of Light. This makes the Christian principle to be the superabundant and unsurpassable principle of every aesthetics; Christianity becomes *the* aesthetic religion par excellence. (191, 208)

Such a statement, replete with implications for practical criticism, hits the mark squarely as an impartial arrow that strikes both the aesthetes and the dogmatists among us with a salutary wound. First and last, the theological critic must embody in his work the reverence due the humble, limited forms of phenomenal reality, and, as von Balthasar shows, this imperative is itself rooted in theological ground. In John, chapter 14, we read a dialogue which is the foundation of a revolutionary epistemology:

> Philip said to him, "Lord, show us the Father, and we shall be satisfied." Jesus said to him, "Have I been with you so long, and yet you do not know me, Philip? He who has seen me has seen the Father; how can you say, 'Show us the Father'? Do you not believe that I am in the Father and the Father in me?" (8–10a)

This unprecedented and unequalled identification of transcendent Ideal and concrete human Form at once abolishes whole abysses of Platonic dichotomies and justly provokes the enraged horror of the law-abiding Sanhedrin. And John insists: "The Jews were grumbling about him for saying, 'I am the Bread that came down from heaven.' They remarked, 'Is this not Jesus, the son of Joseph, whose father and mother we know?'" (6:41f.).

We conclude by recalling one of the most remarkable examples of the piety before the phenomenal world demanded by the Incarnation: the work of Ernest Hello, a little-known French poet of the last century. In his "Hymn to the Dust" he exclaims with clairvoyant simplicity: "O faithful dust . . . , you who fly obediently before the passing breath of God. . . . How can you bear me, sacred earth, who have borne the weight of

God?! . . . Come to me, Lord, you who are a lover of the abyss" (24f.). The Christian "scandal of particularity," that finds the eternal Absolute manifested in the human-specific, extends to the whole of creation by its sharing in the divine life; and it extends primarily and par excellence to the spirit of man and its highest expression in works of thought and art.

If theology has been called the *regina scientiarum* it is because it has its roots and unique identity in the interpretive understanding of the Word of God. Now theological criticism, steeped in the faith of the theandric reality of Jesus Christ, cannot in turning to the interpretation of the Word of Man do so other than in a spirit of piety analogous to the way a monk approaches his *lectio divina*. Poetry may in this manner be variously seen as spiritual exercise (Wahl), as the speech of Being (Heidegger:9ff., 35ff.), or even as a kind of prayer (Bremond:85ff.), but always as a spiritual document containing the message of a *vox humana*: poetry taken as the most intimate evidence of the state of the human spirit at a given moment in its history.

NOTES

/1/ The first three volumes of von Balthasar's *Herrlichkeit* are tentatively scheduled for publication in English in 1983 by T. & T. Clark, of Edinburgh. French and English translations already exist.

/2/ Christianity especially is not a system that "explains" the world in a philosophical sense, and it does not, therefore, compete with the truth of other religions. This is because no other religion raises the claim made by Christianity: that God has revealed himself to man in person, shattering all preconceived ideas of the divine and, with them, all tight systems of religious thought.

/3/ Lawall in *Critics of Consciousness* (76, 97f.) summarizes the outlook of Poulet's book as follows: "The concept of the circle and its emanating center represents man as a perceiving, active figure who reacts to his environment. The pattern of human existence . . . is a central emanating thought which proceeds in increasing concentric circles to vivify and unite the universe of 'interior distance' existing for man between himself and the ultimate range (the 'circle') of his perceptions. . . . The circle, as a 'privileged form' in human consciousness, becomes the metaphor of its literary organization. It is a natural metaphor for existential thought, since it represents the uniform horizon of perception around each person: 'the field of human consciousness.'"

/4/ With the clarity and incisiveness that are his wont, Julien Green (18) provides the following appraisal of Mallarmé, the grand "sorcerer of language," and this critique is an eloquent example of the synthesis of ecstasy and judgment of which I speak as constituting *praxis*: "Mallarmé's valiant effort to give the impression of great poetic delirium . . . [has a result] which is marvelously beautiful; but it remains true nonetheless that his obscurities hide very simple things, and they are there only to stimulate the sacred fever of great poetry. . . . I would not want a different Mallarmé, but one can love without being fooled."

/5/ An excellent example of profound awe before the transcendental dignity of creation is the speculative theosophy of Vladimir Soloviev as developed in his book *Lectures on Godmanhood*, in which he relates the triunity of Being in its transcendental aspects to the Trinity of Persons in God, of which the world is an image. Similarly Dorothy Sayers (13–16) establishes an analogy between the triunity of God and that of the creative mind, which proceeds in a dialectic of experience, expression, and recognition. This *locus theologicus* is as ancient as Augustine's *De Trinitate*.

WORKS CONSULTED

Balthasar, Hans Urs von
1961 *Herrlichkeit: eine theologische Ästhetik*. Vol. 1, *Schau der Gestalt*. Einsiedeln: Johannes Verlag.

Berdyaev, Nicholas
1964 *Dostoyevsky*. Trans. Donald Attwater. New York: Meridian Books.

Blanchet, André
1961 *La littérature et le spirituel*. Vol. 3. Paris: Aubier.

Bremond, Henri
1926 *Prière et poésie*. Paris: Bernard Grasset.

Eliot, T. S.
1964 *Selected Essays*. New York: Harcourt, Brace and World.

Green, Julien
1977 *Journal: Vers l'invisible*. Vol. 5, *Oeuvres complètes*. Paris: Gallimard-Pléiade.

Heidegger, Martin
1959 *Unterwegs zur Sprache*. Pfullingen: Verlag Günther Neske.

Heller, Erich
1952 *The Disinherited Mind*. Cambridge: Bowes & Bowes.

Hello, Ernest
1917 *Prières et Méditations inédites*. Paris: Bloud et Gay.

Hulme, T. E.
1924 *Speculations*. Ed. Herbert Read. New York: Harcourt, Brace & Co.

Jonas, Hans
1958 *The Gnostic Religion*. Boston: Beacon Press.

Lawall, Sarah N.
1968 *Critics of Consciousness: The Existential Structures of Literature*. Cambridge: Harvard University Press.

Leclercq, Jean, ed.
1957 *Sermones super Cantica canticorum*, XVII/8, in *S. Bernardi Claravallensis Opera*, Vol. 1. Romae: Editiones Cistercienses.

Poulet, Georges
 1961 *Les métamorphoses du cercle*. Paris: Plon.
Sayers, Dorothy
 1964 "Toward a Christian Aesthetic." In *The New Orpheus*, edited
 by Nathan A. Scott, Jr., pp. 3–20. New York: Sheed & Ward.
Soloviev, Vladimir
 1944 *Lectures of Godmanhood*. Trans. Peter Zouboff. London: D.
 Robson; Poughkeepsie, N.Y.: Harmon Publishers.
Rothe, Wolfgang
 1969 "Expressionismus und Theologie." In *Expressionismus als Lit-
 eratur*, edited by Wolfgang Rothe, pp. 37–66. Bern: Francke
 Verlag.
Wahl, Jean
 1948 *Poésie, pensée, perception*. Paris: Calmann-Lévy.

The New Generation of American Directors and Cinema's Subversive Art

John R. May

Binx Bolling in Walker Percy's *The Moviegoer* is perhaps most clearly remembered—doubtlessly because of the novel's title—as the prototype of those whose reality is framed by the illusion projected on the silver screen. The name that Binx gives this phenomenon of moviegoing is "certification." "Nowadays when a person lives somewhere, in a neighborhood, the place is not certified for him," he confesses. "More than likely he will live there sadly and the emptiness which is inside him will expand until it evacuates the entire neighborhood. But if he sees a movie which shows his very neighborhood, it becomes possible for him to live, for a time at least, as a person who is Somewhere and not Anywhere" (61). In *Lancelot*, where the climactic action evolves out of the movie*making* process, Percy's central character, who has been cuckolded by a filmmaker, proves his wife's infidelity by means of an electronic image and thus establishes to his satisfaction the existence of evil in the world. However one would classify the uses and abuses of cinema, there can be no question in life—as in literature—of its profound effect on its audience.

From the earliest days, the magic of film was a factor of its capacity either to represent reality with apparent fidelity or to create the appearance of reality by obvious deception. The simplest of cinematic techniques, though, gave evidence of the deceiver's art. True, there were those who felt that the motion picture camera was merely a glorified still camera, that it would enhance the capacity of the latter to capture reality as the camera had the eye's. On the simplest level, in fact, there is the technological deception itself of effecting the experience of motion by feeding static frames through a projector at standard speed. There is also the potential for conscious deception by the director in the composition of frames, through the convenient use of props or rear projection, for example, but nothing so subversive as the possibilities for the deceptive use of editing or for the effective deception that results from an editor's often unconscious juxtaposition of images.

Film's two principal stylistic tendencies—realism and expressionism—were thus evident in the very first successful experiments in motion pictures before the turn of the century, Louis Lumière's *The Arrival of a Train* and

Georges Méliès's *A Trip to the Moon*. The former delighted with its repre-
sentation of everyday events; the latter achieved the same effect through
trick photography and imagined fantasy. Although most culturally typical
films today are mixtures of these two styles, it is still desirable—indeed nec-
essary for the critic concerned with the religious dimensions of film—to
analyze tendencies toward realism and expressionism and thus to be guided
toward a surer understanding of film. Realist cinema tries to create the illu-
sion that its world is a mirror of the world we live in; the expressionist film
makes no such pretense, but deliberately distorts its presentation of other-
wise commonplace subject matter to make its point. Realism is unobtrusive,
expressionism flamboyant: its technique, especially its use of the camera and
editing, constantly calls attention to itself.

 There are at least two additional senses in which the art of cinema can
be viewed as subversive, and both senses touch upon modes of interpreting
and evaluating film from a religious perspective. One can find the world a
film portrays—its own created world—at odds with one's own values or with
one's view of the everyday world outside. This sense of cinema's subversion
is analogous to T. S. Eliot's criterion of heteronomy; literature, because of its
indirect power over the whole person, can be judged great, Eliot insisted,
only if it adheres to the norms of orthodox theology. Now it was this aspect
of film that the first theological critics dwelt on; their concern was blatantly
ethical and they tended to read the film world as directly reflective of their
own religious vision of the world. The behavior or motivation of the central
character was of prime importance, or the world of the film insofar as it
reflected standard Christian assumptions about retribution and mercy (cf.
Getlein and Gardiner; Schillaci).

 Another and more seriously subversive potential of cinema is a factor of
the inner consistency of a film's world, that precarious balance of assump-
tions about world (which inevitably touch ours at that level of subconscious
experience requisite for the suspension of disbelief) and the authoritative
modes of human behavior that flow from them. Because film's power over
the personality lies precisely in a presumption in favor of fidelity to our
everyday world even though every film's world—whether realistic or
expressionistic—is *reshaped* reality, one must work against the odds to dis-
cern its level of internal consistency of metaphysics and ethos (cf. Gunn).
The obstacles to this perception constitute that subversive quality of cinema
that even popular critics warn about. "Movies are felt by the audience long
before they are 'understood,'" Roger Angell points out. "Going to the
movies, in fact, is not an intellectual process most of the time but an emo-
tional one. Any serious, well-made movie we see seems to wash over us there
in the dark, bathing us in feelings and suggestions, and imparting a deep or
light tinge of meaning that stays with us, sometimes for life" (128). Attention
to the matter of inner consistency is particularly important because a viewer
can so easily be lost in the experience itself or focus on externals of action,

character, or setting and thus miss altogether film's more subtle indices of assumptions about world.

Furthermore, the more a film tends toward realism, the greater its potential for subversion in this regard. We can, for instance, justifiably expect the realistic filmmaker to be generally true to that aspect of reality he claims to portray, even if we would be less justified in demanding that the film conform to our overall system of values or total vision. In the case of the expressionistic film, we are forced to rely almost exclusively upon the norm of inner consistency even if we feel compelled to take exception to the film's direct assault on our sensibility. (Expressionistic films tend toward the openly propagandistic and are, therefore, readily engaged on the level of issues.) That realism as a film style is a more subtle, and thus a more potent shaper of world views is clear from its acknowledged importance as a servant of the Marxist revolution. Once Communism in Russia passed into the rigor of its Stalinist phase, the expressionism of Eisenstein and Pudovkin was deemed elitist and effete because it sacrificed subject matter to technique. Realism, in fact "socialist realism," became the official cinematic style of the Soviet Union.

My concern, then, is with style as it effects world within a film, with specific reference mainly to the merits of a new generation of American directors. My thesis, which is clearly more suggestive than prescriptive, is twofold: namely, that realism as a cinematic tendency employed by some of our promising, though limited younger directors has lent itself usually to subversion, whereas expressionism as a current American cinematic style has proved more successful artistically and less subversive of world. And even where these talented new directors are still struggling for a happier blend of style and vision, they seem inevitably to turn toward integral expressionism.

British critics Michael Pye and Lynda Myles have coined the phrase "movie brats" to characterize the new generation of American directors, who came from suburbia, learned their craft in the principal film schools spawned by the industry (University of Southern California and University of California, Los Angeles), then revolted against the Hollywood establishment and the restrictive conditions imposed by the dying generation of great producers; they include in their group Francis Ford Coppola, George Lucas, Martin Scorsese, Brian DePalma, John Milius, and Steven Spielberg. Though Pye and Myles have come at their project with an admitted socioeconomic bias, they have nonetheless identified two common characteristics of recent American directors—their relative independence from studio control as well as their studied craftsmanship. Broadened in this way, the concept of a new generation of American film directors satisfactorily serves to include both the currently promising and those already successful, where promise and success relate solely to artistic achievement.

The former category includes Woody Allen (*Annie Hall, Manhattan*). Peter Bogdanovich (*The Last Picture Show*), Brian DePalma (*Dressed to*

Kill), William Friedkin (*The French Connection*), George Lucas (*Star Wars*), Paul Schrader (*American Gigolo*), and Martin Scorsese (*Mean Streets*); in the latter group of the artistically successful are Robert Altman (*Nashville, A Wedding*), Hal Ashby (*Shampoo, Being There*), Michael Cimino (*The Deer Hunter*), Francis Ford Coppola (*The Godfather, Apocalypse Now*), Stanley Kubrick (*2001: A Space Odyssey, Barry Lyndon*), Terrence Malick (*Days of Heaven*), and Steven Spielberg (*Close Encounters of the Third Kind*). Although the context will not permit analysis limited even to the major films of each of these directors, selected examples from recent cinema will suffice, I hope, to confirm my hypothesis about the relative merits of realism and expressionism vis-à-vis film art's potential for subversion of world.

What is perhaps least known about Paul Schrader's background as a director is his authorship of a scholarly work on religion and cinema, an effort that Schrader himself has labeled a concession to his Dutch Calvinist training. *Transcendental Style in Film*, which attempts to discern a cinematic style akin to high religious art, draws parallels between the films of Yasujiro Ozu and Zen painting, of Robert Bresson and Byzantine iconography, and Carl Dreyer and Gothic architecture. *Taxi Driver*, a film of Scorsese's that Schrader wrote the screenplay for, and Schrader's first two films, *Blue Collar* and *Hardcore*, left informed audiences wondering about the rift in his art between theory and practice, for these displayed the absence of anything that could even remotely be considered transcendental.

With *American Gigolo*, however, Schrader has matured as a writer-director. Although he employs repeated establishing shots designed to convey the impression of a realistic southern California setting, his Los Angelesque road-, beach-, and apartment-scapes have been isolated by the cool, disconcerting eye of a surrealistic painter. Moreover, the principal character, Julian Kay, is as cold and attractive as the settings we see him in. As played by Richard Gere, Kay is calculating, self-contained, narcissistic, almost mechanistic, but basically human—because ultimately vulnerable—and thoroughly American in terms of D. H. Lawrence's view of the hero of *The Deerslayer* as "the very intrinsic-most American, . . . an isolate, almost selfless, stoic, enduring man" (92). Although Kay, unlike the Deerslayer, is anything but celibate, it is well worth noting that Schrader does not pander to Julian's exploits—the almost selfless manner in which he endures being attractive to women. In fact, we never see him giving pleasure to any woman, except the woman whom he discovers finally he loves and who clearly loves him, and the one scene that shows their love is visually like a stylized series of cubistic frames from Picasso's blue period.

The surreal quality of the cinematography and of the art direction makes it clear enough that Schrader is observing his character with something akin to the objectivity of the microscope, not in the way the microscope distances the viewer from an object, but rather as it scrutinizes for

evidence of pathology. For its final sequence, the film fades to white in and out of scenes, a pattern reminiscent of both Bresson and Bergman, although the latter uses color as often as its absence. The shift is subtle, but nonetheless a confirmation that Schrader's mode is more expressionistic than realistic. Like Bresson, whom he imitates, Schrader has discovered that disparity between abundant and sparse means he feels triggers awareness of the transcendent—in this instance, the mystery of love's power to heal the diseased gigolo.

Although William Friedkin's *The French Connection* is an intelligently made and reasonably plotted film in the realistic vein that assumes, sensibly, that even those who uphold law and order are not necessarily above base motivation, two of his later films are regrettable examples of the abuses of realism. *The Exorcist* is a thoroughly cheap venture, in every sense but financial, into the world of the demonic; its superficial presentation of the problem of evil is both a religiously simplistic view of reality—the source of evil is external to human affairs—and a dreadfully disproportionate filmic world—Satan's violent power is wasted on petty sexual gestures. *Cruising*, on the other hand, despite confirming Friedkin's apparent obsession with sensational subject matter (it chronicles a series of butcher-murders in the midnight world of homosexual sadomasochism), reverts to expressionism in its brief concluding sequence in an attempt to universalize its treatment of evil's presence in society. The shift from protracted sordid realism to a final expressionistic suggestion that the undercover detective himself is, if not *the* killer, at least *a* killer, is both disconcerting and unwarranted because, stylistically, it offers too little too late. The film's apparent equation of evil and perverted sexual violence is undoubtedly unintentional but nonetheless subversive; what may offend the sensitive viewer even more is the suggestion that there is a potential for sadomasochism in us all—since all of the film's survivors are infected with it. Finally, because the only "normal" homosexual, according to the film's standards, dies violently (he explicitly eschews the sadomasochistic subworld), the impression remains that all homosexuals live a potentially dangerous life since the "homosexual world," to use the unfortunate phrase from Friedkin's introductory disclaimer, thrives on barely concealed violence.

Dressed to Kill, like all of Brian DePalma's earlier films, is weakest on the level of ideas; plausibility is strained even more so than in *Carrie* and *The Fury*, where he attempts realistically to develop characters with bizarre preternatural gifts. Since *Dressed to Kill* deals with everyday people and commonplace problems—at least for a large, contemporary metropolitan area—one is inclined to wonder about or be annoyed at the absence of that believable motivation that is a necessary ingredient of realism. Yet the very absence of character delineation is a possible clue to DePalma's developing purpose. He does not seem to be concerned with the underside of reality, but with its appearances. It is foolish, if not futile, to explore the deep

recesses of human drives: these remain ultimately clothed in mystery any-
way, DePalma's style implies.

Added confirmation of the fact that technique rather than subject matter
is more significant to DePalma is buried in the film's silly (if realistic)
assumptions about sexual styles and their inevitable consequences. The call
girl's success in pursuing the murderer, and her absolute freedom from harm
as contrasted with the fate assigned to the hidden drives of a middle-class wife
and mother, point unequivocally to an absurdist world in which one is far
better off living by sex than merely dabbling in it. But the construction of a
believable world in which behavior and meaning fit together reasonably could
not be farther from DePalma's intention. The subjective camera, the look of
outer regard, a hand in the frame—he has mastered these and all the devices of
suspense and shows a decided penchant for exploiting their expressionistic
potential. For DePalma, technique in the genre of suspense may actually be all
the message there is. Around the corner or beyond the door, *Dressed to Kill*
suggests, is life's unexpected inversion of delight and terror, and surely no one
will consider that subversive of world. We must learn, DePalma's craft
testifies, to observe keenly even if doing so scares us out of our wits or surprises
us into peals of nervous laughter.

Hal Ashby's film *Being There*, based on Jerzy Kosinski's novel, is both a
parody of the power the media exert in our lives as well as a paradigm of
the film artist's capacity to satirize world effectively and purposefully
through the use of expressionism. *Shampoo* and *Coming Home* were prior
evidence of Ashby's achievement as a director. *Shampoo*, itself a first-rate
satire on American sexual mores, is set ironically against the quietly apoca-
lyptic background of Nixon's ominous 1968 presidential election campaign
and victory; *Coming Home* is Ashby's indictment of the Vietnam war in its
effect upon the lives of three people, whose love triangle ends melo-
dramatically—a weak, though clear reflection of the war's real tragedy. In
Being There, a man whose only name is Chance has worked all of his life as
a gardener for someone referred to simply as "the old man" (not the least of
the novel/film's facetious transfigurations of the Jesus narrative). Although
Chance seems to have only a limited awareness that there *is* a world beyond
the garden walls, whatever he has learned of it—when he is rudely thrust
out into it after the old man's death—has come to him through television.

While the substance of both the novel's and the film's critique of our
culture is that we are media-dominated, if not obsessed, film is obviously better
suited as a medium for the presentation of such material inasmuch as it
proceeds by the juxtaposition of visual images. Kosinski's satire is almost
devoid of specific references, especially to television; since he has written a
fable, its narrative is picked clean, with only the threads of generic satire left
hanging. The film cuts constantly, and pointedly, to television images (the
expressionistic juxtaposition of narrative continuity and media commentary is
the heart of its meaning) because Chance turns on a set whenever he can and

wherever he finds one; the space control is his magic wand. All types of programming—cartoons, news, films, advertisements, quiz shows, and children's education programs—have the same claim on reality for him; more often than not the television image is expanded to cover the whole movie screen with its graininess, and the rhythmic punctuation of the film with carefully edited sequences from the electronic box provides a transparent paradigm of the fabric of illusion and reality that clothes unreflective, technological man. *Being There* capitalizes, finally, on the satire inherent in television's omissions as well as its deeds. Television is, of course, notoriously quiet (or was until recently) about the aftermath of the passionate kiss. Has too much television, Ashby following Kosinski jests, made Chance—and us—sexually impotent? What borders on the absurd at the level of superficial visual realism makes profound sense at the level of the film's expressionistic meaning: it is the mind that is left limp by the experience.

George Lucas's *Star Wars* is refreshing and innocent in its appeal to our primal instincts for good, but all that it really adds to the archetypically flat characterizations of classic westerns and detective films is the stunning display of space-age visual technology. It is of course basic expressionism masked as realism: its superficial realism enhances its excitement and appeal; its inner world of absolute dualism is nonetheless perfectly consistent, as effective expressionism should be. Once the primal emotions favoring the triumph of good over evil are purged, however, there is little left to challenge the mind. Even though its special effects are impressive in quality and superior in quantity to Stanley Kubrick's *2001: A Space Odyssey* (380 to 35, according to publicity), the educated moviegoer cannot live on special effects alone; and it is doubtful that any one of the nine installments Lucas has planned will ever surpass the sheer brilliance of Kubrick's film in the genre of space fantasy. Certainly *The Empire Strikes Back* (which Lucas had Irvin Kershner direct), the sequel to *Star Wars*, has not done it although Lucas has mitigated somewhat the absolute dualism of the earlier film. *2001* remains unrivaled as expressionistic science fantasy that is both metaphysically profound, in its portrayal of man's enduring infancy in the face of mystery, and artistically hypnotic in its masterful symmetry of sight and sound.

Steven Spielberg, the youngest of this new generation of American directors, has already created a realistic classic touching fantasy—a film that deals with the impact of space on ordinary human lives. As realism, *Close Encounters of the Third Kind* is perhaps the exception that proves our rule about the ascendancy of expressionism (although a case could also be made for Robert Altman's success with realism). Especially as revised in *The Special Edition, Close Encounters* is a visual celebration of what Gabriel Marcel calls fundamental hope, a basic affirmation of the hopefulness of human existence. Spielberg skillfully builds two separate lines of narrative—the odyssey of ordinary people drawn by the extraordinary, and the efforts of a team of

specialists to interpret a series of related sightings of UFOs and various physical evidence of visitors from other planets—toward a spectacular climax in the descent of the alien spaceship and actual contact with its cautious but friendly occupants. Although Spielberg uses realism seductively in favor of the presumed existence of extraterrestrials, the sophisticated viewer, wary of UFOs, but alert to the film's exuberant mixture of ritual and play, will willingly be seduced too by Spielberg's more fundamental assumption, one that can offend no religious sensibility; namely, that the universe is indeed radically and happily benign.

It has obviously not been my intention here to judge the intentions of those directors whose efforts, in my estimation, have succumbed to the pitfalls of realism, but rather to indicate both that film style necessarily reveals the limits of an artist's vision and that his limited vision inevitably appears subversive in proportion to its claim on reality.

WORKS CONSULTED

Angell, Roger
 1980 "Mean Streets." *The New Yorker* 55/53:126–30.

Arnheim, Rudolf
 1957 *Film as Art*. Berkeley: University of California Press.

Bazin, André
 1967 *What is Cinema?* Trans. Hugh Gray. Berkeley: University of California Press.

Eliot, T. S.
 1936 "Religion and Literature." In *Essays Ancient and Modern*. New York: Harcourt, Brace and World.

Getlein, Frank, and Gardiner, Harold C.
 1961 *Movies, Morals and Art*. New York: Sheed and Ward.

Gunn, Giles
 1975 "Threading the Eye of the Needle: The Place of the Literary Critic in Religious Studies." *Journal of the American Academy of Religion* 43:164–84.

Kracauer, Siegfried
 1960 *Theory of Film: The Redemption of Physical Reality*. New York: Oxford University Press.

Laeuchli, Samuel
 1980 *Religion and Art in Conflict*. Philadelphia: Fortress Press.

Lawrence, D. H.
 1923 *Studies in Classical American Literature*. New York: Thomas Seltzer.

Percy, Walker
 1962 *The Moviegoer.* New York: Popular Library.
 1977 *Lancelot.* New York: Farrar, Straus and Giroux.

Pye, Michael, and Myles, Lynda
 1979 *The Movie Brats: How the Film Generation Took over Holly-wood.* New York: Holt, Rinehart, and Winston.

Schillaci, Anthony
 1970 *Movies and Morals.* Notre Dame: Fides.

Schrader, Paul
 1972 *Transcendental Style in Film.* Berkeley: University of California Press.

"*Muthos* is mouth": Myth as Shamanic Utterance in Postmodern American Poetry

Daniel C. Noel

To state briskly and bluntly what I have not the space to lead into with all the appropriate supporting references and qualifications: Modern literary criticism has neglected the etymology of the term "myth" as well as the anthropological emphasis on the ritual aspects of myth./1/ To be sure, the reflection of ancient ritual patterns in the themes of modern novels or poems has been discerned by critics with Frazer's *Golden Bough* or some more recent study of primitive ceremonials at their fingertips. But even those literary interpreters known as "archetypal" or "myth critics" have largely ignored the presence of a line of American poets who go beyond faintly echoing primitive ritual motifs to an active interest in anthropological scholarship and a penchant for oral enactment which makes their work a ritual performance in itself. Here the etymology of "myth," where *muthos* means any word conveyed by oral expression, returns to become a guiding principle.

As Charles Olson—in many ways the father of this line of poets— translates the Greek, "*muthos* is mouth," and his followers' poetry has come to constitute a kind of shaman song uttered beyond the antimythological skepticism of modern consciousness. Moreover, since that very skepticism virtually *defines* modern consciousness, the etymological and anthropological connection to myth in some recent American poetry offers what I would claim is a *post*modern opportunity—although I will be able only sketchily to imply the ramifications of such a postmodernity in the present essay.

What I want to treat more explicitly, if still all too briefly, is the new connection, the alternative avenue, I see opening up between myth and poetry. To continue with Charles Olson's insight:

> *Muthos* is mouth. And indeed *logos* is simply words in the mouth. And in fact I can even be stiffer an etymologist and tell you that if you run the thing right to the back of the pan and scraped off all the scrambled eggs and there's still rust on it and you can't wash it, you'll find that what you have to say *mutbologos* is, is "what is said of what is said"—as suddenly the mouth is simply a capability, as well as words are a capability, they are not the

ultimate back of it all. . . . And that . . . he who can tell the story right has
actually not only, like, given you something, but has moved you on your own
narrative. (1971:47–48)

Now some of this, as is notorious with Olson, sounds rather needlessly
enigmatic. But it is at least clear in saying that Olson (drawing on the schol-
arship of classicists Jane Harrison and J. A. K. Thomson) felt something very
important lay in the etymologies of "myth" and "mythology," something
which had to do with oral enactment, so that the oft-noted story or narrative
element of myth becomes, for Olson, the right *telling* which makes a certain
kind of contact with a hearer.

The contents or themes of myth—including their supposed supernatural
focus—seem subsidiary here, as do myth's explanatory function and ficti-
tious character as claimed by even the most sympathetic modern interpre-
ters. The "right telling" which Olson emphasizes instead is related to what
he called "causal" mythology and to what the poet Robert Duncan has
termed Olson's "essentially magic view of the poem." In her introduction to
Olson's *The Special View of History* Ann Charters quotes Duncan's com-
ment, to which he adds, "not magic in the sense of doing something that you
mean to do in the end, but in the sense of causing things to happen" (Olson,
1970:11). This, again, is Olson's insistence on myth as utterance which moves
you on your own narrative.

It is also an emphasis on the causal or active which Duncan himself
shares. In an essay significantly titled "The Truth and Life of Myth in
Poetry," he makes the following statement to that effect, while also main-
taining the focus on relevant etymology: "If *poiein*, the concept of the poet
as fashioning the poem, making a world of the poem, enters into my poetics,
and it does; so also does the Celtic idea of the poet as bard, the chant that
enchants, the myth or tale as *spell* and words that cast images on the
mind . . . " (43). Duncan's declaration provides something of a link between
oral performance and shamanic magic, which is partly to say a link between
the etymology of "myth" or related terms and the anthropology of ritual.
This is an interconnection I want to explore further below.

However, it is necessary first to pause in order to consider another facet
of myth in poetry. Ann Charters has suggested that for Robert Duncan as
for another of Olson's literary heirs, Denise Levertov, myth would be any
personal experience of heightened significance. Let me quote at some length
from one of the latter poet's essays to see what this "personal approach"
might imply for the points about myth stressed so far. Levertov has this to
say:

Examination of my own work for the presence of myth has confirmed me in
my belief that myth arises from within the poet and poem rather than being
deliberately sought. I think I may have shown that dreams may be a more
frequent and—in an age when the Western intellectual, along with the rest of

the people, is rarely in live touch with a folkloric tradition of myth and
epic—a more authentic source of myth in poetry than a scholarly knowledge
would be unless that scholarly knowledge is deeply imbedded in the imagina-
tive life of the writer. (29)

The reference to dreams as a source of myth in poetry recalls, of course, the
contribution made by Freud and Jung in clearing out a subterranean con-
duit between modern individuals and the collective and anonymous myths
of the ancient past. This has obviously been a channel giving the modern
artist access to vital material, and Levertov is right to bring up the depth-
psychological factor in relation to the role of myth in poetry.

On the other hand, we today take the dream to be a private source,
segregated from the public waking life of the community, the *polis* or
ethnos. And it is precisely this privatization which strikes me as yet another
limitation of myth in modern poetry, or in poetry—or criticism—operating
as a province of modern consciousness. Like the notion of myth as fictitious
narrative, the idea of myth as personal dream material finally imposes upon
myth a second-class citizenship in the cognitive domain of modernity, and
for myth to assume a more central role as knowledge it would need to
become *waking* dream and *public* dreamtime. Or, to put it another way, the
modern boundaries between social daylight reality and the private dreams
of night would have to be experienced as less rigid—without the concomi-
tant psychopathologies which such an experience has generally entailed for
modern consciousness.

I believe the poets whose work I am surveying (and surveying almost
entirely by way of their poetics, given spatial strictures) are effecting just
such a *post*modern revaluation of myth. Curiously, although these poets lack
the sort of classical education which served earlier modern poetic mythmak-
ers, it is scholarly knowledge of a sort which aids in the postmodern connec-
tion as much as dream material does. Denise Levertov admits that there are
poets—and she specifically names Duncan and Olson—"in whom scholarship
is an extension of intuitive knowledge" (29). It was noted above that etymol-
ogy and anthropology are often joint sources of myth for these poets, and
now I want to turn to several others whose familiarity with etymological and
anthropological scholarship, while far from classical or formal, is indeed
"deeply imbedded," as Levertov has put it, in their imaginative lives.

David Antin is both an art critic and a poet who performs spontaneous
"talk poems." The boundaries between the daylight *polis* and the personal
dreams of night have just been discussed, and earlier it was stressed how
close to the sense of "talking" is the etymology of "myth." Antin deals with
these same issues in his collection called, aptly enough, *Talking at the
Boundaries*: talk poems transcribed, without the interference of conven-
tional punctuation, from taped performances. What follows is an especially
pertinent sample of his poetry, where the boundary between discussing and
embodying myth is also being blurred:

theres a word close to talking a word that may finally mean talk-
ing but used to have a very grand meaning a word myth which
has a very grand meaning for most people and i know that robert
duncan has given a lot of attention to the word "myth" the one definition
he did leave out when he rehearsed the definitions for the middle voice greek
verb *mytheomai* is to talk which it was it was a verb "to talk" and
"to tell" and it was a verb meaning "to put a rap in the air" when
odysseus the great con-man the trickster gets up to talk in coun-
cil he "myths" and he "myths" regardless of whether he "myths" the
way nobody else remembers and i think the word may not be very preju-
dicial at that point differently now . . . the word "myth" is the name
given to the lies told by little brown men to men in white suits with bin-
ocular cases because nobody knows of the myth that the man in the white
suit believes there is one important thing about a story told
you by a little brown man if the story sounds as if you could have
observed it yourself you being the man in the white suit you wouldnt
call it a "myth" youd say "he told me what happened" youd say "he
told me a fact." (5–6)

It occurs to me that the situation Antin is "mything" about here is a late-
modern boundary skirmish in regard to myth versus fact which his very sort
of active mything is designed to dissolve or transcend. Also, when Denise
Levertov spoke of the rarity of our being "in live touch with a folkloric tra-
dition of myth and epic" she, too, was indicating a modern impasse which
may be less absolute now, over a decade after she wrote those words. Not
only are there poets who are talking and telling in bardic actualization of
their etymological researches on terms like "*muthos*," "*logos*," and "*poiein*";
there are also poets (sometimes they are the *same* poets) whose involvement
in anthropological scholarship has seemed to afford their poetry the benefit
of a "live touch" with one or more myth traditions.

Clearly in the scholarship and poetry of a Gary Snyder or a Jerome
Rothenberg it is not "lies told by little brown men," however quaint, that we
are given. Rather, in an important sense the "primitive" poetries these two
men draw upon are seen as "tellings of what [actually] happened."

In 1971 Gary Snyder was interviewed by Nathaniel Tarn, himself a
trained anthropologist as well as a poet, about the compatibility and mutual
relevance of anthropology and literature. The interview is conducted as
though Snyder were one of Antin's "little brown men" and Tarn were the
man in the white suit with the binocular case. The interview is in fact called
"From Anthropologist to Informant: A Field Record of Gary Snyder." In it
Snyder refers to his bachelor's thesis for Reed College—"Dimensions of a
Myth"—and his contacts with and study of the Indians of the Pacific
Northwest, his attraction to the writings on California Indians of Jaime
de Angulo, his work in Chinese language studies and his later per-
sonal involvement in Buddhism and the environmental movement, and his
brief career as a graduate student in anthropology at Indiana University
(1972:104–9).

Snyder left the formal study of anthropology because, as he tells Tarn, "I didn't want to be the anthropologist but the informant" (1972:109), except of course the two perspectives are blended in Snyder's poetry, and Tarn uses the term "anthropoets" to describe Snyder, himself, and Jerome Rothenberg (1972:108).

All three, along with several other poets and scholars, including anthropologists such as Dennis Tedlock, Stanley Diamond, and Dell Hymes, were involved in the founding of *Alcheringa: A Journal of Ethnopoetics* in the early 1970s. The title is from Australian aborigine culture and denotes that "dreamtime" referred to above in the context of suggesting a postmodern possibility for myth to be the public waking enacted dream. During the past decade *Alcheringa*, under the editorship of Rothenberg and Tedlock, mounted an exciting attempt to put us all in "live touch with folkloric traditions of myth and epic" (echoing again Levertov's formulation) by presenting translations of various ancient or contemporary tribal poetries as reworked from the often bowdlerized English of earlier anthropologists by current practicing "anthropoets." A particular concern of *Alcheringa* was to experiment with so-called "total translation" or "total transcription": the effort to replicate, through typography and the placement of print on the page, the total sound environment of *oral* renditions by various informants (cf., for example, Goodwin), so that once more we come to myth as words in the mouth—chanting, talking, and right telling—and to myth as closely tied up with ritual enactment.

The emphases of *Alcheringa* have also been those of Jerome Rothenberg's work as an anthologist whose collections of primitive poetries such as *Technicians of the Sacred* (the title a definition of the shaman borrowed from Mircea Eliade's normative study) and *Shaking the Pumpkin* (focusing on Amerindian material) have influenced his own sense of the boundaries of European and American poetry (as in the anthologies *Revolution of the Word* and *America, A Prophecy*) and his *vocation* as a poet with deep roots in the Jewish tradition. The ancestral Jewish sources are explored in his recent book of poems *Poland/1931* as well as in the anthology he calls *A Big Jewish Book: Poems & Other Visions of the Jews from Tribal Times to Present*. Rothenberg was assisted on this last project by Harris Lenowitz, a scholar of Middle Eastern languages and linguistics, and Charles Doria, a classicist, both of whom were also contributing editors of *Alcheringa*. In turn, Rothenberg has written a "Pre-Face" to the Doria and Lenowitz anthology, *Origins: Creation Texts from the Ancient Mediterranean*.

It is in the latter piece that Rothenberg points to "the development, the unfolding, changing recovery of cultures & civilizations, that is now to enter its latest phase. . . . A historical reconstruction to start with, it was at once more than that: a present concern turned backward, to see the past anew & to allow it to enter the process of our own self-transformation. 'We live,' Charles Olson once wrote . . . 'in an age when inherited literature is being

hit from two sides, from contemporary writers who are laying bases of new discourse at the same time that . . . scholars . . . are making available pre-Homeric & pre-Mosaic texts which are themselves eye-openers'" (xiii). We have seen that sometimes the scholars and the writers are combined in the same people, and in Rothenberg's case, although he is not a trained anthropologist he has lived among the Seneca Indians of upstate New York in order to make available some Native American chants and poems that are also eye-openers (cf. 1978b). His work with the Senecas convinced him more than ever of the centrality of shamanic utterance to the vocation of the contemporary poet.

He speaks for all the poets surveyed in the present essay—and perhaps for others such as Robert Bly and Allen Ginsberg—when he says that:

> Among us the poet has come to play a performance role that resembles that of the shaman. . . . The poet like the shaman typically withdraws to solitude to find his poem or vision, then returns to sound it, give it life. He performs alone . . . because his presence is considered crucial & no other specialist has arisen to *act* in his place. He is also like the shaman in being at once an outsider, yet a person needed for the validation of a certain kind of experience important to the group. . . . The act of the shaman—& his poetry—is like a public act of madness. It is like what the Senecas, in their great dream ceremony . . . called "turning the mind upside down." (1976:11)

In his effort to make contact with such powers as the Senecas had expressed and embodied, Rothenberg went so far as to perform some of their songs or chants himself, feeling foolish as a Brooklyn Jew intoning Seneca sounds while shaking a gourd rattle, but willing to risk the embarrassment in the interest of underscoring the continuity now discernible between a tribal ritual and a contemporary poetry-reading.

Anne Waldman, herself a poet whose long chant *Fast Speaking Woman* was composed and performed in direct adaptation of the mushroom-induced shaman songs of the Mazatec Indian healer Maria Sabina (1979:315), makes a similar point in recalling her first hearing of Charles Olson, talking and reading at the Berkeley Poetry Conference in 1965. Her statement also adequately sums up the nature of the postmodern etymological and anthropological linkage I have been seeking briefly to describe here, myth's new role in poetry.

After hearing Olson, she remembers, "I could really see the poet as a tribal shaman, speaking and moving and being embarrassing not just for himself or herself, but for you, the audience" (1979:279).

NOTE

/1/ I am indebted in what follows to a little essay, as far as I know unpublished, by Richard Greene, whom I do not know. It was written in 1966, and I found, or refound, it in the mid-1970s about the time I also encountered William Righter's

definitive (and rather despairing) assessment of myth criticism. Greene's essay, which damns the literary usefulness of etymological and anthropological approaches to myth with faint attention, stressed those presumed major differentia of myth—its character as fictitious narrative, its supernatural focus, its etiological function—in such a way as to convince me that mainline literary criticism was in league with modern consciousness generally to denigrate and devitalize myth even while seeming to make approving gestures in its direction. At least that was the conclusion forced upon me when I compared Greene's apparently representative critical orientation with the practice and the poetics of the poets I deal with in the current essay, which I presented in an earlier form at the Eastern International AAR meeting in Syracuse in April 1980.

WORKS CONSULTED

Antin, David
1976 *Talking at the Boundaries.* New York: New Directions.

Atlas, James
1980 "New Voices in American Poetry." *The New York Times Magazine*, 3 February, pp. 16, 19–20, 24, 51–52.

Charters, Ann
1971 "I, Maximus: Charles Olson as Mythologist." *Modern Poetry Studies* (Buffalo) 2:49–60.

Doria, Charles, and Lenowitz, Harris, eds.
1976 *Origins: Creation Texts from the Ancient Mediterranean.* Garden City, NY: Anchor Press/Doubleday.

Duncan, Robert
1968 "The Truth and Life of Myth in Poetry." In *Parable, Myth, and Language*, edited by Tony Stoneburner. Cambridge, MA: Church Society for College Work.

Frye, Northrop
1967 "Literature and Myth." In *The Relations of Literary Study*, edited by James Thorpe. New York: Modern Language Association.

Goodwin, W. T.
1972 "From 'Easter Sunrise Sermon' (total transcription by Peter Gold)." *Alcheringa*, no. 4:1–13.

Greene, Richard
1966 "Myth in Literature: An Elementary Essay." Unpublished essay (mimeographed copy: three pages).

Levertov, Denise
1968 "A Personal Approach." In *Parable, Myth, and Language*, edited by Tony Stoneburner. Cambridge, MA: Church Society for College Work.

Olson, Charles
 1969 *Causal Mythology*. San Francisco: Four Seasons Foundations.
 1970 *The Special View of History*. Berkeley: Oyez.
 1971 *Poetry and Truth*. San Francisco: Four Seasons Foundation.

Righter, Charles
 1975 *Myth and Literature*. London and Boston: Routledge & Kegan Paul.

Rothenberg, Jerome
 1969 Ed., *Technicians of the Sacred: A Range of Poetries from Africa, America, Asia & Oceania*. Garden City, NY: Doubleday/Anchor Books.
 1972 Ed., *Shaking the Pumpkin: Traditional Poetry of the Indian North Americas*. Garden City, NY: Doubleday/Anchor Books.
 1974a *Poland/1931*. New York: New Directions.
 1974b Ed., *Revolution of the Word: A New Gathering of American Avant Garde Poetry 1914–1945*. New York: Seabury Press.
 1976 "Pre-Face To A Symposium On Ethnopoetics." *Alcheringa* New Series 2:6–12.
 1978a Ed., *A Big Jewish Book: Poems & Other Visions of the Jews from Tribal Times to Present*. Garden City, NY: Anchor Press/Doubleday.
 1978b *A Seneca Journal*. New York: New Directions.

Rothenberg, Jerome, and Quasha, George
 1974 Eds., *America A Prophecy: A New Reading Of American Poetry from Pre-Columbian Times to the Present*. New York: Vintage Books.

Tarn, Nathaniel
 1972 "From Anthropologist to Informant: A Field Record of Gary Snyder." *Alcheringa*, no. 4:104–13.
 1975 *Lyrics for the Bride of God*. New York: New Directions.

Vickery, John B., ed.
 1966 *Myth and Literature: Contemporary Theory and Practice*. Lincoln: University of Nebraska Press.

Waldman, Anne
 1975 *Fast Speaking Woman*. San Francisco: City Lights Books
 1979 "My Life a List." In *Talking Poetics from Naropa Institute*, vol. 2, edited by Anne Waldman and Marilyn Webb, pp. 293–322. Boulder & London: Shambhala.

The Promise and the Pitfalls
of Autobiographical Theology

Richard L. Rubenstein

The telling of one's own story has had an important place in the history of Western religion. There is a strongly autobiographical element in the letters of St. Paul; few writings have had the abiding impact of the *Confessions* of St. Augustine, and it is impossible to understand the history of Methodism without some knowledge of the personal religious history of John Wesley. Moreover, in American popular religion personal testimony plays a significant role. Thus, at first glance, autobiography would appear to be peculiarly suited to the theological enterprise, especially in religions in which history is regarded as of crucial importance. Nevertheless, the very nature of the theologian's vocation may render it difficult, if not impossible, to utilize autobiographical writing for the expression of his or her ideas. There may be an inherent contradiction between the requirements of honest autobiography and the role of the theologian, again especially in the religions of history.

There are, of course, very real differences between the attitudes towards autobiographical theology even within the major Western religious traditions. Autobiographical writing has been historically more at home in Christianity than in Judaism. In Judaism one can discern an autobiographical element in the literary remains of some of the prophets, such as Hosea and Jeremiah. Nevertheless, in the rabbinic period one discovers little, if any, resort to autobiography. The outstanding example of a Jewish religious thinker whose thought contains an autobiographical component at the beginning of the rabbinic period is, of course, Paul of Tarsus, and his story is one of turning away from the predominant interpretation of faith and institutions of Judaism in his time. Normative rabbinic Judaism has not proven to be a particularly fertile ground for the expression of personal religious testimonies. The reasons for this may include the following:

(a) First and foremost, normative rabbinic Judaism tended to stress the aspirations of the group rather than the individual and his personal religious story.

(b) Insofar as normative Judaism stressed conformity to the community's typifying patterns, which were regarded as divinely ordained behavioral norms, the acculturation process tended to downgrade the cultivation of uniquely personal modes of religious experience.

(c) Although much has been written about the *baal t'shuvah*, the person from the margins of Jewish religious life who repents his old ways and comes to accept traditional norms, there is absolutely no place in Judaism for the kind of dramatic rebirth experience that is at the heart of Christian conversion. By dying in the old self and being reborn a new man in Christ, the Christian personally identifies himself with the death and Resurrection experience of Jesus. The central affirmations of Christianity, namely, that Christ died and rose again and that the Christian identifies with Christ's death and Resurrection through baptism, provide the basic paradigm for religious autobiography in Christianity, in which the turning point is always the moment at which the self-defeating ways of the old man are abandoned, and the Christian achieves new life and salvation in Christ. In Judaism, there can be changes in attitudes and behavior, coupled with growing wisdom, but never the kind of dramatic rebirth experience that is at the heart of Christian conversion. Jewish religious development is more likely to be unilinear than those branches of Christianity that value highly conversion and rebirth.

(d) As the religion of a radically insecure community, Judaism tended to discourage individualism in behavior and overt expression of spontaneous emotions.

(e) The intellectualism and scholasticism involved in the training of the religious elite also discouraged the kind of individualism that would have been suitable for autobiography. The sheer magnitude of the literature to be mastered in order to qualify as a religious authority demanded that the candidate begin training at a very early age and remain undeviatingly devoted to its pursuit until completion. Also, in Eastern Europe it was often the practice for rabbinic candidates to enter into an arranged marriage with a suitable bride. There was little opportunity for the impression of individualistic behavior or explicitly heterodox beliefs that might hold a reader's interest in an autobiography.

Nevertheless, whatever the constraints on belief and conduct in Judaism may have been in the past, it was inevitable that some contemporary Jewish religious thinkers would respond to the unprecedented trauma of their era in highly personal terms and that they would give expression to that response in published writings. I include myself and Elie Wiesel in that category. In the era that has witnessed both Auschwitz and the rebirth and the continuing travail of the State of Israel, I found it impossible to separate personal belief, religious and communal history, and autobiography. Nor was I alone. On the contrary, it is my conviction that there is a strong biographical element, whether expressed or implied, in all contemporary Holocaust theology. This is

especially evident in the novels of Elie Wiesel./1/ When Jewish theologians reflect on the religious significance of the Holocaust, there is a deeply personal element in their thinking.

In my own case, I first raised one of the fundamental questions of what was to become known as Holocaust theology; namely, the question of whether it is possible to affirm traditional faith in the God of covenant and election in view of the Holocaust, in an autobiographical essay in *After Auschwitz* (1966) entitled "The Dean and the Chosen People." In that essay I describe my encounter with Dean Heinrich Grüber, then dean of the Evangelical Church in East and West Berlin, during the Berlin Wall crisis of August 1961. The dean averred that it was God's will to send Adolf Hitler to punish the Jews at Auschwitz. I understood immediately that the dean was not speaking out of malice but was reiterating the old biblical theology of covenant and election and applying it to events of the twentieth century. It was the shock of hearing the dean speak as he did in the apocalyptic atmosphere of a war crisis in the city that had been the capital of the Third Reich that caused me to rethink my entire theological position. Had I conversed with Dean Grüber in less heated circumstances in another place, I doubt that his words would have had the same impact. Hence, when I discuss the issue of traditional faith and the Holocaust, I usually feel compelled to share with my readers the dramatic circumstances in which I first experienced the challenge to that faith. I have only one regret about the way I describe the encounter in *After Auschwitz*. I took a large number of photographs of the people, the mass meetings, the military, and the dean himself during that visit to Berlin. They convey more graphically than I can in words the atmosphere of anxiety and terror that pervaded the divided city. Frequently, when I tell of the counter with the dean in lectures, I show slides of these photographs. I am very sorry that I did not include these pictures in *After Auschwitz* to illustrate the autobiographical essay.

There is also an autobiogaphical element in the way *After Auschwitz* is organized. The book itself is largely a collection of essays written over a number of years, but each essay is preceded by a brief introductory note describing the circumstances under which I came to write it. I added these notes at the suggestion of my editor, Mr. Lawrence Grow, who felt strongly that the subject matter of the book called for this autobiographical element.

Insofar as autobiography has found a place not only in my writing but in contemporary Jewish theology, it has been a result of recent Jewish history. Nevertheless, precisely *because Judaism is a religion of history, post-Holocaust Judaism may ultimately prove to be inhospitable to autobiographical theology*. As we know, religions of history do not simply assert the existence of God. They assert that he has quite explicitly manifested himself in concrete historical events. Moreover, that which divides Judaism and Christianity is the distinctive interpretation each tradition gives to the ways in which God is said to have acted in history. For our purposes, there is no reason

to assess the merits of either the Jewish or the Christian views. It is, however, important that we recognize a unique and critical problem shared by all religions of history that is absent from other types of religion. By placing so great an emphasis on that claim that concrete historical events express God's will, religions of history are uniquely subject to crises of disconfirmation, or, at the very least, disconfirming challenges. For example, if a group comes into being because a number of individuals become convinced that God intends to destroy the world on a certain date, the members' shared experience of preparing themselves spiritually for the end may create enduring bonds of fellowship that make the group an important part of their lives whether or not God actually does intend to destroy the world. If the date of destruction passes without event, the members may still want to continue their fellowship even though their ostensible purpose was spiritual preparation for the end. Should the purpose be recognized as without substance, the group might dissolve leaving an emotional vacuum in the lives of the members. The failure of the world to end according to expectation will be experienced as a crisis of disconfirmation. In order to preserve the integrity of the group its members are likely to attempt to prove that the original expectation, when properly understood, had been correct all along.

As is well known, social psychologist Leon Festinger and his colleagues developed the theory of cognitive dissonance by observing such a group. When the expectation of the end of the world failed to be realized, the members of the group Festinger observed had a strong emotional investment in its continuation. As a result, they developed a series of rationalizations to explain away the disconfirming evidence of the absence of world catastrophe. Festinger and his colleagues held that, in the face of *dissonance* between a group's belief and disconfirming items of information, a group that is strongly committed to its belief will find some way to reduce the dissonance between the belief and the disconfirming evidence. In the case of the group under study most members continued their fellowship by formulating an ideology that explained why the apparent absence of catastrophe nevertheless confirmed the group's original position. As difficult as the challenge might seem, a way was found to meet it.

Over the years I have come to identify dissonance-reduction as one of the most important functions of a theologian within the Judaeo-Christian tradition (Rubenstein:1979). I have concluded that the theory of cognitive dissonance throws important light on the role and function of the theologians in the religions of history. Whenever established beliefs, values, or collectively sanctioned modes of behavior appear to be in conflict with information available to the members of the community, it will be the task of the theologian to reduce the dissonance. This role is especially important in cultures such as our own whose religious beliefs are vulnerable to empirical disconfirmation by historical events that are perceived as inconsistent with traditional notions of justice and divine governance. The theologian in both

Judaism and Christianity is likely to be an intellectual professional who is skilled in the art of dissonance-reduction.

The dissonance-reduction function of the theologian is especially important in contemporary Judaism. The Holocaust is an event which can be regarded as presenting a profound challenge to traditional notions of divine governance. The Holocaust may also present an especially strong disconfirming challenge to the traditional belief in the election of Israel. Much of contemporary Jewish theology can be seen as an attempt to reduce the dissonance between the stark evidence of recent history and traditional Jewish modes of religious self-interpretation.

But if dissonance-reduction is fundamental to the task of the theologian, is it consistent with honest autobiography? Honest autobiography has its own canons that have very little to do with the requirements of traditional theology. Relevance, truthfulness, and candor are the first requirements of autobiography. Unless the story has relevance beyond the private life of the author, there is no point in publishing it. This, however, presupposes that the author has been truthful with his readers. But to what degree is truthfulness possible when the author is being brutally candid in telling his tale? In his novel *Nausea*, Jean-Paul Sartre points to a problem which is intrinsic to the process of story-telling. He depicts his protagonist, Antoine Roquentin, as writing in his diary:

> Nothing happens while you live. The scenery changes, people come in and go out, that's all. There are no beginnings. Days are tacked on to days without rhyme or reason. From time to time you make a semi-total: you say: I've been travelling for three years. Neither is there any end: you never leave a woman, a friend, a city in one go. . . .
>
> That's living. But everything changes when you tell about life; it's a change no one notices: the proof is that people talk about true stories. As if there could possibly be true stories; *things happen one way and we tell about them in the opposite sense.* You seem to start at the beginning: 'It was a fine autumn evening in 1922. I was a notary's clerk in Marommes.' And *in reality you have started at the end.* It was there, invisible and present, it is the one which gives to words the pomp and value of a beginning. . . . We forget that the future was not yet there. (Italics added: 57)

According to Sartre, it is impossible to tell a story without distortion. Things do not and cannot happen the way we tell them. We impose a meaning and a coherence on the narrative that was seldom, if ever, present when the events were being directly experienced. Moreover, even accurate memory plays tricks. Thus, even if we are firmly resolved to tell the truth we may not be able to.

The difference between events and their description discussed by Sartre is, of course, the difference between immediate experience and reflection. The difference is always operative whenever an author tells of the past in the light of what he knows in the present. Unfortunately, it is impossible for

an author to tell a story in any other way. For example, in my book *Power Struggle: An Autobiographical Confession* (1974), I devote a chapter to my experiences as a rabbinical student at the Hebrew Union College from September 1942 to June 1945. I write that it is impossible for me to describe my experiences during that period without immediately juxtaposing it with images of what was happening to Jews in wartime Europe. Since I passed those years in relative security and even comfort, my current response is mediated not only by a normally fallible memory but also by a knowledge of that period that I could not possibly have had at the time. My writing is also mediated by values that I hold now but did not then maintain. Such hindsight can be enlightening, but it also distorts. My present perspectives influence not only how I tell the story of those years, but even the process whereby I select events and turn them into a coherent narrative.

Telling the truth with a minimum of distortion is by no means the only problem involved in attempting to write honest autobiography. Sometimes there can be a thin line between telling the truth and both self-pleading and paying back old scores in public. Sometimes telling the truth can itself be a way of wounding old enemies. When I wrote *Power Struggle* there were a number of situations in which I was tempted to discredit an adversary or to avenge an old injury. I believe that I was aware of the temptation and sought to avoid it, not because of any special virtue on my part, but because I was convinced that I would diminish the book's value were I to use it as a vehicle for either verbal injury or self-justification. There were a number of situations in which I felt compelled to portray a person in a negative light, but I did so only when I was convinced that the person's behavior or attitudes were representative of a serious institutional or religious problem within Judaism. Thus, in *Power Struggle* I discuss my relations with two of my teachers at the Jewish Theological Seminary between 1948 and 1952, Abraham Joshua Heschel and a man to whom I give the name Aaron Kleinman (126). My personal relations with Heschel were far worse than with Kleinman, yet in the book I am far more critical of Kleinman. Kleinman had far greater authority over students during my years at the seminary because of his preeminence as a rabbinic scholar. In the book I describe a conversation I had with Kleinman in which he expressed contempt for men who elected careers as congregational rabbis rather than scholars. Most of his students were destined to become congregational rabbis. Unfortunately, because of Kleinman's great learning and religious authority, it was almost impossible for his attitudes not to influence his students. They were destined to devalue their vocation as a result of the training they had received to enter upon it. Nor were Kleinman's attitudes idiosyncratic. They were shared by most of his colleagues. Thus, to describe Kleinman's attitudes towards rabbis and their training was to describe a problematic tendency in contemporary conservative Judaism in the highly important area of the training of rabbis. Nor would the situation have been different had someone else stood in Kleinman's place. Only a man with

Kleinman's training, background, and attitudes could have qualified him for the role he played at the seminary. That is why it was appropriate to give him a pseudonym. I was describing a type, not a single individual.

A theologian turns to autobiography when he becomes convinced that his life story is of relevance to the understanding of the religious position he holds. It is my conviction that in good theological autobiography—if such a thing is possible—the person of the author is only important as a vehicle for the exploration of the theological issues he raises. It is, for example, possible for a Christian to assert that Christ is Lord without relating that affirmation to the facts of his own biography. In autobiographical theology, we would be concerned with how such an affirmation fit into the believer's life story. The story would serve to illustrate the transformative power of the believer's faith. The believer would thus become a vehicle for expressing something that was by no means solely personal or idiosyncratic.

The telling of one's story can be especially important if the position the theologian seeks thereby to illustrate is either novel or heterodox. Since my position on God, Israel's election and the Holocaust constitutes a departure from normative trends within both Judaism and Christianity, the initial reaction of those who read or listen to what I have to say often involves considerable resistance. Even those who have their own private religious doubts are often reluctant to accept as valid a religious position that openly takes issue with the religious mainstream, if for no other reason than the apprehension that heterodox opinions are not conducive to an orderly society. Autobiography can be helpful in meeting this situation. By telling readers or listeners about the circumstances that brought me to the position I now hold, I am in effect asking them, "What would you have done had you been in my place? Would you, for example, have agreed with Dean Grüber that God sent Hitler to punish the Jews at Auschwitz?" If I do not secure the intellectual assent of my audience, I at least stand a chance of making my position humanly comprehensible to them. By telling my story I invite my readers or listeners to *identify* rather than argue with me. Since (a) the issues under consideration may constitute a challenge to the emotional and institutional commitments of the audience, and (b) since all theological issues are inaccessible to conclusive proof by normal arguments, identification and empathy rather than arugment are more likely to overcome a resistance that is in any event rooted in the emotions.

In addition to being suited to serve as a vehicle for communicating heterodox theological ideas, autobiography can be useful if one wishes to explore what is at stake emotionally in affirming or rejecting a given religious position. For example, in my autobiographical writing I have attempted to share with my reader some of the complicated emotional elements involved in my choice of a religious vocation. The very title of the book, *Power Struggle*, was chosen with that in mind. I tell the story of the way my choice of vocation was motivated both by a desire to serve and by a

relentless desire to dominate others. The means I chose for this latter pur-
pose were the magic and the charisma of the priestly office. As a young
adolescent in the 1930s, I was convinced that I had none of the realistic
resources, such as family wealth or social position, with which I might satisfy
a very strong will-to-power. At the same time, I feared that the terrible
impotence of the Jewish community would be translated into personal impo-
tence on my part. I turned to means of achieving dominance that were
essentially magical, what I call the "magic of the priesthood" in the book.
What I called my "vocation for the summit," utilizing Camus' phrase, was
both a career choice and an attempt to defend myself against my own
deepest fears (Camus:25). Yet the story I tell of that "power struggle" is one
of irony, misperception, and failure. Although I became a priest-rabbi out of
a quest for dominance over others, I soon learned that by seeking an archaic,
magical dominance over others I had exposed myself to the archaic,
nonrational response of those whom I sought to dominate. I also learned that
in the archaic sensibility of humanity, such preeminence is often achieved
by those who, willy-nilly, are prepared to pay for it with their own death.
Put differently, I learned that the king must die a sacrificial death, that
psychological action-at-a-distance can be a two-way street, and that he who
becomes the father-surrogate elicits, in addition to the admiration of the
group, their death wishes. Furthermore, such death wishes invariably have a
profound influence upon their intended target.

Not surprisingly, the classic theme of the sacrificial death of the leader
figures very largely in my writings. Late in 1964, about a year after the
Kennedy assassination, I was invited to deliver a paper on the role of the
rabbinate in contemporary society at a conference on that theme sponsored
by the Jewish Theological Seminary for its rabbinic alumni. The paper has
subsequently been published under the title "A Rabbi Dies." At the time, I
was seriously considering the possibility of leaving university chaplaincy
work and returning to the congregational rabbinate. I welcomed the oppor-
tunity to write the paper because of the opportunity it afforded me to give
serious thought to the functions I might once again be called upon to fulfill.
I was, however, deeply troubled by a series of premature deaths, usually as a
result of a heart attack, of a number of relatively young rabbis whom I
knew. I suspected that there might have been a psychosomatic element in
some of the cardiac failures. The most dramatic instance was the death of
the rabbi of the congregation to which I belonged the day after he had
officiated at my oldest son's bar mitzvah. In addition, in my published writ-
ings I have consistently argued that, whether or not Sigmund Freud's ver-
sion of the primal crime, the original fraternal act of parricide whereby the
institutions of human civilization came into being, had ever actually
occurred, it was a profound metaphor for the complex interplay of the
dynamics of authority and community, both religious and secular. This view
is not unlike that expressed by Norman O. Brown in *Love's Body*, although I

do not accept his radical prescription for human social and religious transformation (Brown:3–31). Still, having been born a commoner, I wanted to be a priest-king. Experience was to teach me how terrible the price might be for so preeminent a status.

Although *Power Struggle* had a very limited circulation, somehow or other a great many rabbis managed to read it. A number of rabbis have told me that, although they were not prepared to say so publicly, their own experience corroborated my insights about the sacrificial elements in the priestly office.

It is also my conviction that autobiography can sometimes have an important place in scholarly and historical studies in the field of religion. Here again, I offer my own experience to illustrate the point. In addition to writing one wholly autobiographical book and autobiographical chapters in *After Auschwitz*, I began my book on St. Paul, *My Brother Paul* (1972) with an autobiographical chapter in which I sought to communicate to my readers some of the reasons for my involvement with Paul's life and theology. I entitled the chapter "The Point of View of the Observer." My reasons for so doing were fairly straightforward. Is there any Jew or Christian, seriously interested in religion, who can be entirely objective about this overwhelmingly important figure in the spiritual life of mankind? The more interpretations of Paul and his letters I read, the more convinced I became that no writer on Paul could possibly present him as he was in himself but only as he appeared to the writer. The screening elements of cultural influence, historical era, and the personal religious commitments of the interpreters seemed to play a decisive role in each reading of Paul, as indeed is apparent from a perusal of Albert Schweitzer's *Paul and His Interpreters*. I came to the conclusion that the only way to give my own investigation of Paul a measure of objectivity was to begin with a frank exploration of some of the *subjective* elements that had brought me to the study of Paul. I had no doubt that all readings of Paul by Jewish and Christian scholars, including my own, contained personal and subjective elements. Nevertheless, few scholars were prepared publicly to explore their own involvements in presenting their views. Since I was attempting a psychoanalytic reading of Paul, it seemed especially important to explore the dynamic elements involved in both my interest in the apostle and in the way I read him. It is my conviction that by frankly acknowledging his or her own subjective involvements in a literary or scholarly enterprise, a writer can enhance rather than diminish the objectivity with which he or she writes.

Let us now return to a further consideration of the fundamental problem of autobiographical theology. If, as I have suggested, a principal function of theology is the reduction of dissonance between the beliefs and values of a religious community and potentially disconfirming sources of information, is it realistic to expect that a theologian can be the bearer of explicitly disconfirming information? Yet, is there not always the possibility

that autobiography will intensify the dissonance? Autobiography is a public presentation of the self and its story. As we have suggested, good autobiography must be a truthful presentation of the self, yet this imperative to truthfulness may easily conflict with the dissonance-reduction function of the theologian. We have also noted that the very process of retelling an event or a life inevitably distorts, but that is not the only problem. In an era in which an important section of the reading public is sophisticated about the insights of the social sciences and depth psychology for an understanding of personal motivation, no retelling of a life story will be credible if it fails to inquire into the latent motivations and the socio-cultural bias inherent in the biographee's experience. The writer will be under a strong impetus to make *manifest the unmanifest* in order to present a credible story or one that others will find worth reading. Put differently, good autobiography may involve demystification, but a theologian who tells his own story may arouse profound resentment for attempting to demystify his tradition's religious beliefs and institutions, including his own role. If, for example, the clergy function as authority figures within a religious tradition, their effectiveness in meeting the emotional needs of their community may require them to accept as valid and even to encourage the mystification of their role. A community's need for authority does not cease simply because a theologian comes to understand that honest biography may require demystification. It can, of course, be argued that the prophets were demystifiers and that honest autobiography is consistent with the prophetic tradition. However, the demystification of the prophets was always based upon the unshakeable foundation of faith in the sovereignty of God. Contemporary demystifications, even the demystifications offered by the autobiographical theologian, may not rest on so firm a foundation. They may, in fact, be all-dissolving.

Even apart from this issue, there are times when it is probably best for those whose emotional needs are being met by a religious tradition to be shielded from demystifying insight. For example, from the perspective of psychoanalysis the ritual of circumcision functions as an emotional safety valve for the harmless expression of ambivalent feelings of both paternal love and infanticidal hostility. Since the actual ritual is always experienced at the prereflective level as a joyful family occasion, few fathers are likely to welcome the suggestion by a person with religious authority that what is taking place is fundamentally an abreaction of ambivalent feelings, of love and murderous hate. On the contrary, such a suggestion could very well prevent the abreaction from taking place and thus do more harm than good.

Max Weber has characterized Judaism as a "pariah religion" in his sociology of religion (1952:336–55; 1968:492–500). If Weber is correct, Jewish claims to divine election can best be interpreted as compensatory delusions that help to mitigate the actual status of the Jew. Whether or not Weber is correct, a sociologically-trained theologian who concurred with Weber in the process of telling his own story would hardly be performing a welcome

function in the eyes of those whose emotional needs were met by the doctrine and whose lives would be impoverished without it. Nevertheless, if the theologian had come to the conclusion that his own experience corroborated Weber's insights, the imperatives of good autobiography would compel him to spell this out in his writings.

I could multiply the examples of the conflict between the role of the theologian and the role of the writer, but the point needs no further elaboration. There is, however, the question of why any theologian would turn to autobiography if he or she were aware of the conflict between the imperatives of his vocation and that of a writer. It is my conviction that a theologian would only take upon himself or herself such a demystifying role after he or she had become convinced that his or her inherited tradition no longer offered a credible structure of meaning and interpretation with which life's vicissitudes could be ordered, and came to the conclusion that he had been thrown back upon his own experience and insights to construct a viable, alternative structure of meaning. It is, of course, entirely possible that a theologian who despairs of finding meaning in the inherited tradition is profoundly in error. The failure may very well be his or hers rather than the tradition's. Nevertheless, once the tradition loses its credibility, the theologian will have little choice but to seek for meaning within his or her own story. For those who are forced back upon personal resources, religious thinking is likely to develop a significant autobiographical component.

Let me conclude with an observation concerning why there may be more rather than fewer attempts to find meaning in one's own story in the future. I have been told that after my grandfather Jacob Fine and his brothers emigrated from Lithuania to America, my great-grandfather Elijah Fine decided to come to America and settle here with his sons. When he arrived in New York, he was so horrified by the lax religious situation that he concluded that it would be impossible for him to lead a fully traditional Jewish life in America. Within a few weeks he returned to Lithuania to live out his life secure in his unwavering traditionalism. In June, 1980, his great-grandson visited the Imperial Shinto Shrine at Ise, Japan, and conversed about Judaism, Christianity, Buddhism, and Shinto at a luncheon with the chief priest of the Sanctuary and several members of his staff. Apart from any consideration of the extraordinary events of twentieth-century history, the technologically induced cultural and intellectual transformations of our time have so utterly altered the quality of our personal experience and, hence, the kind of persons we are, that many of us simply cannot uncritically reaffirm our inherited traditions. Certainly, it is difficult for many contemporary Jews who have had any opportunity to encounter the traditions and personalities of the world's other major religions to rest comfortable with the doctrine of election and the faith that Israel is a "light unto the nations" as did my great-grandfather.

Yet, there is one respect in which I am wholeheartedly at one with my

great-grandfather's religious position. He understood clearly that he could preserve the integrity of his traditional ways only by strictly separating himself from an American civilization that was so obviously breaking down cultural if not social boundaries. His sons were less clear. They may have been under the illusion that they could both preserve the old ways, at least in spirit, and participate in the ways of the new world. In reality, the day they sent their first child to a secular, public school, they smashed more than they knew. The time would come when Elijah Fine's great-grandson would be ordained a rabbi, but instead of reaffirming for yet another generation that the old stories contained the wisdom to sustain us, the great-grandson would have no choice but to confess that he could no longer tell the old stories as his own, that he was condemned to finding meaning in the process of telling his own story.

NOTE

/1/ For discussions of Wiesel cf. Berenbaum, *Elie Wiesel*, and Roth, *A Consuming Fire*.

WORKS CONSULTED

Berenbaum, Michael G.
 1978 *Elie Wiesel: The Vision of the Void*. Middletown, Conn.:
 Wesleyan University Press.

Brown, Norman O.
 1966 *Love's Body*. New York: Random House.

Camus, Albert
 1961 *The Fall*. Trans. Justin O'Brien. New York: Alfred A. Knopf.

Festinger, Leon; Riecken, Henry W.; and Schachter, Stanley
 1956 *When Prophecy Fails*. Minneapolis: University of Minnesota
 Press.

Roth, John
 1979 *A Consuming Fire: Encounters with Elie Wiesel and the Holocaust*. Atlanta: John Knox Press.

Rubenstein, Richard L.
 1966 *After Auschwitz*. Indianapolis: Bobbs-Merrill.
 1972a "A Rabbi Dies." In *American Judaism*, edited by Jacob Neusner, pp. 46–60. Englewood Cliffs: Prentice-Hall.
 1972b *My Brother Paul*. New York: Harper and Row.
 1974 *Power Struggle: An Autobiographical Confession*. New York:
 Charles Scribner's Sons.

1979 "The Unmastered Trauma: Interpreting the Holocaust."
 Humanities and Society 2:417–33.

Sartre, Jean-Paul
 1959 *Nausea.* Trans. Lloyd Alexander. Norfolk, Conn.: New Direc-
 tions.

Schweitzer, Albert
 1948 *Paul and His Interpreters: A Critical History.* London: Adam
 and Charles Black.

Weber, Max
 1952 *Ancient Judaism.* Trans. and ed. Hans H. Gerth and Don
 Martindale. Glencoe, Ill.: Free Press.

 1968 *Economy and Society: An Outline of Interpretive Sociology.*
 Vol. 2. Ed. Guenther Roth and Claus Wittig. New York:
 Bedminster Press.

The Rediscovery of Story
in Recent Theology and the Refusal
of Story in Recent Literature

Nathan A. Scott, Jr.

It is not, I think, incorrect to remark the rediscovery of story as one of the more notable developments in recent theology, particularly in theology on the American scene of the past fifteen years. In my own reckoning, it was the Roman Catholic theologian John Dunne who, in two books of the 1960s—*The City of the Gods* and *A Search for God in Time and Memory*—was the first to suggest that the issues of doubt and perplexity and faith may in our time find their most acute expression in narrative and that this, therefore, is a form that needs to be made the subject of systematic reflection within the theological community. Then, Fr. Dunne's proposal in this vein was soon followed by an immense amount of similar testimony that came from Sam Keen and Harvey Cox and Michael Novak and David L. Miller and John Dominic Crossan and various others; and by the mid-70s there had begun to be a sizable number of young theologians who were muttering dark, gnomic sayings about what they sometimes rather inflatedly called "theology of story."

Now undoubtedly this was a development prompted in part by a certain failure of nerve that had overtaken the technicians of thought in the religious community. For, as it began increasingly to be felt, whether one turned to the work of a Barth or a Bultmann or a Niebuhr or a Rahner, none of the great projects in theology of the past generation seemed able with any sort of final adequacy either to articulate the full reality of Christian existence in our time or to facilitate any kind of genuinely fresh and bracing exchange between the Christian community and the world of secular thought. So it seems to have been concluded by many younger people that perhaps the time had come to bypass or "bracket" altogether the conventional protocols of formal theology and, by way of a kind of postcritical naiveté, to pursue that prereflective experience which the verbal symbols of formal theology seek to enunciate and interpret. It would appear that the tacit assumption was that the renewal and deepening of the theological imagination await such a reexamination of primary experience as will disclose the dimensions of ultimacy and of the sacred that are already latent in

the realm of man's actual, concrete *Lebenswelt*. And this notion proved to be so mesmerizing that what was often by way of being sponsored was something like a retreat from systematic reason in the direction of a new kind of *mythopoiesis*.

Now those who proposed this maneuver as a basic strategem for contemporary theology expected that it would gather much of its plausibility, as a type of method, from the fact that narrative figures very prominently amongst the chief rhetorical forms employed by the Fathers of the primitive church. And it is undeniably the case that much of the language used by the founders of the Christian movement, as they trudged about the ancient Roman world, was a language of story. For they conceived themselves to be in the midst of a great drama, and this drama itself was the Good News they wanted to proclaim. There was the primordial age before the Creation; and then there was the "present" age in which they were themselves living and in which the central event was Jesus Christ, his public ministry, and his death and his Resurrection; and, finally, there was the great age to come in which the definitive eschatological drama would be enacted. The apostolic people wanted to speak, in other words, of a series of events in which, as they believed, "the finger of God was . . . visible before men's eyes in grace and deliverance" (Wilder:68), and thus there was a large body of story, of anecdote, that they had to recount. The words and actions of Jesus had to be rehearsed; the post-Easter experience had to be reported; a tale had to be told about the coming of the last age in which every knee would bow in acknowledgment of the reign of God; and all this had to be set in the context of that vast *Heilsgeschichte* reaching back to the very foundation of the world. So it is no wonder that the first Christians were distinguished far less by formal teaching than by their commitment to narrative modalities; and story is, indeed, perhaps the principal literary form to be encountered in the canonical literature of the early Church.

But then, of course, once the Christian witness began to be a significant reality in the Graeco-Roman world, it found itself to be confronting the numerous mystery religions and salvation-cults that had drifted westward from Egypt and Syria and Asia Minor, and it also found itself to be gravely challenged by the various speculative systems that we customarily refer to as Gnosticism. Now it was these encounters that, inevitably, led the early Church not only to try cogently to interpret itself to its pagan competitors but also to seek to deepen and clarify its own self-understanding. No longer would it suffice merely to rehearse the stories which had constituted the original witness of faith, for what was now required was a systematic explication of the metaphysical claims and the Christology and the anthropology which these stories entailed. And thus the Christian community found itself dedicated to the kind of enterprise that was undertaken by Ignatius and Justin Martyr and Irenaeus and Clement of Alexandria. Nor has there been any subsequent moment in Christian history in which this systematic theological effort could

be suspended, for, over and again, new situations and new issues arise that require the Church to repossess its faith by reconceiving not only the nature of the internal coherence of that faith but also the kinds of conceptual forms whereby it may speak most persuasively to its environing culture.

Which is to say that the vitality of any great religious faith is in part dependent on the steadiness and seriousness of the support it offers systematic reflection: it must be a faith constantly seeking more deeply to understand itself and to interpret itself to its cultural environment. When the Christian recounts the story of the Crucifixion and of the empty tomb, this is, to be sure, faith properly expressing itself in the "first-order" language of that primary enthrallment by the *mysterium tremendum*. But, to speak in a vernacular way, if this enthrallment is to become a "going concern," it must step back from itself and subject itself to reflection—and this means that there is no available shortcut bypassing the exactions of the kind of linear discourse that characterizes formal theology, since, in the last analysis, the story of the Crucifixion and the empty tomb is but a datum for reflective thought.

So it is surely a miscalculation to presume that story, simply in and by itself, affords a viable mode for "doing" theology, since it is precisely the stories by which the religious imagination is quickened that give rise to the theological enterprise. True, many of those who are sometimes rather curiously spoken of as "radical theologians" have at one time or another in recent years advanced a different view. Having decided, if I may adapt a phrase of the sociologist Daniel Bell—having decided that we have reached "the end of theology," in the sense of all the great options for theology having been played out and found to be indecisive, they have reasoned that at this point of impasse the religious imagination will best serve itself and the world at large not by refashioning old arguments or by fashioning new ones but rather by telling stories. As they seem sometimes to be saying, what we need is not so much demythologization as remythologization—or, as one strategist of this new program puts it, "The temptation of theology has been to interpret the foundational stories given by religion and then to treat the interpretation as if it were that which was originally given. Perhaps," he says, "that is what we have grown so tired of in theology and perhaps that is one of the contributing reasons for the return to stories" (Wiggins, 1975:19). The charge, in other words, is that formal theology tends to deplete the religious universe and to set up what is merely "a shadow world of 'meanings'": which is to say that theology is something like the revenge that the discursive intellect takes on the world of the religious imagination. So, as this proposal says in effect, instead of a hermeneutics let us have a poetics of religion: let theology become an affair of narrative, of storytelling. Moreover, it is often proposed that the theologian need not undertake to tell anything other than his own personal story, since, as it is supposed, the individual's account of his own experience of coming to belief, if rendered

with sufficient amplitude and spaciousness, will prove at bottom to be the story of us all.

Undoubtedly, of course, for the Christian imagination the most natural language of avowal is the language of confession and story. But, as Paul Ricoeur has been reminding us in many of his essays of recent years in hermeneutical theory, it is precisely those stories that "confer universality . . . and ontological import upon our self-understanding" that ask, as it were, to have "this universality . . . [and] this ontological exploration" thematized in systematic terms: as he says, they "push toward speculative expression" (1970:39). And most especially must this be so for those of us whose consciousness has been scored by the legacies of Descartes and Hume and Kant and Nietzsche and Freud and Wittgenstein. Indeed, it is a part of what Ricoeur calls "the distress of modernity" (1967:352) that we, having lived through the adventure of the Enlightenment and all that has followed in its wake, can no longer aim at the primitive naiveté of archaic man, since we are, for better or for worse, a people of the Idea. And thus, however much the first-order language of religion will inevitably remain the language of story, the theological community will surely be courting a hopeless kind of marginality in the cultural forums of our time, if it takes narrative modes to represent any kind of simple alternative to systematic discourse.

Now, at a time when in certain quarters many of our younger theologians are finding story to be the form that deals most authentically with human experience, it makes one of the ironies of the present cultural scene that our writers, particularly our novelists (to say nothing of our historians), are reflecting a very adverse opinion indeed of narration, of the telling of stories. Substantial evidence of the diminished status of story in recent literature can easily be gathered from the various capitals of European literary life, but our American situation does itself make a fully representative case. Here, of course, Saul Bellow and William Styron and John Updike and Bernard Malamud—who are perhaps our ranking novelists—clearly intend still to practice that old magic whereby the storyteller mesmerizes us by his tale. But these writers, for all their eminence, are not amongst those to whom one turns for typical expressions of our postmodern period-style. It is rather such figures as John Hawkes, Donald Barthelme, Thomas Pynchon, John Barth, William Gass, Robert Coover, and Randolph Wurlitzer who, in Matthew Arnold's phrase, carry "the tone of the centre"—and these and numerous others of a similar bent are writers who are notable for the very considerable ambivalence of feeling that they represent in regard to the traditional arts of narration.

In a famous essay of the 1950s on the generation of Gorky and Rothko and Pollock the late Harold Rosenberg remarked the tendency of the painter in our period to dispense with pictorial conceptions of painting and to want to put on his canvas "not a picture but an event"—namely, the event consequent upon his approaching his easel "with material in his hand

to do something to that other piece of material in front of him" (25). So
Rosenberg said that the artist working with oils and canvas has become an
"action-painter." And, in a similar way, the Donald Barthelme of *Snow
White* and the John Barth of *Giles Goat-Boy* and the Thomas Pynchon of
Gravity's Rainbow and the Raymond Federman of *Double or Nothing*
might be said to be action-writers. For they are writers who assume that, as
narrative, as story, the novel (as John Barth puts it) "has by this hour of the
world just about shot its bolt": so they turn out "novels which imitate the
form of the Novel, [as if they had been written by authors imitating] . . . the
role of Author" (32–33), and, *as novelists*, they say *credo quia absurdum est.*
Or, we may adopt William Gass's phrasing of the matter and say that they
take it for granted "that literature is language, that stories and the places
and the people in them are merely made of words as chairs are made of
smoothed sticks and sometimes of cloth or metal tubes" (27). And thus, since
"there are no events but words in fiction" (30), they conceive the storyteller's
art to be nothing other than the game of managing words, of scrubbing
them and polishing them and putting them together in new and surprising
combinations—which simply record the event, the action, of the writer's
having done certain interesting things with language itself. Indeed, as the
title of a book on recent American fiction by an English critic suggests, they
dwell in a City of Words (Tanner).

John Hawkes, who, among novelists of the avant-garde, is perhaps as
representative a figure on the American scene as can be cited, said a few years
ago in an interview: "My novels are not highly plotted, but certainly they're
elaborately structured. I began to write fiction on the assumption that the true
enemies of the novel were plot, character, setting, and theme" (149). And this
statement takes us close to the heart of the new poetics of fiction. So sparely
plotted a novel, say, as Mr. Hawkes's *Second Skin*, represents, of course, a
narrative procedure very much different from that which is controlling so
calculatedly over-plotted a book as Thmas Pynchon's *V.* or John Barth's *Giles
Goat-Boy.* Yet both methods can claim a large typicality in relation to
novelistic practice of the present time, and the one reflects quite as much as
the other an intention to signify the great discredit into which storytelling has
fallen, for even those who follow Mr. Barth's line—of crowding the
foreground of things with as much of event and image as can be packed in—
are doing so, one feels, chiefly for the sake of insisting upon what such a writer
as John Hawkes would want us to remark: namely, the absurd discrepancy
between all plots, even the most knottily complicated, and the human
actuality. And it is a similar deposition that is being implicitly urged by
Ronald Sukenick's *Out* and Gilbert Sorrentino's *Splendide-Hotel*, by Clarence
Major's *No* and Ishmael Reed's *The Free-Lance Pallbearers*, by Rudolph
Wurlitzer's *Flats* and Donald Barthelme's *City Life* and John Barth's
Chimera and countless other fictions of the past ten or fifteen years that
express in various ways that *gran rifuto* which John Hawkes enunciates.

So, on the issue of the status to be accorded story, we face now a sharp divergence between the literary community and certain spokesmen for the theological community, and the latter will no doubt be inclined to view with some disfavor the general drift in contemporary fiction that I have been remarking. For the theologian who wants to make a large investment in story is so disposed not only because he regards story as the form best adapted to certain ranges of Christian thought and feeling but also because he believes the structure of human experience itself to be inherently narrative. The notion that the inner form of primary experience is essentially narrative in character has, I suppose, by no one been more strongly insisted upon than by Stephen Crites in an essay entitled "The Narrative Quality of Experience," where he extends in various ways the analysis of time and memory put forward by Augustine in the Xth and XIth books of the *Confessions*. Indeed, he maintains, along essentially Augustinian lines, that it is memory alone which gives unity and intelligibility to human experience, since it is there, in the deep recesses of the memory, that the residue of all our dealings with the things and creatures of earth is lodged. But, as Mr. Crites argues, this residue is not simply a vast assemblage of *disjecta membra*, for, as he says, "The memory . . . has its order . . . [which is] a simple order of succession." And this succession is itself nothing other than "the order in which the images of actual experience through time have been impressed upon the memory." In other words, the materials of experience are so fixed in one's memory as to furnish "a kind of lasting chronicle . . . of the temporal course" of one's life, "of what comes before and what comes after." Which is to say that that most rudimentary consciousness which is offered by memory is itself "an incipient story." But, of course, the chronicle of memory is merely one modality of experience, since it embraces only the past: we dwell also in the present and in the future. And the future is, as Stephen Crites suggests, as much an affair of narrative as is the past, since we possess it only by way of "scenarios of anticipation," only "by framing little stories about how things may fall out." It is the intersections between the chronicles of memory and the scenarios of anticipation that give rise to the tensions that constitute the living present, and the *praesens de praesentibus*—the present of things present—finds its unity only as these chronicles and scenarios are absorbed into some richer narrative that does justice to the full temporality of experience in its triadic pattern of past, present, and future. So, as Mr. Crites concludes, such formal quality as human experience in time may have is a consequence of its being inherently narrative (291–311).

But now, of course, what is at issue in much of contemporary literature is precisely the question as to whether indeed life is like a well ordered story. The gifted American writer Joan Didion begins an essay devoted to her experience of the 1960s by saying: "We tell ourselves stories in order to live." Yet the brilliant account she gives of her actual days during those

years suggests that they were far from fitting into any kind of narrative pattern. Of her life in the period between 1966 and 1971 she says: "I appeared, on the face of it, a competent enough member of some community or another, a signer of contracts and Air Travel cards, a citizen: I wrote a couple of times a month for one magazine or another, published two books, worked on several motion pictures; participated in the paranoia of the time, in the raising of a small child, and in the entertainment of large numbers of people passing through my house; made gingham curtains for spare bedrooms, . . . put lentils to soak on Saturday night for lentil soup on Sunday, . . . renewed my driver's license on time, missing on the written examination only the question about the financial responsibility of California drivers. . . . I did no good works but I tried to keep in touch. I was responsible. I recognized my name when I saw it. Once in a while I even answered letters addressed to me, not exactly upon receipt but eventually. . . . This," she says, "was an adequate enough performance, as improvisations go." And she is very strongly insistent on the improvisatory way in which she handled her days in the late '60s, because, as she tells us, instead of having at hand something like a movie script, all that she really saw were "flash pictures in variable sequence, images with no 'meaning' beyond their temporary arrangement"—so that her life was "not [like] a movie but [rather more like] a cutting-room experience." "I wanted still," she says, "to believe" that it was a narrative, that it had the intelligibility of a narrative—but "the sense [of it seemed to change] with every cut," and thus it was quite unlike any sort of plotted story (11–13).

Such is the testimony Miss Didion offers about her own situation in the period of Janis Joplin and Bishop James A. Pike and the Black Panthers and Charles Manson. The events with which she had to cope in those years carried, she says, no messages, no counsel—and, though "we tell ourselves stories in order to live," she is nevertheless persuaded that to impose a narrative line upon the thousand natural shocks that flesh is heir to is to do little more than "to freeze the shifting phantasmagoria which is our actual experience."

So Joan Didion registers an emphatic denial that our lives are essentially narrative in form, and thus, though she is herself today one of the most interesting novelists on the American scene, she is in effect also denying that story necessarily offers a decisive hermeneutic wherewith to probe and clarify the human situation. For (as the French novelist Alain Robbe-Grillet reminds us) the whole machinery of narrative—its reversals and recognitions, its climaxes and dénouements—tends "to impose the image of a stable, coherent, continuous, unequivocal, entirely decipherable universe" (32). It represents a kind of revenge of the storyteller against the pervasive contingency of human existence: he presents us with lovers who become separated or with a child who becomes lost in a forest, and he invites us to ask: "What happened to them next? And, after *that*, what happened? And *then* what happened?" (Gallie:45). The very logic of narrative, in other words, invites

us to suppose, as Lionel Trilling puts it, "that life is susceptible of comprehension and thus of management." "It is the nature of narration to explain; it cannot help telling how things are and even why they are that way. . . . The tale is not told by an idiot but by a rational consciousness which perceives in things the processes that are their reason and which derives from this perception a principle of conduct, a way of living among things" (135–36). Or, as the British philosopher W. B. Gallie would say, the prime requisite of a story is "followability." At each and every stage a story must pull "our interest . . . forward by the presumption that its result is to be one of a few roughly specifiable kinds. The hero will either win or lose— be it his girl or his glory: he will be rescued—either by his own cunning or because of the compassion of his guard, and so on. In every case what is presumed is a strong disjunction: this or that or the other, not both or all" (42). And to tell a story is to imply that the human world does itself have this kind of followability: it is to imply (in a figure of Frank Kermode's) that the human order proceeds in something like the manner of a clock, that the *tick* is followed by a *tock* and that the interval between the two is "charged with significant duration" (Kermode:45).

But it is, so to speak, this primitive and flagrant Aristotelianism which belongs inherently to the nature of narrative—it is just this that Joan Didion and her literary generation want flatly to disavow. For stories, as they feel, by submitting the realities of man's worldly life to various patterns of concord, inevitably tell a kind of lie. The story—with its beginnings and middles and ends—is so delighted with its own inventions that it ends by transfiguring, by redeeming, contingency and by offering us what Iris Murdoch calls "the consolations of form" (20). Whereas the vanguard of our period wants literature thoroughly to decontaminate itself of story in order that, stripped of all those devices that "humanize" the world, it may simply confront us, naked and unaccommodated, with the irremediable fortuities and indeterminacies that belong to the whirligig of human time. In short, the writer's task, as it is urged, is not to gather us into what Yeats called "the artifice of eternity" but, rather, it is to dislodge us from all artifice, from all the well-made worlds of fiction, in order that our vision of things may be so renovated that we may once again know something of the primordial terrors of history.

Yet any work of literary art that did the kind of justice to the world's contingency which is required by the new poetic "would be nothing but a discontinuous unorganized middle" (Kermode:140), for no sooner does a work of the literary imagination begin, as it were, to speak than it begins perforce to impose a kind of causality and concordance on the primary stuff of experience: otherwise, it would be an affair of utter chaos. And, faced with such a frustration as this which is inherent in the very nature of *écriture*, it is no wonder that so many of the storytellers of our period—the Nabokov of *Pale Fire*, the Borges of *Labyrinths*, the Barth of *The Sot-Weed*

Factor, the Pynchon of *V.*—are to be found, over and again, producing works of *meta*fiction, of a fiction which makes the questionableness of storytelling itself the subject of story.

In any event, given the disesteem with which in our day story is increasingly regarded, it would seem that ours is hardly a time in which it would be wise for constructive theology to convert itself into a mode of narrative. To be sure, numerous proposals to this effect have been made in recent years, and somebody or other is regularly to be found eager to present some new program under the rubric "theology as narrative." But, as the German critic Harald Weinrich suggests, "A merely narrative theology is now hardly conceivable . . . in our post-narrative age" (55). Even, of course, if story were not suffering its present impairment of status, the theological enterprise would be ill-advised to convert itself, without remainder, into narrative modalities, for, as Julian Hartt was cautioning us not long ago, "it is a fundamental and far-reaching mistake to suppose that [merely] telling the story is the whole thing. What one makes of the world and of one's own existence on the strength of the story: that," as he says, "is the pay-off" (254). And certainly, as it would seem, purely narrative programs for contemporary theology are not likely, in the context of the present time, to exert any disarming power over "the cultured despisers" of religion.

But, however dubious as a specific program "narrative theology" may be, surely it would be a mistake to suppose that Christian theology, even in this late time, needs to be embarrassed about that wealth of biblical story which is the main wellspring of the Christian message. For it is by no means so obvious as the literary vanguard of our period imagines that story as such is a necessarily fraudulent way of representing the human reality. The case that is made against it rests largely, of course, on a great supposition, that the absolute contingency of existence is bound to be falsified by the causalities and concordances of narrative form. But is it indeed the case that the world in which we dwell is filled with nothing but "the meaningless ash of contingency" (Kermode:147)? This, undoubtedly, is a question the answering of which, whether in the affirmative or the negative, must of necessity express one or another decision of *faith*—and, if it be answered negatively, then the ordered world of story will not be thought to be, as a matter of course, something specious.

Moreover, if, by a decision of faith, we venture to believe that, under God, the world is so ordered as finally to be supportive rather than spendthrift of the human enterprise, then, inevitably, we shall seek to objectify for reflection not only the deepest ground of this order but also its relation to the continuities and novelties of historical passage. But, of course, this relation is something ineluctably dialectical, for historical existence, invaded as it is by radical contingency, is never wholly an affair of continuity and order and "is [always] experienced as both . . . incoherent and coherent, as . . . condemned and as redeemable" (Gilkey:151). And thus that which is

taken to be the ultimate guarantor of meaning in history, though it is not absolutely suprahistorical, is never wholly immanent within history: its relation to historical time is neither that of simple conjunction nor of simple disjunction—but, rather, the relation is irresolvably dialectical, and one that eludes any purely "rational" scheme of interpretation, since every interpreter is himself involved in the flux of history and must view historical passage from a highly limited vantage point (cf. Niebuhr:117–19). Which is why the religious imagination has perennially had recourse to story, since by no means other than "global myth" has it been able to embrace the total horizon of meaning within which the human voyage runs its course.

So it is no wonder, as the Christian movement in its earliest period began to shape a new form of speech, that this speech (as Amos Wilder says) "took the form of a story" (57). It was, of course, the life, the teachings, the death, and the Resurrection of Jesus that formed the central element of this story. But the rehearsal of the whole event of Jesus Christ was set within a great epic chronicling the entire history of salvation that extended from Creation to the end of the world. And, though Jesus was the crucial figure in this world-drama, it included a vast number of other characters (both legendary and historical) stretching all the way from Adam to Noah to Peter and Stephen and Paul. Now, to be sure, various facets of this world-story are transmuted by theological interpretation into conceptual form, into such themes as providence and revelation and incarnation and redemption. But it is the rich subsoil of story that, nevertheless, remains the fecundating source of authentically Christian thought. And thus, however injudicious it may be for Christian theology to abdicate from its more distinctively systematic work for the sake of converting itself into a mode of narrative, since its own most essential taproot is a large and intricate body of story, one of its fundamental tasks must perforce be that of relating the Christian story to the various other stories—or, as it may be now, to the various anti-stories—that have some form of significant life in our culture. Which is to say that a kind of comparative poetics will form one important element of the agenda to be taken up by any theology that intends to have some genuine cultural vitality.

It is, however, a quirk of bad luck that the conceptual apparatus which such an enterprise will find available just now in literary theory is one that will not prove to be particularly advantageous. For the currently fashionable doctrines do, in one way or another, insist that stories are quite without any capacity to deal referentially with the circumambient world. Indeed, in the period of Jacques Derrida and Roland Barthes and Michel Foucault, it begins to be taken for granted that stories are not about life but only about other stories, that language in fact "is tautological, if it is not nonsense, and [that] to the extent that it is about anything [at all] it is about [nothing other than] itself" (Scholes:1–2).

Now I cite the names of Derrida and Barthes and Foucault merely as emblems of that French movement which we speak of as Structuralism and

which, as it has drifted onto the Anglo-American scene over the past decade, has increasingly demanded recognition as the most influential theory today of symbolic forms. And what chiefly distinguishes this newly prestigious school of thought is its claim that stories, like all the other products of the literary imagination, do not have any meaning apart from the codes and grammars which generate them: nor indeed, as the argument goes, do they refer to anything other than the codes and grammars themselves. Moreover, we are told that this is true not only of stories but of all the great symbolic forms wherewith human experience is organized. Even man himself, in Structuralist theory, is simply a linguistically encoded machine—which means that the truly decisive cultural fact is not the creative power of the autonomous self but, rather, it is the impersonal systems of language-structures which shape and authenticate all human utterance. True, first-person verbs refer to the human individual as an agent of certain vocal and bodily acts, but, as Derrida and Foucault and Julia Kirsteva and Algirdas Greimas and Gérard Genette and various others lay it down, the transcendental subject of traditional humanism is in point of fact an invented fiction quite without any substantial nonlinguistic reality. So the poetries and religions and sciences that man might himself be thought to have created are seen rather to be merely diverse materializations of that vast superstructure defining the nature and range of linguisticality in a particular cultural situation.

We are, in other words, trapped within the various language-systems that rule us, and thus it is thought to be simply futile to search after some transitive relation that symbolic forms bear to any reality extrinsic to themselves. Indeed, as the *nouvelle critique* maintains, the notion of there being something outside or beyond the symbolic order is nothing but a phantasm, since any accessibility it could have to the mind would necessarily be a consequence of its having already been organized and constituted by some system of signs. So, as it is taken for granted, the symbolic order *is* reality, and thus each "text" that we confront, whether it be a story or a scientific theorem or a style of courtship or a mode of burying the dead—each "text" that we confront makes reference to nothing other than that system of *intertextualité* that forms the grid through which it asks to be read and placed with respect to the other "texts" to which it is adjacently related within the system. By "text," of course, the *nouvelle critique* means *any* system of signs whereby meaning is conferred on human existence, whether it be a narrative or a style of eating or a method of economic transaction or a system of child nurture. Wherever, in other words, man touches the world, there some form of textuality is to be found. As the American critic Edward Said puts it, *"Everything* . . . is a text—or . . . *nothing* is a text" (338). Which is to say that the symbolic order itself is coextensive with all of reality.

So, in the terms of poetics, it is thought to be utterly misguided to suppose that stories, that narratives, make any kind of reference to the circumambient world. Hillis Miller, for example, tells us that the notion of literary

discourse as having some bearing on any "social, historical, or psychological reality can no longer be taken for granted," since, as he says, "meaning in language rises not from the reference of signs to something outside words but from differential relations among the words themselves" (1971:85). Or, again, Michel Foucault likes to speak of what he calls the "radical intransitivity" of literary language—which, as he says, "has no other law than that of affirming . . . its own precipitous existence; and so," as he tells us, "there is nothing for it to do but to curve back in a perpetual return upon itself, as if its discourse could have no other content than the expression of its own form" (1973:300). In short, the figurative impulse leads nowhere beyond sheer figuration itself, and literary art is therefore quite "blind" with respect to the world "out there": it has no "meaning": it exhibits only a play of tropes whose mercuriality "forbids . . . [the text] to be read as an 'organic unity' organized around some version of the *logos*" (Miller, 1979:19). And thus the task of criticism is to "deconstruct" or nullify what may *appear* to be those intimations given off by a literary text of a coherent account of human experience. It is such doctrines as these that now make up the "folk mythology" of the more advanced clerks of literary criticism and theory.

We face, then, in recent theory of symbolic forms the advent of a strange, new mood that appears to express on the part of the curators of *litterae humaniores* an intention to express the essential emptiness of literary art. So I say that, when the Christian theologian attempts today to study his own inheritance of story in relation to the stories (or antistories) being fashioned by the literary imagination of our time, he will find little guidance in the literary theory which is now in the ascendancy, for this is a theory which conceives narrative as such to represent an essential weightlessness and worldlessness, since it is held to be incapable of making any contact with what Innocence takes to be "the ordinary universe." The kind of comparative poetics that forms one phase of the theology of culture needs to have at hand, in other words, a theory of imagination that is prepared to posit some genuinely cognitive import for story, and this is precisely what cannot be expected from the reigning dispensation in contemporary poetics.

It may be, of course, that some guidance is to be found in that current work in hermeneutics that follows in the line of Heidegger and Hans-Georg Gadamer. But, though the German hermeneuts do not impugn the fundamental dignity of the literary universe in the way that Structuralist thinkers do, even their lessons may finally be of but very limited value, since theirs is an ideology that has the effect of denying that story has any really determinate meaning. Gadamer, for example, would say that a story does not begin to *speak* until it begins to be listened to and caught up into a dialogue with an interpreter—which means that it does not have real life except in the context of the give-and-take between itself and its interpreter: it wins its fullest life, in other words, in the moment in which its horizon begins to be

fused with the horizon of its interpreter (cf. Gadamer:267–74). But, then, each interpreter will bring to any given story his *own* horizon, and thus, as Gadamer quite candidly declares, "There cannot . . . be any one interpretation that is correct 'in itself'" (358). Which is, as E. D. Hirsch has rightly argued, a position that represents, at bottom, a kind of hermeneutical nihilism (245–64).

The insistence of the German hermeneutical tradition on the "historicality" of narrative—if it is not wedded to a highly relativistic theory of interpretation—may, however, offer one good point of purchase for the kind of enterprise which is in view. Narrative is, of course, a special sort of "language-game," and if, indeed, a language-game is, as Wittgenstein maintained, "part of an activity or form of life" (23), then I believe Paul Ricoeur is on the right track when he suggests that "the form of life of which . . . narrative is a part is [none other than] our historical condition itself" (1978:187). Story, of course, wants perhaps first of all simply to glory in itself *as story*, in its own inventedness, and thus it tends in varying degrees to distance itself from "the world of everyday language," presenting what Ricoeur calls "a distanciation of the real from itself." But, then, precisely through this "distanciation," it proposes "new possibilities of being-in-the-world" (Ricoeur, 1974:80), in the everyday world, and, in the process, it rehearses and mirrors and confirms "our creaturely participation in the dimension of the historical, the dimension of elected and continuing human life" (Berthoff:24).

So, given the intention of narrative to speak, even if obliquely and indirectly, about the historical condition of man, in reflecting on the claims of the Christian story vis-à-vis the claims of those other stories whereby the modern imagination rehearses the human reality, we ought, I think, to be unintimidated by the sophistications of current literary theory, and we ought to try to aim at simplicity—at the fine kind of simplicity that was expressed many years ago by Mark Van Doren in his great book *The Noble Voice*, when he said:

> What is a given poem about? What happens in it? What exists in it? If too little of the world is in it, why is that? If all of the world is there, by what miracle has this been done? Is tragedy or comedy at work, and what is the difference between those two, and what the resemblance? Are the facts of life accounted for in the unique way that poetry accounts for them, and is this poem something therefore that any man should read? Does its author know more, not less, than most men know? Such seem to me the great questions, though they are not regularly asked by criticism. (xiii)

Now, when we begin to test the Christian story in relation to the stories of a Kafka or a Beckett or a Borges and then to test these in relation to the Christian story, a proper simplicity will prompt us to ask, in the spirit of Mark Van Doren, what is happening, what is being shown, what is being

included, what is being left out. How is the historical condition of man being rendered? Is it being represented as an affair of fate and doom, and as something dark and irremediable and futile? Or is it being so construed as to make our freedom and sin and guilt and eligibility for redemption the decisive realities? Where is the seat of the human problem located—in some constellation of circumstance external to man himself, in some inertia of intelligence perhaps, in something fundamentally defective in the constitution of human nature as such, or in our own misuse of our freedom? And, indeed, is man represented as being in some sense genuinely free, or is he represented as being essentially unfree, as nothing more than the pawn of natural and historical and psychological forces beyond his fathoming? Or, again, how are things being plotted? What kinds of beginnings and middles and ends do we face? Is the beginning, for example, really a beginning, or is it already determined by something that happened prior to the onset of the story's action? It will, of course, arise out of a particular situation which will, in the nature of the case, be something limited. But is the initial situation filled with real possibilities, and is there something of genuine importance to be decided by the agents who are implicated in this situation? And is the end of the story an absolute end, or does it look toward some brave new world, some possibility perhaps of life reconstituting itself by way of renewal and rebirth? Does it look toward a future that is open or closed? Is the essential structure of life represented as being controlled by fatality and fortuitousness, or does it appear to be under the sway of some kind of providence? And is the story as a whole something realistic or allegorical? Whereas realistic modes accord primary importance to events rather than meanings, and whereas allegorical modes simply reverse this valuation, symbolic modes are governed by something like an incarnational principle, in the sense of finding the events of our world to exemplify indeed the actual meanings of life—and thus, to speak theologically, we might say that they testify implicitly to the immanence of Transcendence. So we will ask, to what extent does a given story, in its basic form and structure, overcome the old dualisms between appearance and reality, between Nature and Supernature, between time and eternity? And so on and so on./1/

It is such questions as these that will be addressed when theology, in the terms of what I call "comparative poetics," seeks to understand the Christian story in relation to the kinds of stories about human existence that issue from the general imagination of our time. What is at stake is not a question of theology abdicating its properly discursive mode for the sake of converting itself into some mode of story—but, rather, of its needing to reckon ever more trenchantly with its own deepest roots. Perhaps the most important part of its own inheritance is the great, massive body of narrative that forms so large a part of the Christian Scriptures: here it is that Christian theology finds the norms and paradigms and archetypes to which at last it is most answerable, and in a period such as ours, when it is undertaking radical

reconstruction of itself, it would seem reasonable to suppose that its repossession of the Christian story itself will be deepened the more it brings that story into dialogue with other stories whose tenor and emphasis are of quite a different kind. It is a dialogue that must, of course, be managed with great patience and with great tact. And we may be certain that nothing much will come of it, if it is merely made the occasion for bullying our various modern stories and anti-stories into reinstating those modes of thought which theology has traditionally taken the Christian story to imply and sanction. True, the Christian story will for the community of faith remain what Robert McAfee Brown calls "the normative story" (166–73). But this normative story that comes down to us from a time long ago is likely to become something desiccated and moribund, if it is not being kept constantly in a lively interplay with all that issues forth from the important storytellers of the age. For, apart from this kind of confluence, the normative story will have no chance to discover new idioms and narrative strategems whereby it can be retold in fresh and arresting ways: nor will it have a chance to gather the kind of new vitality that can come only, as it were, by its "proving" itself against those stories that offer some radical challenge to its essential validity.

So, despite the reservations I express regarding narrative as a fundamental method and program for theology, I have wanted to register a strong plea for the enfranchisement within the total field of theological work of what I call comparative poetics. For by way of this whole venture of comparativist study of the Christian story in relation to what we are offered by the literary imagination of the modern period the theological community may, I believe, greatly deepen its understanding of its own inheritance and may also win a larger appreciation of the moods and humors controlling the characteristic forms of the sensibility of our time.

NOTE

/1/ This paragraph is indebted to Preston Roberts's essay, "A Christian Theory of Dramatic Tragedy," in *The New Orpheus: Essays toward a Christian Poetic*, ed. by Nathan A. Scott, Jr. (New York: Sheed and Ward, 1964), pp. 255–85: see especially pp. 266–69.

WORKS CONSULTED

Barth, John
 1967 "The Literature of Exhaustion." *The Atlantic* 220:29–34.

Berthoff, Warner
 1971 *Fictions and Events: Essays in Criticism and Literary History*. New York: E. P. Dutton.

Brown, Robert McAfee
 1975 "My Story and 'The Story.'" *Theology Today* 32:166–73.

Crites, Stephen
 1971 "The Narrative Quality of Experience." *Journal of the American Academy of Religion* 39:291–311.

Didion, Joan
 1979 *The White Album*. New York: Simon and Schuster.

Gadamer, Hans-Georg
 1975 *Truth and Method*. New York: Seabury Press.

Gallie, W. B.
 1964 *Philosophy and the Historical Understanding*. New York: Schocken Books.

Gass, William H.
 1972 *Fiction and the Figures of Life*. New York: Vintage Books.

Gilkey, Langdon
 1976 *Reaping the Whirlwind: A Christian Interpretation of History*. New York: Seabury Press.

Hartt, Julian
 1977 *Theological Method and Imagination*. New York: Seabury Press.

Hawkes, John
 1965 "John Hawkes: An Interview." *Wisconsin Studies in Contemporary Literature* 6:141–160.

Hirsch, E. D.
 1967 *Validity in Interpretation*. New Haven: Yale University Press.

Kermode, Frank
 1967 *The Sense of an Ending: Studies in the Theory of Fiction*. New York: Oxford University Press.

Miller, J. Hillis
 1971 "The Fiction of Realism: *Sketches by Boz, Oliver Twist,* and Cruickshank's Illustrations." In Ada Nisbet and Blake Nevius, eds., *Dickens Centennial Essays*. Berkeley: University of California Press.
 1979 "On Edge: The Crossways of Contemporary Criticism." *Bulletin of the American Academy of Arts and Sciences* 32:13–32.

Murdoch, Iris
 1961 "Against Dryness." *Encounter* 16:16–20.

Niebuhr, Reinhold
 1951 *Faith and History*. New York: Charles Scribner's Sons.

Ricoeur, Paul
 1967 *The Symbolism of Evil*. Trans. Emerson Buchanan. New York: Harper and Row.
 1970 *Freud and Philosophy: An Essay on Interpretation*. Trans. Denis Savage. New Haven: Yale University Press.

1974	"Philosophy and Religious Language." *The Journal of Religion* 54:71–85.
1978	"The Narrative Function." *Semeia* 13 (Part 2).

Robbe-Grillet, Alain
1965	*For a New Novel: Essays on Fiction.* Trans. Richard Howard. New York: Grove Press.

Rosenberg, Harold
1959	*The Tradition of the New.* New York: Horizon Press.

Said, Edward W.
1975	*Beginnings: Intention and Method.* New York: Basic Books.

Scholes, Robert
1975	*Structural Fabulation: An Essay on Fiction of the Future.* Notre Dame: University of Notre Dame Press.

Tanner, Tony
1971	*City of Words: American Fiction, 1950–1970.* New York: Harper and Row.

Trilling, Lionel
1972	*Sincerity and Authenticity.* Cambridge: Harvard University Press.

Van Doren, Mark
1946	*The Noble Voice: A Study of Ten Great Poems.* New York: Henry Holt and Co.

Weinrich, Harald
1973	"Narrative Theology." In Johann Baptist Metz and Jean-Pierre Jossua, eds., *The Crisis of Religious Language.* New York: Herder and Herder.

Wiggins, James B.
1975	"Within and Without Stories." In James B. Wiggins, ed., *Religion as Story.* New York: Harper and Row.

Wilder, Amos N.
1971	*Early Christian Rhetoric: The Language of the Gospel.* Cambridge: Harvard University Press.

Wittgenstein, Ludwig
1958	*Philosophical Investigations.* Trans. G. E. M. Anscombe. New York: Macmillan.

Poststructuralist Criticism
and Biblical History

David Seeley

Jacques Derrida's complex but profound investigations of language and texts have caused considerable interest on both sides of the Atlantic. The interest on this side has for the most part been confined to literary criticism, but it is spreading. For instance, at the 1980 Society of Biblical Literature convention, a Yale colleague of Derrida, J. Hillis Miller, presented a paper applying Derridean methodology to the parables. It is becoming more and more apparent that Derrida is a genuinely important figure, and that his thought will eventually influence all disciplines whose primary task is the interpretation of texts. Biblical studies will, I believe, be no exception, and scholars working in that field should have an acquaintance with Derrida.

I will begin my presentation by trying to "place" Derrida in such a way that persons within the Anglo-American tradition may gain some idea of the nature and direction of his work. This undertaking is not easy, however, because there is hardly anyone or anything in the Anglo-American tradition *like* Derrida! As far as such gross generalizations go, we may say that our tradition has usually taken a rather down-to-earth, common-sense tack. "British empiricism" is a phrase familiar to all who have read the philosophical handbooks, and in many ways it applies to American thought as well. Derrida, on the other hand, has put forth a radical critique of some of the most basic and seemingly down-to-earth elements in the customary Western mode of doing philosophy. He attempts to show inconsistencies within the fundamental procedures often used to construct metaphysical systems and is thus akin to Continental figures like Nietzsche or Heidegger. For this reason, it seems to me that of all those who have ever worked within the Anglo-American tradition, Derrida most resembles Ludwig Wittgenstein. The Austrian-born Wittgenstein is hardly as "within" our tradition as one might wish, but one seizes on him almost in despair, hoping that the mere familiarity of his name and his general position within our own philosophical heritage might mitigate some of the strangeness English speakers often feel when confronting Derrida.

David Pears, in his incisive study of Wittgenstein, places the latter in what he calls "the second wave of critical philosophy" (Pears:20). The determining characteristics of these "waves" are, in Pears's opinion, bound up

with their starting points:

> When human thought turns around and examines itself, where does the inves-
> tigation start? And how does it proceed? The short answer to the first question
> is that there are two forms in which the data to be investigated may be pre-
> sented. They may be presented in a psychological form, as ideas, thoughts,
> and modes of thought: or, they may be presented in a linguistic form, as
> words, sentences, and types of discourse. Kant's critique starts from data of
> the first kind, and the second wave of critical philosophy, the logico-analytic
> movement of this century, starts from data of the second kind. (20)

Others, too, have noticed this distinction; the following passage by Cornel
West speaks of "modernity" and "postmodernity" instead of first and second
waves, but the criteria remain the same:

> Self-consciousness, the discovery and preoccupation of modern thinkers, has
> now been extended to the very medium in which self-consciousness takes
> place. Instead of mere consciousness of the self as a self, we now reflect on the
> nature of the means by which we self-consciously constitute ourselves as a
> self. . . . Modernity has been obsessed with the self; postmodernity, with lan-
> guage. (67)

This last assertion is, as we shall see, amply borne out by both Wittgenstein
and Derrida. But before we examine their work, let us look briefly at their
great precursor in critical thinking, Immanuel Kant. Kant's critique was
aimed at speculative metaphysics, a kind of conceptuality which had often
been regarded as the epitome, essence, or center of Western thought. Ideas
about philosophy or religion seemed to many to form a sort of focal point
from which Western culture radiated outwards. Kant performed a decenter-
ing operation on this focal point. He allowed that "the ideas of speculative
metaphysics have a proper function" (Pears:21). But:

> Their proper function, according to him, is to serve as notional points of ref-
> erence, which lie outside the system of factual knowledge, and so can be used
> to orient it. They are not parts of the system, but ideals to which it approxi-
> mates. For example, a single theory, in which everything would find a place
> and be explained, is neither necessary nor possible, but the idea of such a
> theory serves as a guide for the theories which we do construct. . . . The mis-
> take, Kant thought, is to suppose that such metaphysical ideas have an objec-
> tive basis outside the system of factual knowledge, instead of recognizing
> them for what they are, purely notional prolongations of lines which guide
> the development of human thought. It is as if a diagram were misread,
> because a point, which functioned only in its geometrical construction, was
> taken to represent something. (Pears:21–22)

The later Wittgenstein, too, performed a kind of decentering operation,
but as suggested, his was oriented towards language rather than consciousness
or ideas. Pears points out that Wittgenstein began his work on language with
the study of "ordinary factual discourse" (55). He then sought to analyze and

break this discourse down into its "ultimate components, which, according to him, are elementary propositions" (55). The latter would provide him with a basis on which to ascertain the nature and limits of language per se. However, a very serious problem arose regarding the exact determination of "elementary propositions." No matter how acute the analysis, any given proposition seemed always to entail further propositions, a fact which vitiated its status as "elementary." Pears offers the following analogy to the problem: "A country, whose frontier was always a little further out than at any moment it was deemed to be, would not really have a frontier, and so would not be a territorial unit at all. Similarly, the aggrandizement of the sense of a proposition must come to a halt" (64). Eventually, Wittgenstein came

> to the conclusion that it was no good looking for the essence, because there was nothing worthy of that title there to be found. There was only a crowd of differing, but variously related, forms of factual propositions. (Pears:98)

> In the *Tractatus*, he had said that a proposition is like a ruler laid against reality to measure it. But . . . his new view was that elementary propositions . . . are like the intervals marked on a ruler, and that it is the whole system of these propositions which is like the ruler. So we do not apply elementary propositions to reality singly, but in systematically related groups. (Pears:135–36)

Wittgenstein's abandonment of the search for essences brought him finally to what Pears calls an "extreme anthropocentrism." This viewpoint left the foundations of our ideational world somewhat confused: "It is Wittgenstein's later doctrine that outside human thought and speech there are no independent, objective points of support, and meaning and necessity are preserved only in the linguistic practices which embody them. They are safe only because the practices gain a certain stability in that we agree in our interpretations of the rules" (Pears:179).

Derrida, like Kant and Wittgenstein, has also engaged in a "decentering." And, like Wittgenstein but unlike Kant, he has focused on language, primarily as it appears in texts. It is not surprising, therefore, that one of his key terms is "intertextuality," which Vincent Leitch defines as follows:

> Every text emerges out of a textual tradition. In actuality, countless sources, influences and epochs—both hidden and revealed, spoken and written—are interwoven into language itself. The very syntax and lexicon in the system of language carry the work of innumerable and often unnameable precursors. Consequently, the lineage of any text quickly approaches an impasse in the inevitable labyrinth of intertextual connections and combinations. (21)

Intertextuality brings to an eventual impasse not only a text's lineage, but also its critical interpretation. Like Wittgenstein's "elementary propositions," the place of a text within its tradition, as well as its "meaning," involve shifting boundaries.

Derrida has also criticized structuralist linguistics. As John Carlos Rowe points out, he argues that

> the structuralist's "signified" suggests "concepts" or "ideas" that might be abstracted analytically from the play of language. Derrida attacks structuralism by insisting that the "signified" is merely an "economy" of signifiers that may be interpreted only by the supplementary substitution of yet another chain of signifiers. The semantic mirage of the "signified" betrays for Derrida the structuralist's yearning to reinstate the "metaphysics of presence," which would offer the possibility of unmediated truth or meaning. (8)

We may compare this "metaphysics of presence" to the search for "essences" that Wittgenstein undertook in *Tractatus* and later abandoned. Like the later Wittgenstein, Derrida has attempted what he calls "the de-construction of the transcendental signified, which, at one time or another, would place a reassuring end to the reference from sign to sign. I have identified logocentrism and the metaphysics of presence as the exigent, powerful, systematic, and irrepressible desire for such a signified" (1976:49). Derrida's "deconstruction" of Western thought can be summed up most succinctly as follows: "*The thing itself is a sign*" (1976:49). Like Wittgenstein's "elementary propositions," "things themselves" never occur outside a web of signifying structures which influence and help to determine them.

Much of the burden of Derrida's major work, *Of Grammatology*, is to show that the so-called "thing itself" is a highly problematical notion. It is, says Derrida, "always already" a representation, "shielded from the simplicity of intuitive evidence" (1976:49). That is to say, the "thing itself" cannot be approached directly or without mediation. It comes into being for us only by giving rise to an interpretation "that itself becomes a sign and so on to infinity" (1976:49). In this sense, we may say that the "thing itself" always carries within it a necessary, if implicit, reference to *other* "things themselves." It cannot be constituted as a meaningful entity without taking its position within a matrix of other, cross-referential entities. The property of any "thing itself" is thus "to be itself and another, to be produced as a structure of reference, to be separated from itself" (1976:49–50). Derrida maintains that the "metaphysics of presence" has always tried to get around this difficulty by regarding the signifier as a mere self-effacing instrument at the service of the signified. "History and knowledge, *isotoria* and *episteme* have always been determined . . . as detours *for the purpose of* the reappropriation of presence" (1976:10). Yet, this is a reappropriation which must always—even from the "very start"—be a "re-," a repetition of a presence which was never truly there. The origin, writes Derrida, "did not even disappear"; rather, "it was never constituted except reciprocally by a nonorigin, the trace, which thus becomes the origin of the origin" (1976:61). "Presence" exists only within the interplay of presence and absence. "Privation of presence is the condition of experience, that is to say of presence" (1976:166).

Now then—given that Derrida has located what he calls the "contradictorily coherent" (1978:279) nature of Western thought, what is the point? Does this insight really change anything, or do we just put all our assertions in quotes and continue as before? I believe that Derridean analysis or "deconstruction" does make a difference, primarily in terms of reading texts. Indeed, Derrida almost always expresses his thought through the treatment of specific texts. Perhaps the best way to demonstrate such difference as deconstruction makes would be to look briefly at several of those treatments.

For example, in *Of Grammatology*, Derrida offers close readings of a 1948 dissertation by Lévi-Strauss and of *Tristes Tropiques*. In examining the former, he focuses on a passage which he calls "The Writing Lesson." This passage, says Derrida, "sets up a premise—the goodness or innocence of the Nambikwara" (the South American tribe among whom Lévi-Strauss worked) (1976:117). Lévi-Strauss states that the tribespeople's "embraces are those of couples possessed by a longing for a lost oneness; their caresses are in no wise disturbed by the footfall of a stranger" (285; Derrida 1976:117). Lévi-Strauss professes to find in the Nambikwara "a great sweetness of nature, a profound nonchalance, an animal satisfaction as ingenuous as it is charming, and . . . one of the most moving and authentic manifestations of human tenderness." Yet, as Derrida points out, "Round about the 'Lesson,' it suffices to open *Tristes Tropiques* and the thesis at any page to find striking evidence to the contrary. We are dealing here not only with a strongly hierarchized society, but with a society where relationships are marked with a spectacular violence" (1976:135). Derrida then goes on to quote a passage from the thesis testifying to the savagery endemic in Nambikwara life.

Later in *Of Grammatology*, Derrida examines several of Rousseau's writings and again finds a fundamental contradiction. One of Rousseau's most important tenets is the belief in a state of nature in which presence is full, is immediate to itself, and has no need for the "otherness" of explication or commentary; in short, no need for the exteriority of writing or other such "mere signs." Yet, Rousseau must employ writing and the exteriority of books to express this state. Otherwise it would remain unknown or, worse, misconstrued. The situation is similar when Rousseau attempts to convey his own, personal reality. In the *Confessions*, he says, "I would love society like others, if I were not sure of showing myself not only at a disadvantage, but as completely other than what I am. The part that I have taken of *writing and hiding myself* is precisely the one that suits me. If I were present, one would never know what I was worth."/1/ Thus, Rousseau must use the very exteriority, the very nonpresence he disdains, to make present his character and identity. The means belie the end. As indicated above, a state of pristine, unfallen nature cannot even be conceived apart from the play of self and otherness. Its conception is dependent upon "the opposition of presence and absence" (Derrida, 1976:143). This opposition cannot be attenuated or broken by valorizing one element as in some sense original. Without such

opposition, "the desire of presence as such would not find its breathing-space" (Derrida, 1976:143).

In other words—and the fact that I must employ "other words" shows that a kind of displacement or supplementarity lies at the heart of the constitution of presence and meaning—Rousseau could not make his notion of a "state of nature" comprehensible to anyone—even himself—if the possibility of writing, of the breaking of self-presence open into exteriority, did not already exist. It does a critic no good here to reply to Derrida that Rousseau can simply think to himself the notion of a "state of nature" and so dispense with writing. For Derrida's point is precisely that "thinking to oneself" is always already a kind of exteriority, an articulation of one aspect of self to an *other* aspect of self: i.e., a kind of message or "writing." Part of the impact of Derrida's work is to make us curious and more than a little anxious about the (necessary) gaps in our own presumed self-identities. When we talk to ourselves—and thereby constitute our identities—who does the talking, and who does the listening?

Derrida's readings of Lévi-Strauss and Rousseau are of course much more complex than suggested above. However, although our exposition offers only two brief examples of deconstructive reading, we may take them as illustrative of deconstruction as a whole. Deconstruction entails the playing off of one "text" or language-structure against another. In both cases noted above, several texts were used, and specific parts of individual texts were singled out as particularly representative of some viewpoint. This juxtaposition of texts or even what we might call "mini-texts" often involves the issue of intention. In fact, one of the earliest critiques of Derrida interrogated him on just this point. Paul de Man, in *Blindness and Insight*, charges that Derrida makes Rousseau seem more naive about his myth of pristine, self-present nature than he really is.

> Having convincingly demonstrated that an arbitrary inside-outside dichotomy
> is used in *Essai sur l'origine des langues* to make it appear as if the hardships
> of distance and alienation were wrought upon man by an external catastro-
> phical event, he makes it appear as if Rousseau understood this catastrophe in
> a literal sense, as an actual event in history or as the act of a personal god.
> Whenever a delicate transposition from the literary to its empirical referent
> occurs, Derrida seems to bypass Rousseau's complexities. (120)

In other words, Derrida tends to make Rousseau's intention more simple and single-minded than it was. For instance, de Man objects to the following sort of reduction. Rousseau, claims Derrida, "wants to say that progress . . . moves *either* towards deterioration, *or* towards improvement."/2/ But instead (still according to Derrida), "Rousseau describes what he does not want to say: that progress moves in both directions . . . at the same time."

Thus, by a resort to intention or to "what Rousseau really meant," Derrida establishes a particular interpretation which he then uses to "break

open" or "deconstruct" the text. Indeed, though calling it "too dialectical a solution," Christie McDonald does pose the rhetorical question, "Could it be that Derrida needs a sparring partner" (93)? I will not take up here the validity of de Man's and McDonald's remarks. Arguments could be made on both sides. I want simply to point out that Derrida engages texts in this way.

Another favorite deconstructive method of constructing a reading which can then be played off against another reading is to identify a critical trend or a customary, accepted interpretation. This is de Man's own strategy in "Shelley Disfigured," an essay in *Deconstruction and Criticism*. Quoting a gloss by Donald Reiman, de Man states that "it remains typical of the readings generally given *The Triumph of Life*" (Bloom:42), readings which are then shown to be belied by the poem itself. In fact, this technique has appeared often enough that Gerald Graff has incorporated it into his summary example of deconstruction: "Much of the criticism of the works of X has argued that these works revolve around some central view of the world. But a closer examination of these works reveals that any such thematic idea or ideal center which X's language presents as its point of reference or origin is called into question and compromised by this very language" (145). Intention, whether it be that of the author or of the "typical," critical reader, thus provides the deconstructor with one version of the text which, as noted, can then be opposed to an alternate version. In doing so, deconstruction highlights a universal dialectic of texts. For a text to be comprehensible or meaningful, it must (as must all language) partake of, participate in, and depend on all manner of "others": other language from other texts and other eras. That this dialectic pertains, to at least some degree, to any text is guaranteed by every text's ineluctable historicity, its setting, at whatever time it might be written or read, within a significatory context of enormous complexity and ambiguity.

Every text, to be recognizable as such, must attain some measure of unity, coherence, integrity, and independence; it thereby announces its presence. But in its connectedness with other texts, it announces their presence and its own absence. This is "intertextuality."

Some, who might be called "doctrinaire Derrideans" (i.e., more Derridean than Derrida himself), have taken this dialectic and applied it rather rigidly to the process of reading texts. If presence and absence are each other's dialectical prerequisite, they reason, then a reading emphasizing a positive aspect of a text (the "central view" of Graff, above) can always be opposed by another reading emphasizing a contrary and negative stance (the "calling into question" and "compromising" of Graff's summary). This "doctrinaire" technique is clearly illustrated by Hillis Miller's etymological peregrinations in "The Critic as Host" (Bloom:218ff.). Miller quotes M. H. Abrams's citation of Wayne Booth's statement that a deconstructionist reading is "plainly and simply parasitical" on what Abrams calls the "obvious and univocal reading" (Bloom:217). Then Miller notices that every parasite must have a "host," and proceeds to trace that

word and its ever-expanding group of cognates back through various languages. This analysis, he contends, shows that the word's opposite inheres in it. "A host is a guest, and a guest is a host" (Bloom:221).

> What does this have to do with poems and with the reading of poems? It is meant as an "example" of the deconstructive strategy of interpretation. The procedure is applied, in this case [i.e., the case of Miller's quotation of Abrams's citation of Booth's statement], not to the text of a poem but to the cited fragment of a critical essay, like a parasite within its host. . . . To get so far or so much out of a little piece of language, context after context widening out from these few phrases to include as their necessary milieux all the family of Indo-European languages, all the literature and conceptual thought within those languages, and all the permutations of our social structures of household economy, gift-giving, and gift-receiving—this is an argument for the value of recognizing the equivocal richness of apparently obvious or univocal language, even of the language of criticism. (Bloom:223)

Where does such an argument lead? Miller maintains that it leads not to nihilism (i.e., a refusal and rejection of metaphysics), but to a twilight zone between nihilism and metaphysics.

> Deconstruction does not provide an escape from nihilism, nor from metaphysics, nor from their uncanny inherence in one another. There is no escape. It does, however, move back and forth within this inherence. It makes the inherence oscillate in such a way that one enters a strange borderland, a frontier region which seems to give the wildest glimpse into the other land ("beyond metaphysics") though this land may not by any means be entered and does not in fact exist for Western man. (Bloom:231)

Miller admits that this represents a kind of extremism. "This 'place' . . . may be made to appear . . . only by an extreme interpretation of that text, going as far as one can with the terms the work provides" (Bloom:231–32). But it may be this extremism which, while giving deconstruction some of its most penetrating insights, also creates serious limitations. Though these limitations are most pronounced in Derrida's Yale enthusiasts, they influence his own work as well. According to Frank Lentricchia, "The effect of his many analyses of representative Western thinkers is to give the impression that traditional philosophical discourse is monolithically preoccupied with a formally self-sufficient set of logocentric issues, that . . . Western philosophical discourse has eluded the multiple relations of force traversing any society" (176). When such massively overarching concepts as "logocentrism" or, as in Miller, "nihilism" and "metaphysics" become the operant categories in a textual analysis, there is a marked danger of all texts being equalized. Concepts like these are

> so historically inclusive that they deny that a given text, or group of texts, is enmeshed in circumstances any different from the circumstances that enclose any other text. Our impression (and it is an impression unavoidably shaped by the Yale mediation) is that at a certain preferred Olympian level of analysis

the environments (intellectual, social, political, etc.) of Plato, Descartes, Rousseau, and Lévi-Strauss are reassuringly interchangeable. (Lentricchia:176–77)

Lentricchia's appeal for greater sensitivity to the particularities of textual and historical interplay is appropriate and important. After all, Derrida's contention that "I don't destroy the subject; I situate it" (Donato and Macksey:271) should have committed deconstruction to a more careful investigation of the historical vicissitudes impinging upon the subjects which produce texts and readings—even if those subjects are themselves construed as texts.

In theory the Derrideans cannot believe in a self before interpretation, but since in their practice they have celebrated the free-play of interpretation without exploring the idea that the reading self is a kind of text, itself subject to constitutive determination, they allow us to conclude that beneath the theory lies the sort of solipsistic impulse . . . that Hirsch, Abrams, and others charge them with. (Lentricchia:187)

If, according to Derrida, we are afloat in an ocean of intertextuality, we are still in no way prevented from charting various courses within that shoreless sea. Michel Foucault, writing along these lines, states that he wants to "dispense with 'things'" and their ontological claims. His goal is to

substitute for the enigmatic treasure of "things" anterior to discourse, the regular formation of objects that emerge only in discourse. To define these *objects* without reference to the *ground*, the *foundation of things*, but by relating them to the body of rules that enable them to form as objects of a discourse and thus constitute the conditions of their historical appearance. To write a history of discursive objects that does not plunge them into the common depth of a primal soil, but deploys the nexus of regularities that govern their dispersion./3/

In his work, Foucault tries to articulate the space in which a given cultural phenomenon becomes manifest. Toward that end, he employs the notion of a "space of dispersion," a "discursive formation," or an *epistēmē*. This notion "provides a broadly Derridean alternative to the totalizing history that wants to draw 'all phenomena around a single center—a principle, a meaning, a spirit, a world-view, an overall shape.'"/4/ Within the epistēmē,

what Foucault calls the discursive *"rules of formation"* establish the conditions of the existence of the object. But because such rules, unlike a set of Kantian universals, have themselves only historical being, they change, they are themselves subject to appropriation, and therefore account not only for the existence of the object, but also for "coexistence, maintenance, modification, and disappearance."/5/

Foucault's published work demonstrates that while this approach follows the traditional quest for some measure of determinacy, it nevertheless eventuates in a history-writing more subtle and sophisticated than what we have been used to.

In a sense, this essay has now come full circle, in that Foucault's attempt to trace the connections within a certain field of play (the epistēmē) bears a striking resemblance to the later Wittgenstein's position on ascertaining the meaning of a language. It was a mistake, Wittgenstein decided,

> to suppose that each elementary proposition gets its meaning independently of every other, because the truth is that they come in interrelated groups. . . . It would be a natural development of this new account of elementary propositions to say that the meaning of any proposition is always a function of its place in a larger whole. This, of course, is what he does say in his later writings. He does not completely reject the old method of analysis by paraphrase. But he is always aware of its limitations, and of the need to supplement it with an account of the surroundings of a particular kind of utterance, and of its place in our lives. (Pears:191)

We are thus left with a scholarly task which is in many ways like the old one, but as Lentricchia says, "the old one disturbed, questioned, its duplicities and its techniques illuminated" (210).

I will now offer a brief example of how deconstruction might be applied to the New Testament. As we shall see, the latter is in some ways ripe for such analysis. The first thing we need to establish is a "positive" reading, one which offers a theme to be questioned or compromised. Any biblical scholar worth his or her salt should be able to find and substantiate such a reading. I have chosen one in Colossians, a text which is especially closely gathered around a central theme and a central figure of speech. The theme might be expressed as "the presence of the divine," and the figure of speech as "the Body of Christ." The occasion for the letter was the outbreak of heretical doctrines and practices among the community of Colossae. The author admonishes his readers to eschew such aberrations as unnecessary and misguided in view of the fact that Christ's actions have already assured their salvation and that he is even now among them. His presence in the community is described in bodily terms. For instance, a change has been made in the hymn of 1:15–20, placing "the church" in opposition with "the body." The effect of this change is to portray Christ as indissolubly linked with congregations like the one being addressed. Again and again, Colossians echoes the motif of a bodily continuity between the believers and Christ: "In him also you were circumcised . . . and you were buried with him in baptism, in which you were also raised with him. . . . And you, . . . God made alive together with him" (2:11–13). Conversely, the author criticizes the heretics for "not holding fast to the Head, from whom the whole body, nourished and knit together through its joints and ligaments, grows with a growth that is from God" (2:19). We might go so far as to say that the theme of the believers' substantial and effective continuity with Christ provides the basic presupposition without which Colossians could not have been written. After all, who would bother to send such a letter to outsiders, who might better profit from proclamation than admonishment or instruction?

Looked at from another perspective, however, this presupposition makes contradictory the entire enterprise represented by the epistle. If we assume that the believers at Colossae did have a living connection with Christ, then we must ask why it was necessary for anyone to do something so mundane as to write a letter in order to set them straight. Derrida has pointed out that Western culture has generally considered writing "as mediation of mediation and as a fall into the exteriority of meaning" (1976:12–13). For our purposes here, we might say that it would be embarrassing if a community, having been established in Christ by the preaching of an evangelist (cf. Col. 1:7a), would then have to be spoken to again because that establishment apparently did not "take." But it would be doubly embarrassing for the community to be in such sad shape that the author has seemingly despaired of the power of God's living voice to correct it, and has instead resorted to the relatively dead and exterior, twice-removed mediation of writing.

Perhaps this way of looking at the epistle can help us to understand the contrast between the grand, poetic theology of most of the first three chapters, and the rather banal directives of 3:18ff. For it appears that Colossians contains little paranesis which, according to its own doctrine, could not be gained in a much more valid and effective manner from prayerful, immediate contact with the vital speech of God. If it, as a kind of "fallen speech," is really necessary, then its point about the believers' direct connection with God must be seriously called into question. The more theological portions of the epistle are so intensely oriented toward the simple, fundamental sufficiency of divine contact that it is difficult, if not impossible, to evolve an ethic out of them. The author is thus left with bland exhortation, most of which might appear in any Hellenistic treatise on the subject.

Now, I admit that the organic metaphors used throughout Colossians make allowance for some sort of guidance to help the community grow and come to fruition. But at the same time it seems to me that by Colossians' own statements, such guidance can and definitely should come from the divine itself. The believers are already "in"; they have achieved communion with Christ and the latter, if he is a true and effective savior, should be able to take it from there. Again, the need for writing is, as it was in Derrida's reading of Rousseau, a distinct embarrassment. The means belie the message.

Having now seen an actual "deconstruction," the reader may well ask, "What good is it? What lesson does it teach?" After one has seen a number of deconstructions and learned how to do them, they can seem facile and repetitive. But in this, deconstruction is no different from any other critical technique, be it a structuralist chart or a "close reading" of the New Criticism. We need not all become deconstructionists and go about showing how every text entails its opposite; scholarship is already too mired in that sort of mechanical instrumentalism. But we should learn what deconstruction has to teach us. The essence of that lesson is as follows. A clever deconstructionist can show that a given text and its negation are inextricably intertwined. That this is

possible demonstrates powerfully the interconnectedness of texts with other texts. If a critical reader can get from Text A to the opposite of Text A without making any illicit jumps, then the bonds linking all texts with all other texts must be very strong indeed. Perhaps in some ways this is no news, but neither was the Golden Rule. It is often the old lessons which need to be stressed sharply again and again. However, no matter how prominently interconnectedness may have figured in the thought of philosophers from Heraclitus to Heidegger, an application of a Derridean-Foucauldian perspective would most certainly change the shape and orientation of biblical studies.

Let me offer a thumbnail sketch of the discipline, with a particular eye towards my own specialty, the New Testament.

Form criticism, in its legitimate attempt to locate a *Sitz im Leben* for textual units, has necessarily lent a fragmented, atomistic tone to much biblical scholarship. In reading form critical studies, one often gets the feeling that a pericope is being pinned to a specific setting which produced it and of which it is reflective. Understandably, this leads to a rather poor sense of the animated, ongoing exchange which takes place between texts and the people and conditions that create, influence, and are influenced by them. I do not mean here to question form criticism's legitimate goals, only to point out its tendencies.

Redaction criticism has ameliorated the fragmentary vision of the Bible which form criticism sometimes fostered. However, since the redactional focus has usually been on a single work, a sense of the interconnectedness of different texts and different *Sitze* has still been lacking in many cases. As the reader should know from the above exposition, the effect of Derrida's and Foucault's work has been to stress this interconnectedness most strongly.

In New Testament studies, the notion of "trajectories," put forth by J. M. Robinson and Helmut Koester in their 1971 book, offered a promising step in the desired direction. However, neither scholar has really followed up on the notion. In any event, the "trajectories" pointed out by Robinson and Koester had mainly to do with interaction among texts themselves, and tended to leave out wider considerations. More recently, several books have been published on the sociological background of the New Testament. These are certainly valuable in so far as they represent a renewed interest in the relatedness of texts and their situations, but this emerging sociological trend seems in many ways to be following form criticism's closely focused movement from text to setting. The latter is conceived more broadly, to be sure, but there is still lacking the sensitivity to the interchange of texts which a more Derridean-Foucauldian tack might offer.

We are left, then, with a prospect which is not particularly sanguine. Perhaps the reason for this fact is that biblical scholarship has customarily sought to uinderstand the documents before it as expressions of a theological position, rather than as cultural artifacts. If we take Derrida and Foucault seriously, then we must admit that no text is or can be a direct expression of

anything; that would be tantamount to the "thing itself" discussed earlier. Derrida and Foucault make us aware of the extent to which each text is simply a *locus* for the confluence of various precursor texts. The intertextuality which these two Frenchmen highlight precludes viewing biblical texts simply—or even primarily—as assertions about God. It would be much truer to say that they are assertions about other assertions. Furthermore, as has been shown by Foucault, "intertextuality" cannot be limited to documents alone. To be consistent, we must also investigate the interplay of the "texts" of, say, social, political, and economic realities. These three can certainly have an impact on the formation and character of documents—as the latter can on them. In this way, documents and social, political, and economic phenomena can be seen as texts that enter into and compose each other.

Hence, biblical scholarship needs to cast its net more widely. Events like the Exile, Alexander's conquest, and the destruction of the temple usually make it into commentaries and introductions, but the sense of a surrounding, cultural fabric into which biblical texts were woven remains weak. Alisdair MacIntyre encourages us in the right direction: "Consider what it is to share a culture. It is to share schemata which are at one and the same time constitutive of and normative for intelligible action by myself and are also means for my interpretations of the actions of others" (453). It can only mislead ourselves and others if we conduct our scholarship as though the particular "schemata" with which we are concerned are even relatively isolated or do not need to be traced throughout the cultural matrix in question. Literature, of whatever sort, always reflects its milieu. Literature which is regarded as exceptional enough to warrant canonization (whether in religious or secular traditions) has the power to transform subsequent developments in its milieu. Thus *ethos* produces texts, and texts produce *ethos*. We need badly to examine and understand this interchange better than we do. For instance, how might social stratification, political power plays, or prevailing economic conditions have affected various biblical texts? How might those texts, once written, have been used to pursue social, political, or economic ends? Why were some texts kept and others discarded? These and similar questions must be brought under consideration.

The task is not merely "academic." Our old cultural schemata have experienced significant change in the recent past. Now and in the years ahead, we will all be forced to take on an increasingly global perspective. People from Eastern, Near Eastern, African, and Western cultures will have to deal with one another more and more. Often they will find that the respective schemata according to which they behave do not correlate, leading to embarrassing and dangerous conflicts. Biblical scholarship, even in an era when its sense of direction seems weak or nonexistent, is in an especially good position to help with this dilemma. If we can gain a better idea of how myths work, perhaps we can also understand how our old ones might be used or new ones fashioned to create a more viable and humane world.

NOTES

/1/ Quoted in *Of Grammatology*, p. 142; this passage of the *Confessions* is cited by Derrida within a section of Jean Starobinski's *La transparence et l'obstacle* (Paris, 1958), p. 154.

/2/ Derrida's words; quoted by de Man, p. 120.

/3/ Quoted by Lentricchia, pp. 195–96, from *The Archaeology of Knowledge*, trans. A. M. S. Smith (New York: Harper, 1972), pp. 47–48.

/4/ Lentricchia, p. 191; inner quote from *The Archaeology of Knowledge*, p. 10.

/5/ Lentricchia, p. 194; inner quote from *The Archaeology of Knowledge*, p. 38.

WORKS CONSULTED

Ahlstrom, Gosta Werner
 1973 Review of *Palestinian Parties and Politics that Shaped the Old Testament. History of Religions* 12:372–77.

Bloom, Harold, et al.
 1979 *Deconstruction and Criticism.* New York: Seabury Press.

Derrida, Jacques
 1976 *Of Grammatology.* Trans. G. C. Spivak. Baltimore: Johns Hopkins University Press.
 1978 *Writing and Difference.* Trans. Alan Bass. Chicago: University of Chicago Press.

de Man, Paul
 1971 *Blindness and Insight.* Oxford: Oxford University Press.

Donato, Eugenio, and Macksey, Richard, eds.
 1972 *The Structuralist Controversy.* Baltimore: Johns Hopkins University Press.

Freedman, David Noel
 1973 Review of *Torah and Canon. JBL* 92:118–19.

Graff, Gerald
 1979 *Literature Against Itself: Literary Ideas in Modern Society.* Chicago: University of Chicago Press.

Leitch, Victor
 1979 "The Book of Deconstructive Criticism." *Studies in the Literary Imagination* 12:19–39.

Lévi-Strauss, Claude
 1961 *Tristes Tropiques.* Trans. J. Russell. New York: Criterion.

McDonald, Christie
 1979 "Derrida's Reading of Rousseau." *The Eighteenth Century* 20:82–95.

MacIntyre, Alisdair
1977 "Epistemological Crises, Dramatic Narrative and the Philosophy of Science." *The Monist* 60:453–71.

Pears, David
1977 *Ludwig Wittgenstein*. New York: Penguin Books.

Pietersma, Albert
1972 Review of *Palestinian Parties and Politics that Shaped the Old Testament*. *JBL* 91:550–52.

Robinson, James M. and Koester, Helmut
1971 *Trajectories through Early Christianity*. Philadelphia: Fortress Press.

Rowe, John Carlos
1979 "Structuralism or Post-Structuralism: The Problem of 'The Discourse of History.'" *Humanities in Society* 2:17–23.

Sanders, James Alvin
1972 *Torah and Canon*. Philadelphia: Fortress Press.

Smith, Morton
1971 *Palestinian Parties and Politics that Shaped the Old Testament*. New York: Columbia University Press.

Theissen, Gerd
1978 *Sociology of Early Palestinian Christianity*. Trans. J. Bowden. Philadelphia: Fortress Press.

West, Cornel
1979 "Introduction." *USQR* 34:67–70.

Religious-Imaginative Encounters
with Scriptural Stories

John Shea

The current rumblings in biblical studies suggest a widening of both its methods and its concerns. The methodological expansion is to integrate the various types of historical and literary approaches to the text. The expansion of concerns is to consider not only the prehistory of the text, but its parahistory (significant parallels), and its posthistory (its fate in the hands of later generations) (Crossan). In other words, hermeneutics becomes the tracing of the historical process of the interpretation and transmission of a text (Raschke). The meaning of a text is not fixed but comes about in successive reinterpretations.

With this interest in the postbiblical handling of the text and the ongoing nature of hermeneutics, students of religion will run into a distinctive use of Scripture which is often overlooked. This way of encountering Scripture might be called religious-imaginative. It is religious because the text "performs" like a sacred object, and interaction with it yields an appreciation of the sacred within the profane. It is imaginative because the way of expressing this appreciation is not to interpret the text in "companion language" but to retell the text, reconstructing its elements to express and communicate the experienced meaning. Not all biblical texts are equally open to this process. The stories of the Bible are the primary raw material for this type of encounter.

It is the inclusive dynamics of narrative which make it especially appropriate for a religious-imaginative encounter. Stories have a pull, an interest-lure which brings the readers inside and subjects them to the pain and possibility the characters are undergoing. In the presence of story the reader easily moves from observer to participant (Wilder:84). In fact, recent studies on the parables suggest that this reader participation in the story is not an unwarranted intrusion (cf. *Semeia* 9, 1977). It is not a matter of subjective projection which distorts the story by importing the reader's concerns into the tumult of plot and character. Rather the parables would not be parables without a high degree of reader cooperation. Their objective structure demands it. "The parables invite, even compel the interpreter to become a creator, to engage the text by joining in the creation of its meaning" (Tolbert:70). This seductive nature of story encourages a religious-imaginative encounter.

The retelling of biblical stories which comes about as a result of a religious-imaginative encounter happens in many different settings. On one level, ordinary Christians often relate to the Bible in this fashion. A particular story will strike them or disconcert them, and they will express their sudden self-awareness by elaborating on the story (Shea:160–67). They will add more descriptive material, put more dialogue into the mouths of the characters, take an omniscient third-person posture, and unravel the complex motivations for an action. On a second level, preaching has always engaged in imaginative retelling. Frederick Buechner's work (1966; 1979) contains many examples of this mode of biblical relating. A third level (and our focus) is the transformation of biblical stories in the hands of Christian poets. Christian poets have retold the biblical stories in fascinating and innovative ways. There is no room in this space to parade examples or even to attempt an in-depth analysis of a single retelling; but to situate the discussion concretely—T. S Eliot's *Journey of the Magi*, Brother Antoninus's *Jacob and the Angel*, and Daniel Berrigan's *Abraham* are examples of the poetic dimension of a religious-imaginative encounter.

The poetic retelling of religious-imaginative encounters is the most stable. When ordinary Christians in conversation retell the stories, the result is most often idiosyncratic. They express what they have found in the encounter, but the finding has little resonance outside their own lives. The self-expression can seldom be extended into an exploration of the human condition which all share. So while the retelling has importance in the individual's personal life, it does not have the potential to enter into the mainstream of the community and the tradition. But poetry, if Eliot's ambitions for it are valid (Drew:50–51), attempts to move beyond self-reference to reconfigure the spiritual life of its times.

The imaginative retellings which occur in preaching and are subsequently written down lack the artistry of poetic efforts. These public retellings strive to uncover a universal pattern in the particular rhythms of the story and to tell it so that all hearers would see themselves. And while the inescapable demands of life are often illumined in these efforts, the retelling lacks the intensity and penetration which artistic expression embodies and conveys. The story is retold and new meanings "fall from it"; but it is not a riveting experience, not a memorable re-expression. The poetic retellings of Scripture stories attempt a permanent place in community attention and memory. They cluster around the original story and reveal its ongoing power to trigger human reflection and capture the religious dynamic of human living.

These brief reflections focus on the dynamics of religious-imaginative encounters, especially in their poetic mode. They attempt to sketch the major moves of this process. This is a logical mapping of one *possible* way of understanding the encounter and its expression. It is not a statement of actuality, i.e., this is what happens in every poetic retelling. The perspective at work is both

religious and theological, and so it is those concerns which are analyzing and organizing the data of religious-imaginative encounters and retellings.

A religious-theological focus discerns four general elements. First, there is the predispositional factor of the tradition and the corresponding psychic posture of the reader toward the text. Secondly, there is the revelatory moment itself, the finding. Thirdly, there is the retelling of the text, expressing what was found. Fourthly, the retelling is situated in the history of the text and within the convictions and values of the larger tradition. These factors highlight the fact that religious-imaginative encounters occur within a social fabric which both encourages and criticizes them.

1. What a reader brings to a text has long been recognized as a powerful factor in interpretation. Recent attempts at a "reader critique" have taken the route of exploring genre as a generative principle (Gerhart), and ferreting out the conceptual matrix and specific cognitive interest of the individual reader (Turner). But what is often overlooked is the broader orientation that socialization into the Christian faith provides. Thoroughly socialized Christians approach the Bible as a Holy Book. They are geared for neither historical information nor literary insight. They are looking for salvation.

This basic assumption which the Christian tradition generates was strikingly present at a recent lecture. A well-known scholar spent a good deal of his podium time detailing how archeologists cannot find the precise location of Emmaus. They are debating, he told his audience of ministers and divinity students, between three different sites. The first comment from the floor was, "I don't think they can find Emmaus because no one knows the outcome of any journey with Christ." The man immediately took the mundane archeological facts and turned them into religious meaning. He had not come for archeology and he would not leave with it. It is a commonplace of New Testament scholarship that the Gospels were written "from faith to faith." That intentionality still prevails. The Christian tradition provides the nonscholarly reader of the Bible with a salvific predisposition.

This general orientation of the Christian reader is complemented by a specific psychic posture. In historical and literary approaches to Scripture the reader is aggressive and single-minded. The concerns of each approach are clearly delimited, and all energies flow within the banks of those concerns. In a religious-imaginative encounter with Scripture the psychic posture is receptive and open-ended. This does not mean that the reader has no specific interests, only a vague concern for salvation. But these interests are not "marshalled for attack," screening out all that does not fit and prosecuting the text from their exclusive point of view. The narrowing down of the salvific predisposition is not previously determined. It happens in the encounter with the text. No doubt the concrete salvational concern which surfaces in the encounter was present in the life of the reader previous to the reading; but it was not a conscious methodological tool of inquiry. This

approach makes the text more of a dialogic partner than an object of investigation. The question is not what will the text yield, but in the presence of the text what will be "yielded up" about the reader's relationship to God. When a reader approaches the text under the rubric of "believer," she approaches not to discover but to be discovered.

The poetic-religious encounter is playful and meditative. If the interaction between the reader and the text takes the reader on a "seemingly aberrant" train of thought and feeling, he follows it. He may return to the text periodically, but the text functions more as a catalyst than as a control. The metaphor for its role in this creative reflection is "launching pad," not "boundary." The reader and, through the reader, "the experience of the times" are the center of this process, and his imagination is initiated and subsequently stimulated by the text.

2. The interaction between the reader and the text issues in a disclosure experience (Ramsey). The first moment of this experience is that the reader is situated in the relational flow between himself and the ultimate mystery he lives within. The everyday boundaries of consciousness are expanded to include, in an explicit way, the religious dimension. Awareness is focused on the ultimate conditions of existence which permeate and color all our proximate environments. The second moment uncovers a specific conflict or possibility which this relationship engenders. The reader is not only triggered into religious reality; she is positioned within it. A religious-imaginative encounter with scripture evokes both the fact of a relationship to ultimacy and a content to that relationship.

The religious content that a reader discovers may be similar to the religious struggles that characterized the historical situation in which the text was created. It has been suggested that the way to a revitalization of the Bible is to move beyond the false alternative of history or theology to a recovery of biblical religion (Batson, Becker, Clark:22–42). Or the religious struggle which the text precipitates in the reader may be in close continuity with the religious struggle a literary analysis would uncover. For example, Walter Brueggemann suggests this religious dynamic of the Succession Narratives: "David trusts in Yahweh who trusts David with remarkable freedom and guarantees him space in which to have his freedom. Such a subtle affirmation of faith must have been much needed in the tenth century, even as it is now" (18). It is hoped that the religious possibility which the text objectively displays will be the religious possibility which the reader will experience.

But on the other hand, what happens to the reader in the encounter may move in a direction which neither historical nor literary criticism can foresee. The religious dynamics which Eliot expresses in *Journey of the Magi* are far from the Matthean use of story and barely suggested by anything within the text itself. Antoninus's *Jacob and the Angel* sticks closely to the incidents of the Genesis narrative, but the redemptive struggles it portrays move well beyond what historical or literary investigation would

uncover. It seems the consequence of advocating an open-ended hermeneutic is the construction of a continuity-discontinuity continuum. The factors within this continuum must be the text and the consciousness of the community which remembers and holds in honor the text. The religious struggle of the original people and author or the struggle overtly at work within the story may be communicated to the reader. But then again, an allied but strikingly different religious dynamic may be precipitated.

3. The reader expresses what has been found in the encounter by imaginatively recasting the story. The standard understanding of a religious use of language is that it is multi-intentional (Ricoeur:11; Gilkey:290). It refers to the finite object and to the infinite reality which approaches the person through the finite object. But since the nature of transcendent reality is to include within itself whatever it approaches, language about it is always self-involving. Language happens in the relationship between the self and the sacred, and therefore includes both realities. Therefore, religious language has simultaneously three "touch" points: the speaking self, the medium of disclosure, and that which was disclosed. In other words, there is compressed in religious speech an existential, mediatory, and ontological dimension.

In the language of religious-poetic retelling the self and the sacred "go underground." The medium bears the burden of the revelation. The language is not explicitly self-referential. Nor does it explicitly name the qualities of the Other that was encountered. The language works its magic on the medium, transforming it to express and communicate what happened in the encounter. The poetic-religious process recasts the medium so that the self and the sacred are both hidden and revealed.

The Gospel transformation of Jesus into Christ exemplifies this process. Jesus is the medium of redemptive revelation. As Christian reflection on his mediatorship has always demanded, he brings people to God and God to people. Yet as the medium of religious experience he is not portrayed in a neutral, factual way. He undergoes a mythical, biographical process (Reynolds and Capps). He becomes the Matthean, Markan, Lukan, and Johannine Christs. These transformations are for the purposes of expressing what was revealed through him about the relationship between the people and God. Although the Gospel redactors had theological points to make, the way they made them reflects the poetic-religious process.

The Gospels which transformed the person of Jesus for the purposes of expressing what Jesus communicated are repaid the compliment by later generations of Christians. The Gospels and the individual episodes within them become a medium and are, in turn, transformed to express the new encounter between the self and the sacred which they engendered. This "chain" of mediation is reflected in the threefold meaning of the code phrase: Word of God. In Christian faith the Word of God is primarily Jesus of Nazareth. Secondarily, it is the scriptures which bear witness to him. Thirdly, it is what happens to hearers and readers when the scriptures are

told or read, and it is what they say in response.

One of the salutary side effects of this poetic-religious form of expression is that the medium maintains its mediatory status. The initial scriptural story was generated out of a religious experience; and it is meant to evoke religious experiences. But often the medium "thickens" (Ricoeur:354). It is observed rather than participated in; it becomes an object of investigation rather than a conduit of experience. Poetic retellings are the most blatant evidence that the text still has the power to mediate religious reality. The story precipitated the experience of the poet, and through the poet's retelling perhaps the experience of many.

4. The tradition which provided the predispositional atmosphere, which was implicitly operative throughout the encounter and the retelling, is now explicitly consulted. Since our focus is religious and theological, we are not considering the poetic retelling from an artistic viewpoint. We do not want to judge its literary merits. Our task is to place it in the context of the original story with its consequent interpretations and embodiments and within the scope of the community's convictions and values. While this distinction can be employed for the purposes of understanding, it is abstractive and, to that extent, artificial. In actuality, the quality of the poem as poem is an essential part of the truth of its expression and of its capability in evoking other religious experiences.

First, any poetic retelling stands in relationship to the multiple interpretations of the specific story it has recast. The streams of interpretation can be constructed thematically or structurally. David Steinmetz integrates the many interpretations of a story by setting up a field of meanings. "The language of the Bible opens up a field of possible meanings. Any interpretation which falls within that field is valid exegesis of the text, even though that interpretation was not intended by the author" (32). He exemplifies this procedure with the parables of the workers in the vineyard and traces five interpretations of this parable in the course of Christian history. It has been used to understand Christian and Jewish relations, the problem of late conversion, the death of a young child, the question of proportional rewards in heaven, and the relationship of grace and works. Although each of these interpretations differs, they all affirm God's generosity to those who do not deserve it; and, therefore, they are legitimate renditions of the story. Steinmetz has exercised a meta-judgment. He has intuited the essence of the story—God's mercy to the undeserving. Any interpretation which falls within this field of meaning is accepted; any outside it is rejected. The original story and a judgment about its thematic message set the boundaries for future efforts.

Besides the suggestion of a thematic continuity based on a meta-judgment about the theological truth of the story, there is the suggestion of a structural continuity (Tolbert). The ongoing interpretation of a parable should be guided by the integrity of the story itself. It should take into account all the elements which constitute the total configuration of the story.

Arbitrary selectivity is inappropriate. The elements which should become part of any further interpretation are uncovered by an analysis of the surface structures and patterns of the parable. The aim of this framework of interpretation is "to avoid anarchy . . . while yet exploiting the polyvalency of the parable form" (Tolbert:71).

Secondly, there is a larger stream for reinterpreted texts which is constituted by the enduring convictions and values of the community. For poetic retellings of a given story this is a significant context. The freedom of religious-imaginative encounters often takes the story in new and startling directions. When it is placed in the history of the interpretation of the specific text, there seems to be little or no continuity. But when it is placed within the dynamic complexity of the religious experience of the community taken as a whole, a linkage is established. Antoninus's *Jacob and the Angel* is in some structural continuity with the original tale; but, more powerfully, it resonates with the dynamics of sin and redemption which the tradition affirms. Eliot's *Journey of the Magi* expresses and extends the birth-death themes which many parts of the traditions use to talk of contact with Christ. But its connecting lines, either thematically or structurally, with the Matthean text are weak. From a religious-theological perspective, the tradition which began the process by supplying a salvational predisposition receives the "process and product" back as an expression, not only of the individual's religious struggle and art, but of the community's history.

These sketchy notes focus on a secondary aspect of the Christian religious phenomenon—the poetic retelling of Scripture stories. They attempt to outline the possible religious dynamics which underlie their creation and to place them within the variegated expressions of the Christian tradition. If biblical hermeneutics is going to extend its range of concerns, the poetic retelling of biblical stories which Christians have engaged in is an important source of interpretation.

WORKS CONSULTED

Antoninus
 1962 *The Hazards of Holiness.* New York: Doubleday.

Batson, C. Daniel; Beker, J. Christian; and Clark, W. Malcolm
 1973 *Commitment Without Ideology.* Philadelphia: United Church Press.

Berrigan, Daniel
 1973 *Selected and New Poems.* New York: Doubleday.

Brueggemann, Walter
 1972 "On Trust and Freedom." *Interpretation* 26:3–19.

Buechner, Frederick
1966 *The Magnificent Defeat*. New York: Seabury Press.
1979 *Peculiar Treasures*. New York: Harper & Row.

Crossan, John Dominic
1977 "Perspectives and Methods in Contemporary Biblical Criti-
 cism." *Biblical Research* 22:39–49.

Drew, Elizabeth
1950 *T. S. Eliot: The Design of His Poetry*. London: Eyre &
 Spottiswoode.

Eliot, T.S.
1962 *Collected Poems 1909–1962*. New York: Harcourt, Brace &
 World.

Gerhart, Mary
1977 "Generic Studies: Their Renewed Importance in Religious and
 Literary Criticism." *Journal of the American Academy of
 Religion* 45:309–25.

Gilkey, Langdon
1969 *Naming the Whirlwind: The Renewal of God-Language*.
 Indianapolis: Bobbs-Merrill Co.

Ramsey, Ian
1967 *Religious Language: An Empirical Placing of Theological
 Phrases*. New York: Macmillan.

Raschke, Carl
1977 "Hermeneutics as Historical Process: Discourse, Text, and the
 Revolution of Symbols." *Journal of the American Academy of
 Religion* 45:169–93.

Reynolds, Frank, and Capps, Donald
1976 *The Biographical Process*. The Hague: Mouton.

Ricoeur, Paul
1967 *Symbolism of Evil*. Boston: Beacon Press.

Shea, John
1980 *Stories of Faith*. Chicago: Thomas More Press.

Steinmetz, David
1980 "The Superiority of Pre-Critical Exegesis." *Theology Today*
 37:27–38.

Tolbert, Mary Ann
1979 *Perspectives on the Parables*. Philadelphia: Fortress Press.

Turner, Geoffrey
1975 "Pre-Understanding and New Testament Interpretation." *Scot-
 tish Journal of Theology* 28:227–42.

Wilder, Amos
1964 *Early Christian Rhetoric*. New York: Harper & Row.

Literature and the Bible:
A Comparatist's Appeal

Theodore Ziolkowski

For at least three compelling reasons the Bible should stand close to the center of any consciousness that calls itself liberally and humanistically educated. First, with its almost unsurveyable variety of material—ranging from folktales to sagas, from biography to dramatic narrative, from psalms to erotic lyrics, from short story to epistle—the Bible constitutes one of the great works of world literature, fully deserving our constant perusal on its own merits. Second, as an anthology of themes and forms its impact—from mystery plays and Jesuit school dramas to Archibald MacLeish's *J.B.*, from versified harmonies and the epics of Milton and Klopstock to Thomas Mann's *Joseph and His Brothers*, from medieval hymns by way of the great religious poetry of the seventeenth century down to Rilke's *Marienleben*—has been so pervasive that no reader lacking a sound acquaintance with it can properly appreciate much of Western literature from early medieval times to the present. Finally, its language—in the earthy German of Martin Luther, the vigorous English of the King James version, or other vernacular renditions—has so profoundly shaped the idiom in which we speak and the images in which we visualize reality that it affects the very mode of our thought, even when we may be least aware of it.

It is not my purpose to rehearse truths that are so self-evident. The standard tools of literary study—bibliographies, dictionaries of theme and motifs, handbooks of literary terms, monographs on individual writers—adequately document the attention that the topic of literature and the Bible has elicited. I should like to take this occasion to explore a general misunderstanding that has touched me in my own studies—one that is perhaps inevitable in an interdisciplinary field that brings together students who approach the object of their common preoccupation from such different directions as religion and literary criticism. Let me cite an example.

Paul A. Cantor began a recent article on Byron's *Cain* with the statement: "When we see an author choose a Biblical subject, our natural reaction is to assume a pious intention on his part." In the course of his assessment the author concludes that Byron's treatment of the biblical theme, far from being pious, exemplifies the characteristic romantic inversion of the conventional Christian interpretation of Cain. What concerns me here is not the conclusion

but the assumption with which the paper begins. Why, if an author chooses a biblical subject, should it be our "natural reaction" to assume a pious intention on his part? If a writer selects his topic from classical antiquity, do we assume that he is motivated by a pagan intention? If a writer takes a subject from political history, does it entitle us to draw any conclusions about his voting habits—or, indeed, to guess whether or not he went to the polls at the last election? Thomas Mann devoted many works to characters suffering from various diseases: cholera (*Death in Venice*), tuberculosis (*The Magic Mountain*), syphilis (*Doctor Faustus*), cancer of the womb (*The Black Swan*), and others. Does that conspicuous fact permit us to deduce anything about his medical history? Of course not. Clearly, such far-fetched examples expose the absurdity of drawing from the author's choice of subject matter any conclusions about his own views. Why, then, if we assume that health and politics are as existentially urgent as religion, do so many people unthinkingly attribute a special value to biblical topics? Why should an author's choice of a biblical theme suggest anything at all about his intentions?

I have singled out Cantor's article not in order to attack it—it is in fact a sound literary analysis—but because it is representative of an assumption that often confounds discussions of literature and the Bible—the assumption, namely, that a biblical topic is by definition a religious topic. I am not suggesting, of course, that a biblical topic is *never* religious. Indeed, in the christocentric society that Europe typified down through the seventeenth century, it was generally appropriate to assume that virtually all cultural products, whether explicitly biblical or not, referred to the commonly shared religious center. For example, recent research on Old English literature has demonstrated persuasively that texts once thought to be dominated by pagan Germanic virtues are in fact extensively permeated by Christian ideals.

In the course of the past three centuries, however, that situation has changed substantially. In the first place, the receding of the Sea of Faith that Matthew Arnold sadly noted in "Dover Beach" produced a general secularization of Western culture, with the result that one can no longer automatically assume any religious intention or belief on the part of writers. "What I do wish to affirm," T. S. Eliot argued in his seminal essay on "Religion and Literature," "is that the whole of modern literature is corrupted by what I call Secularism, that it is simply unaware of, simply cannot understand the meaning of, the primacy of the supernatural over the natural life." It is sometimes objected that the process of secularization is not complete because fundamentalists in the Bible Belt still take their Bible literally, and certain American Indian tribes still perform their rain dances. These examples— which I take from responses to my work—while perfectly true are almost wholly irrelevant. Those segments of our culture in which secularization has been retarded have simply not produced many leading practitioners of modern literary culture.

In the second place, the general secularization of Western culture also

deposed the Bible from its dominant position as Holy Scripture. But to the degree that the Bible lost its privileged status as a religious text, it gained new appreciation as a historical and as a literary document (Ziolkowski, 1977a). As a result, in the nineteenth and twentieth centuries we are often dealing with writers who are motivated by no particular religious faith and who regard the Bible simply as one of the cultural possessions among which they may pick and choose for their subject matter, titles, mottos, chapter headings, images, and forms. We know, for instance, that Hemingway sometimes flipped at random through the King James Bible, Shakespeare, and *The Oxford Book of English Verse* in search of appropriate titles—*after* the story or novel was finished. It would be an egregious methodological error, in such cases, to reason from the title back to any particular intention on the author's part. Thomas Mann observed that he stumbled upon the subject matter of his Joseph-tetralogy accidentally and not from any abiding interest in the Bible or any deep religious concern. Far from displaying any religious purpose, it was his intention "to demonstrate that it is possible to be mythic in a humorous manner." Günter Grass, who has made extensive use of biblical motifs and themes in his works, confided to an interviewer: "Questions of religion simply do not disquiet me."

In sum, when we approach a twentieth-century writer, we are not entitled to presume any religious intention from his use of biblical motifs or subjects. Old and New Testament alike belong to the storehouse of forms and materials from which writers indiscriminately take what they need. In a secularized age the stories of Joseph or Jesus have no more inherent religious value than, say, the themes of Ulysses and Doctor Faustus as exploited, respectively, by James Joyce and Thomas Mann. In John Barth's *Giles Goat-Boy,* which amounts to an explicit parody of the New Testament, the story of Jesus claims no greater priority than the themes of Oedipus and Don Quixote, which also inform the novel. This is not to say that a biblical subject may not turn out to have religious implications; but that is a matter to be determined in the course of analysis—not to be presupposed at the outset from the author's choice of topic.

Now all of this is so obvious that it should require no justification. Yet what sophisticated critics know in theory, they sometimes ignore in practice. The Bible, and especially the Gospels, have such a special hold on our cultural consciousness that many find it difficult to maintain an objective detachment vis-à-vis the material. This circumstance generates the misunderstanding that sometimes occurs among scholars working in the field of literature and the Bible. Let me illustrate the difficulties with a particularly striking, if tangential, example.

When a television special on the life of Jesus was produced at Easter a few years ago, *TV Guide* commissioned me to write a "backgrounder" on earlier film versions of the Gospel story. In my article I mentioned medieval dramatizations of the Gospels, in which Jesus appeared in roles ranging from

the coarse jester to the serious teacher, from the severe judge to the gentle lover. If filmmakers since 1900 have portrayed Jesus as an athletic preacher or student revolutionary, their practice is totally consistent with a long tradition of ambivalence regarding his character. I suggested further that scriptwriters who display a curiosity about Jesus' human qualities (including his sex life) or who register a degree of skepticism concerning his alleged miracles (including the Resurrection) reflect certain widespread concerns of contemporary theology.

The response to my essay was disconcerting: scores of letters, almost unanimous in their indignation, poured in from television viewers all over the country. Readers angrily denounced me as being an "educated fool," a "pseudo-intellectual," an "atheistic show-off," a "very fine Pharisee," and even "satanic inspired." They accused me of intellectual arrogance, hypocrisy, irreverence, blasphemy, heresy and—in one memorably sonorous phrase—of "ignorant rantation." I was blamed not only for the corruption of wavering Christians but even for the bad weather that marred the winter of 1976–77. A number of readers canceled their subscriptions to *TV Guide*, others prayed for me; one speculated about the "terrible problems" that I must have in my own life, and another offered to come down to Princeton and "bop [me] in [my] ugly kisser."

Now what, after all, was my offense? I had simply characterized as accurately as possible various interpretations of the Jesus story. I passed no judgment and argued no case. Indeed, I took great care not to expose my own beliefs. Yet the readers projected onto me all their resentment at what they took to be blasphemous treatments of the Gospel narrative. Instead of taking cognizance, they took offense. Anyone rash enough to write for the popular press no doubt deserves what he gets. Yet if I had been discussing film adaptations of, say, the legend of Odysseus, probably not a single viewer would have lifted a pen to reply. To a significant extent the biblical subject matter itself precludes the detachment that should be the basis for reasonable discourse. Of course, scholarly disinterestedness is not necessarily what one expects from the readers of the mass media. Yet it gradually became clear to me—and now we move back to my proper subject—that the reaction of those readers was symptomatic for the problems of communication that sometimes occur among more sophisticated students of literature and the Bible. Let me draw once again upon personal experience.

In my book *Fictional Transfigurations of Jesus* I dealt at considerable length with a topic of literature and the Bible: specifically, I identified and analyzed a number of twentieth-century novels in which the Gospel story was used as a prefigurative basis for plots that expressed attitudes ranging from faith through skepticism to parody. The book was reviewed widely and, in general, quite amiably by scholars from both fields, religious studies as well as literary criticism. However, even generous reviewers were often troubled by my treatment of the Jesus theme. One reviewer objected that

"the Jesus myth is not like other myths." It differs from them because "we do not *believe* the Greek myths, [but] we believe the story of Christ" (Molnar:167). Another took me to task for patronizing Jesus as a culture hero. "We may liken Jesus to Hercules or Osiris, and claim that consciousness of myth frees us from its power. . . . But a difference persists" (Cooke:472). Both of these reviewers—and they are representative of many others—ignored the evidence I had presented to demonstrate that certain writers explicitly denied any religious intention in their works and, indeed, specifically compared the Jesus myth to other myths, as John Barth did. By transferring to the critic the attitudes of the authors, they avoided coming to grips with the uncomfortable fact that a number of contemporary writers in fact do regard the myth of Jesus as no more and no less than other culture myths of Mediterranean antiquity.

Other reviewers, carrying what I think of as religious imperialism a step further, denied not so much the results of the analysis but the very legitimacy of a criticism that is not religious in its approach. Thus Sallie McFague TeSelle objected that "Ziolkowski's self-limitation to formal considerations frees him from dealing with most of the sticky (and more interesting) questions surrounding literary interest in Jesus." TeSelle's remark is revealing because it suggests that she fails to appreciate the fascination and, indeed, the difficulty of formal-aesthetic analysis. But more disturbing is the implication that there is only one proper approach to criticism and one appropriate set of questions to be addressed to the literary work—not questions of literary merit but questions of faith. Similarly, John R. May argued that my "attempted separation of form and 'religious' meaning suggests the worst of the New Criticism insofar as he implies that meaning linked with faith can and must be excluded from literary analysis." *Hinc illae irae!*

New Criticism, understood narrowly as an obsessive concern with formal aspects of the literary work, is of course a red flag—or should I say a cloven hoof?—for many who come to the field of literature and the Bible from religious studies. As Giles Gunn has shown, the discipline of literature and religion arose in no small measure as a reaction against the excesses of the New Criticism, which in the hands of its most mechanical perpetrators sometimes did exclude considerations of meaning and value in favor of ironies, textures, and ambiguities. The study of literature from the religious standpoint—along with Marxian and other philosophical-sociological modes of criticism—played a major role in reaffirming the importance of ethical considerations in literary evaluation. Yet a single-minded obsession with "meaning" and "faith" can have two equally unfortunate effects. It can produce that intellectual imperialism that leads the critic to assume unthinkingly that all literature is religious—a different matter altogether from insisting that all literature may be viewed from a religious-ethical point of view. And it can cause critics to forget that the literary work is, after all, an aesthetic construct and deserves to be analyzed accordingly.

Eliot was alert to the dangers of both extremes, as he suggested in the opening propositions of his essay on "Religion and Literature." "The 'greatness' of literature cannot be determined solely by literary standards; though we must remember that whether it is literature or not can be determined only by literary standards." For Eliot, ethical or theological criticism should *complete* a more purely literary criticism—not replace it. Yet many of the critics who are working at present in the area of literature and religion forget that basic principle, often ignoring the formal aspects of literature and even denying the legitimacy of any criticism that begins quite appropriately by applying literary standards to the work of art. This antiformal bias, I maintain, can be just as counterproductive as a monomaniacal formalistic approach—and doubly so when we are dealing with a subject matter that is biblical and where, therefore, there is already a pronounced—albeit illogical—predisposition to assume that it is religious in thrust.

My own interest in questions of literature and the Bible has emerged from my work as a comparatist, not as specialist in religion. For all the reasons cited in the first paragraph I believe that the Bible constitutes one of the central texts for any comparative study of literature. I am equally convinced, however, that the *literary* critic, in contrast to the religious critic of literature, must put his faith or his beliefs aside if he does not wish to miss important connections in a secularized age. Let me give a few examples.

Certain modern poets have written "psalms" that can be identified solely by their literary form (parallelism) and not—as in the early church hymns— by their content and imagery. In the case of Georg Trakl we can still speak of a simple secularization of genre, for the content and the images, though wholly mundane, stand in no crass opposition to the biblical form:

> Psalm
> . Es ist ein Licht, das der Wind ausgelöscht hat.
> Es ist ein Heidekrug, den am Nachmittag ein Betrunkener verlässt.
> Es ist ein Weinberg, verbrannt und schwarz mit Löchern voll Spinnen.
> Es ist ein Raum, den sie mit Milch getüncht haben.
> etc.

But in Bertolt Brecht's *Hauspostille*, form and content of the so-called "Psalm" diverge so radically that we recognize in it a sort of parody:

> Dritter Psalm
> 1. Im Juli fischt ihr aus den Weihern meine Stimme. In meinen Adern ist
> Kognak. Meine Hand ist aus Fleisch.
> 2. Das Weiherwasser gerbt meine Haut, ich bin hart wie eine Haselrute, ich
> wäre guts fürs Bett, meine Freundinnen!
> 3. In der roten Sonne auf den Steinen liebe ich die Gitarren: es sind Därme
> von Vieh, die Klampfe singt viehisch, sie frisst kleine Lieder.
>etc.

Obviously the interpretation of the poems leads to questions of a substantive

nature: in the case of Brecht the irony is produced precisely by the absence of the religious content that the title suggests. But the identification of the poem as a "psalm" begins with purely formal criteria. Indeed, a preoccupation with meaning could even prevent the critic from recognizing the biblical form of the poems.

The priority of formal analysis is evident in any generic approach to literature, but it should be equally apparent in thematic approaches as well, for it is the structure of the work that enables the critic initially to group works thematically. The theme of Job, for instance, has been conspicuously important in twentieth-century literature, especially in Germany. Any student coming to grips with MacLeish's *J.B.*, Oskar Kokoschka's expressionist dramolet *Hiob*, Joseph Roth's novel *Hiob*, or Alfred Döblin's *Berlin Alexanderplatz* (in which the contrasting themes of Job and Orestes are used to characterize the hero) will of course need to compare the modern treatment of the material with the biblical source. It becomes rapidly apparent, however, that the originally "religious" content of the legend has been almost wholly secularized in the twentieth century to express sexual (Kokoschka), political (Roth), or psychological (Döblin) concerns.

If we use thematics to establish diachronic rather than synchronic connections we can identify a group of works from the mid-eighteenth century to the present that exploit in the opening paragraphs the motif of the Fall in order to signify the hero's emergence from childhood innocence into consciousness: Voltaire's *Candide*, E. T. A. Hoffmann's *The Golden Pot*, Joyce's "Araby" (in *Dubliners*), Hermann Hesse's *Demian*, and Günter Grass's *Cat and Mouse* (Ziolkowski, 1979). In these cases it is exclusively formal criteria that enable us to identify the motif and group the works since—unlike the works based on the Job-theme—nothing in the title or chapter headings suggests the presence of the motif. But when thematic methodology moves from formal analysis to substantive interpretation, it turns out that in no case is the meaning "religious" as such. Indeed, Joyce's story amounts to a little tragedy of a consciousness awakening to the realities of a totally secularized world.

The same principle of dissociation that enables the literary critic to study the use of biblical forms as well as biblical themes from the Old Testament without any preconceived religious meaning in a secularized age also applies to material from the New Testament. The critic should be able to approach modern treatments of the story of Jesus with no preconceived assumptions concerning the attitudes of the author, religious or otherwise. If we look as a concluding example at such a popular genre as fictionalizing lives of Jesus, we find that their authors have been motivated by a wide variety of impulses.

Several of the most successful biographies of the twentieth century—Giovanni Papini's *Life of Jesus* or Lloyd C. Douglas's *The Big Fisherman*—are clearly works of faith. Many other works—ranging from Hugh Schonfield's sensational *The Passover Plot* to George Moore's *The Brook Kerith* and

D. H. Lawrence's *The Man Who Died*—fall into the general category of rationalizations, which attempt to find plausible explanations for the miracles of the Gospels, including the Resurrection, and which are not dependent upon faith for their impact. Several of the most brilliant fictionalizing lives, however, relativize the entire story by narrating it from a contemporary non-Christian point of view.

If we discount the framework fiction, for instance, Sholem Asch's fascinating and learned account in *The Nazarene* is told from three different points of view: the events up to Jesus' arrival in Jerusalem are recounted first by a Roman officer and then in the form of an apocryphal Gospel attributed to Judas; the events of the Passion week are narrated by a young disciple of Rabbi Nicodemon. These three interlocking accounts provide us with a rich panorama of life in Jerusalem at the time of Jesus and contribute to the intellectual power of the novel. Yet nothing in their point of view enables the narrators to understand Jesus as a religious phenomenon. Indeed, Asch specifically disclaims his divinity. He is writing a *historical* novel, not a religious one.

In *King Jesus* Robert Graves achieves a curious effect by having the story told around 90 A.D. by an Alexandrine scholar who, though no Christian himself, became an authority on the new religion when he harbored in his house a refugee bishop fleeing from the persecutions. The alleged date of the narrative suggests that the fictive author has at his disposal information equivalent to the synoptic Gospels. Paradoxically, though he does not believe in the divinity of Jesus, the narrator is perfectly willing to accept the miracles and the Resurrection, for in his eyes Jesus belongs to the familiar category of wonder-workers. In the person of his narrator, in short, Graves has characterized his own attitude—that of the author of volumes on *The Greek Myths* and *Hebrew Myths*, for whom Jesus is no more and no less than another mythic figure from the ancient Mediterranean world. A critic who approached even such works as the lives of Jesus written in a secularized age would go astray if he presupposed any "pious" intention on the part of the authors, or even a generally religious intention. In the cases of Asch and Graves, certainly, the Gospel subject matter enjoys no privileged status whatsoever; a "religious" interpretation of the material would do violence to the author's explicitly historical intentions.

In conclusion, then, I suggest that the most fruitful interaction of scholars in the field of literature and the Bible can take place if those approaching the material from the realm of comparative literature bear in the mind the possibility that a biblical subject may have religious implications, while those coming from the realm of literature and religion always hold in check the impulse to look for religious meaning or intention in every literary work. After all, as a cultural document both literary and religious the Bible has had so vast an impact, even in a secularized age, that it will require the collaborative efforts of critics of *every* persuasion if we hope to do it justice.

WORKS CONSULTED

Cantor, Paul A.
 1980 "Byron's *Cain*: A Romantic Version of the Fall." *The Kenyon
 Review* N.S. 2/3:50–71.

Cooke, Michael
 1973 Review of *Fictional Transfigurations. Yale Review* 62:469–72.

Eliot, T. S.
 1975 "Religion and Literature" (1935). In *Selected Prose of
 T. S. Eliot*, edited by Frank Kermode, pp. 97–106. New York:
 Harcourt Brace Jovanovich.

Grass, Günter
 1967 "Interview with Geno Hartlaub." *Sonntagsblatt* (Hamburg) Jan-
 uary 1.

Gunn, Giles
 1979 *The Interpretation of Otherness: Literature, Religion, and the
 American Imagination.* New York: Oxford University Press.

Mann, Thomas
 1979 "Über den Joseph-Roman" (1928). In *Gesammelte Werke*, vol.
 11, p. 625. Frankfurt am Main: S. Fischer.

May, John R.
 1974 Review of *Fictional Transfigurations. Clio* 3:367–70.

Molnar, Thomas
 1974 Review of *Fictional Transfigurations. The Georgia Review*
 28:166–68.

TeSelle, Sallie McFague
 1973 Review of *Fictional Transfigurations. Commonweal* 100 (20
 April):163–64.

Ziolkowski, Theodore
 1972 *Fictional Transfigurations of Jesus.* Princeton, N.J.: Princeton
 University Press.
 1977a "Die Säkularisation der Bibel." In *Jahrbuch Deutsch als
 Fremdsprache*, edited by Alois Wierlacher, vol. 3, pp. 137–49.
 Heidelberg: Julius Groos.
 1977b "Background: 'Jesus of Nazareth.'" *TV Guide* 25/14 (2
 April):24–35.
 1979 "Religion and Literature in a Secular Age: The Critic's
 Dilemma." *Journal of Religion* 59:18–34.
 1981 "Die Auferstehung: Ein geistesgeschichtliches Motiv des 19.
 Jahrhunderts im Roman des 20. Jahrhunderts." In *Literatur-
 wissenschaft und Geistesgeschichte: Festschrift für Richard
 Brinkmann*, edited by Jürgen Brummack, pp. 616–34.
 Tübingen: Max Niemeyer.
 1982 "Re-viewing Reviews: Jesus between Theseus and Procrustes."
 In *The Horizon of Literature*, edited by Paul Hernadi, pp.
 307–17. Lincoln: University of Nebraska Press.

Art, Literature, and Religion:
A Decade of Scholarship

Rosemary M. Magee

Altizer, Thomas J. J. *The Self-Embodiment of God*. New York: Harper and Row, 1977.
—————. *Total Presence: The Language of Jesus and the Language of Today*. New York: Seabury Press, 1980.
Barthes, Roland. *The Pleasure of the Text*. Tr. Richard Miller. New York: Hill and Wang, 1975.
—————. *S/Z*. Tr. Richard Miller. New York: Hill and Wang, 1974.
Batson, C. Daniel, J. Christian Beker, and W. Malcolm Clark. *Commitment Without Ideology: The Experience of Christian Growth*. Philadelphia: United Church Press, 1973.
Beardslee, William. "Parable, Proverb, and Koan." *Semeia* 12:151–77.
—————. *Literary Criticism of the New Testament*. Philadelphia: Fortress Press, 1970.
Berenbaum, Michael G. *The Vision of the Void: Theological Reflections on the Works of Elie Wiesel*. Middletown: Wesleyan University Press, 1979.
Berthoff, Warner. *Fictions and Events: Essays in Criticism and Literary History*. New York: E. P. Dutton and Co., 1971.
Bloom, Harold. *The Anxiety of Influence: A Theory of Poetry*. New York: Oxford University Press, 1973.
Bloom, Harold, et al. *Deconstruction and Criticism*. New York: Seabury Press, 1979.
Booth, Wayne. *A Rhetoric of Irony*. Chicago and London: University of Chicago Press, 1974.
Boyd, George N., and Lois A. Boyd. *Religion in Contemporary Fiction: Criticism from 1945 to the Present*. San Antonio, Texas: Trinity University Press, 1973.
Brooks, Cleanth. "Religion and Literature." *Sewanee Review* 82:93–107.
Brown, Robert McAfee. "My Story and 'The Story.'" *Theology Today* 32:166–73.
Brueggemann, Walter. "On Trust and Freedom: A Study of Faith in the Succession Narrative." *Interpretation* 26:3–19.
Burke, Kenneth. "Theology and Logology." *Journal of the American Academy of Religion* 47 Supplement:235–50.
Calinescu, Mater. "Hermeneutics or Poetics." *Journal of Religion* 59:1–17.
Carrithers, Gale H., Jr. *Donne at Sermons: A Christian Existential World*. Albany: State University of New York Press, 1972.
Chomsky, Noam. *Reflections on Language*. New York: Random House, Pantheon Books, 1975.
Christ, Carol. "Feminist Studies in Religion and Literature: A Methodological Reflection." *Journal of the American Academy of Religion* 44:317–25.
Clifford, Gay. *The Transformations of Allegory*. London and Boston: Routledge and Kegan Paul, 1974.
Cobb, John B. *Christ in a Pluralistic Age*. Philadelphia: Westminster Press, 1975.
Cone, James H. "The Story Context of Black Theology." *Theology Today* 32:144–50.
Crites, Stephen. "The Narrative Quality of Existence." *Journal of the American Academy of Religion* 39:291–311.

Crossan, John Dominic. *Cliffs of Fall: Paradox and Polyvalency in the Parables of Jesus.* New York: Seabury Press, 1980.

——————. *The Dark Interval: Towards a Theology of Story.* Niles, Illinois: Argus Communications, 1975.

——————, ed. *Paul Ricoeur on Biblical Hermeneutics.* Missoula, Montana: Society of Biblical Literature, 1975.

——————. *Raid on the Articulate: Comic Eschatology in Jesus and Borges.* New York: Harper and Row, 1976.

Davies, Horton, and Hugh Davies. *Sacred Art in a Secular Century.* Collegeville, Minnesota: The Liturgical Press, 1978.

Derrida, Jacques. *Of Grammatology.* Tr. and ed. Gayatri Chakravorty Spivak. Baltimore: Johns Hopkins University Press, 1976.

Detweiler, Robert. "Recent Religion and Literature Scholarship." *Religious Studies Review* 4:107–17.

——————. *Story, Sign and Self: Phenomenology and Structuralism as Literary-Critical Methods.* Philadelphia: Fortress Press & Missoula, MT: Scholars Press, 1978.

——————. "Theological Trends of Postmodern Fiction." *Journal of the American Academy of Religion* 44:225–37.

Detweiler, Robert and Glenn Meeter, eds. *Faith and Fiction: The Modern Short Story.* Grand Rapids, Michigan: William Eerdmans, 1979.

Didion, Joan. *The White Album.* New York: Simon and Schuster, 1979.

Dillenberger, Jane. "Folk Art and the Bible." *Theology Today* 36:564–68.

Dillenberger, Jane and John Dillenberger. *Perceptions of the Spirit in Twentieth-Century American Art.* Indianapolis: Indianapolis Museum of Art, 1977.

Dillenberger, Jane and Joshua C. Taylor. *The Hand and the Spirit: Religious Art in America, 1700–1900.* Berkeley: University Art Museum, 1972.

Dillenberger, John. "English Christianity and the Visual Arts in the Colonies." *Semeia* 13, part 2:9–27.

Dixon, John W. "Art as Religion: Religion as Art." *Semeia* 13, part 2:131–53.

Donovan, Josephine. *Feminist Literary Criticism: Explorations in Theory.* Lexington: University Press of Kentucky, 1975.

Dunne, John. *The Way of All the Earth: Experiments in Truth and Religion.* New York: Macmillan Press, 1972.

Ebeling, Gerhard. *Introduction to a Theological Theory of Language.* Tr. R. A. Wilson. Philadelphia: Fortress Press, 1973.

Estess, Ted L. "The Inerrable Contraption: Reflections on the Metaphor of a Story." *Journal of the American Academy of Religion* 42:415–34.

Foucault, Michel. *The Archaeology of Knowledge.* Tr. A. M. Sheridan Smith. New York: Harper and Row, 1976.

Frei, Hans W. *The Eclipse of Biblical Narrative: A Study in Eighteenth and Nineteenth Century Hermeneutics.* New Haven: Yale University Press, 1974.

——————. *The Identity of Jesus Christ: The Hermeneutical Bases of Dogmatic Theology.* Philadelphia: Fortress Press, 1975.

Friedman, Melvin J., ed. *The Vision Obscured: Perceptions of Some Twentieth-Century Catholic Novelists.* New York: Fordham University Press, 1970.

Frye, Northrop. *The Critical Path: An Essay on the Social Context of Literary Criticism.* Bloomington: Indiana University Press, 1971.

——————. *The Secular Scripture: A Study of the Structure of Romance.* Cambridge: Harvard University Press, 1976.

——————. *Spiritus Mundi: Essays on Literature, Myth, and Society.* Bloomington: Indiana University Press, 1976.

Frye, Roland Mushat. "Literary Criticism and Gospel Criticism." *Theology Today* 36:207–19.

_____. "Metaphors, Equations, and the Faith." *Theology Today* 37:59–67.

Funk, Robert. *Jesus as Precursor*. Philadelphia: Fortress Press & Missoula, MT: Scholars Press, 1975.

Gadamer, Hans-Georg. *Dialogue and Dialectic: Eight Hermeneutical Studies on Plato*. Tr. P. Christopher Smith. New Haven: Yale University Press, 1980.

_____. *Philosophical Hermeneutics*. Tr. and ed. David E. Linge. Berkeley: University of California Press, 1977.

_____. *Truth and Method*. Tr. Garrett Barden and William Glen-Doepel. New York: Seabury Press, 1975.

Gardner, Helen Louise. *Religion and Literature*. New York: Oxford University Press, 1971.

Garvin, Harry R., ed. *Phenomenology, Structuralism, Semiology*. Lewisburg, Pennsylvania: Bucknell University Press, 1976.

Gass, William H. *Fiction and the Figures of Life*. New York: Knopf, 1970.

Gerhart, Mary. "Arts, Literature and Religion: A Research Inventory." *The Council on the Study of Religion Bulletin* 11, 1:3–5.

_____. "Generic Studies: Their Renewed Importance in Religious and Literary Interpretation." *Journal of the American Academy of Religion* 45:309–25.

_____. "Paul Ricoeur's Hermeneutical Theory as Resource for Theological Reflection." *The Thomist* 39:496–527.

_____. *The Question of Belief in Literary Criticism: An Introduction to the Hermeneutical Theory of Paul Ricoeur*. Stuttgart: Akademischer Verlag, 1979.

Gilkey, Langdon. *Reaping the Whirlwind: A Christian Interpretation of History*. New York: Seabury Press, 1976.

Girard, René. *Violence and the Sacred*. Tr. Patrick Gregory. Baltimore: Johns Hopkins University Press, 1977.

Graff, Gerald. *Literature Against Itself: Literary Ideas in Modern Society*. Chicago: University of Chicago Press, 1979.

Gray, James. *Johnson's Sermons: A Study*. Oxford: Clarendon Press, 1972.

Gunn, Giles. *The Interpretation of Otherness: Literature, Religion, and the American Imagination*. New York: Oxford University Press, 1979.

Gunn, Giles, ed. *Literature and Religion*. New York: Harper and Row, 1971.

_____. "Threading the Eye of the Needle: The Place of the Literary Critic in Religion Studies." *Journal of the American Academy of Religion* 43:164–84.

Gunn, Janet Varner. "Autobiography and the Narrative Experience of Temporality as Depth." *Soundings* 60:194–209.

Hartt, Julian. *Theological Method and Imagination*. New York: Seabury Press, 1977.

Hauerwas, Stanley. "Story and Theology." *Religion in Life* 45:339–50.

Hawkes, Terence. *Metaphor*. London: Methuen and Co., 1972.

Hesla, David H. "Religion and Literature: The Second Stage." *Journal of the American Academy of Religion* 46:181–92.

_____. *The Shape of Chaos: An Interpretation of the Art of Samuel Beckett*. Minneapolis: University of Minnesota Press, 1971.

Hillman, James. *The Myth of Analysis: Three Essays in Archetypal Psychology*. Evanston: Northwestern University Press, 1972.

Jameson, Fredric. *The Prison-House of Language: A Critical Account of Structuralism and Russian Formalism*. Princeton: Princeton University Press, 1972.

Kauffman, S. Bruce. "Charting a Sea-Change: On the Relationships of Religion and Literature to Theology." *Journal of Religion* 58:405–27.

Kellogg, Gene. *The Vital Tradition: The Catholic Novel in a Period of Convergence*. Chicago: Loyola University Press, 1970.

Kermode, Frank. *The Genesis of Secrecy: On the Interpretation of Narrative*. Cambridge: Harvard University Press, 1979.

Kort, Wesley A. *Narrative Elements and Religious Meaning.* Philadelphia: Fortress Press, 1975.

──────────. *Shriven Selves: Religious Problems in Recent American Fiction.* Philadelphia: Fortress Press, 1972.

Laeuchli, Samuel. *Religion and Art in Conflict: Introduction to a Cross-Disciplinary Task.* Philadelphia: Fortress Press, 1980.

Lawler, Justus George. *Celestial Pantomime: Poetic Structures of Transcendence.* New Haven: Yale University Press, 1979.

Leonard, Harriet V. *Religion and Literature: Guide and Bibliography.* Durham, North Carolina: Duke Divinity School, 1975.

Lewalski, Barbara Kiefer. *Protestant Poetics and the Seventeenth-Century Religious Lyric.* Princeton: Princeton University Press, 1979.

Lowe, Walter James. *Mystery and the Unconscious: A Study in the Thought of Paul Ricoeur.* Metuchen, New Jersey: Scarecrow Press, 1977.

Lynch, William F. *Christ and Apollo: The Dimensions of the Literary Imagination.* Notre Dame: University of Notre Dame Press, 1970.

──────────. "Foundation Stones for Collaboration Between Religion and the Literary Imagination." *Journal of the American Academy of Religion* 47 Supplement:329–44.

──────────. *Images of Faith: An Exploration of the Ironic Imagination.* Notre Dame: University of Notre Dame Press, 1973.

Mallard, William. *The Reflection of Theology in Literature: A Case Study in Theology and Culture.* San Antonio: Trinity University Press, 1977.

May, John R. *The Pruning Word: The Parables of Flannery O'Connor.* Notre Dame: University of Notre Dame Press, 1976.

──────────. *Toward a New Earth: Apocalypse in the American Novel.* Notre Dame: University of Notre Dame Press, 1972.

May, John R. and Ernest Ferlita. *Film Odyssey: The Art of Film as Search for Meaning.* New York: Paulist Press, 1976.

──────────. *The Parables of Lina Wertmuller.* New York: Paulist Press, 1977.

Meagher, John C. *Clumsy Construction in Mark's Gospel.* New York: Edwin Mellen Press, 1979.

──────────. *The Way of the Word: The Beginning and the Establishing of Christian Understanding.* New York: Seabury Press, 1975.

Medina, Angel. *Reflection, Time, and the Novel: Toward a Communicative Theory of Literature.* Boston: Routledge and Kegan Paul, 1979.

Metz, Johann Baptist. "A Short Apology of Narrative." In *The Crisis of Religious Language.* Eds. Johann Baptist Metz and Jean-Pierre Jossua. New York: Herder and Herder, 1973, pp. 84–96.

Miller, J. Hillis. "The Linguistic Moment in *The Wreck of the Deutschland.*" In *The New Criticism and After.* Ed. Thomas Daniel Young. Charlottesville: University Press of Virginia, 1975, pp. 47–60.

──────────. "Theology and Logology in Victorian Literature." *Journal of the American Academy of Religion* 47 Supplement:345–61.

Miner, Earl, ed. *Literary Uses of Typology from the Late Middle Ages to the Present.* Princeton: Princeton University Press, 1977.

Morris, Ivor. *Shakespeare's God: The Role of Religion in the Tragedies.* London: George Allen and Unwin, 1972.

Noel, Daniel C. "Post-Modern Literature and the Idea of Grace." *Cross Currents* 20:99–102.

──────────, ed. *Seeing Castaneda: Reactions to the "Don Juan" Writings of Carlos Castaneda.* New York: Putnam, 1976.

Nyman, Michael. *Experimental Music: Cage and Beyond.* New York: Schirmen Books, 1974.

O'Connor, Flannery. *The Habit of Being.* Ed. Sally Fitzgerald. New York: Farrar, Strauss, Giroux, 1979.

O'Flaherty, Wendy Doniger, ed. *The Critical Study Sacred Texts*. Berkeley: Graduate Theological Union, 1979.

—————. *Women, Androgynes and Other Mythical Beasts*. Chicago: University of Chicago Press, 1980.

Olson, Charles. *Poetry and Truth*. Ed. George F. Butterick. San Francisco: Four Seasons Foundation, 1971.

—————. *The Special View of History*. Ed. Ann Charters. Berkeley: Oyez Press, 1970.

Ong, Walter J. "Gospel, Existence, and Print." *Modern Language Quarterly* 35:66–77.

—————. *Interfaces of the Word: Studies in the Evolution of Consciousness and Culture*. Ithaca: Cornell University Press, 1977.

—————. *Rhetoric, Romance and Technology; Studies in the Interaction of Expression and Culture*. Ithaca: Cornell University Press, 1971.

Patte, Daniel. *What is Structural Exegesis?* Philadelphia: Fortress Press, 1976.

Petersen, Norman R., ed. *Literary Criticism for New Testament Critics*. Philadelphia: Fortress Press, 1978.

Raschke, Carl. "Hermeneutics as Historical Process: Discourse, Text, and the Revolution of Symbols." *Journal of the American Academy of Religion* 45 Supplement:169–93.

Reynolds, Frank, and Donald Capps. *The Biographical Process: Studies in the History and Psychology of Religion*. The Hague: Mouton, 1976.

Ricoeur, Paul. *The Conflict of Interpretations: Essays in Hermeneutics*. Ed. Don Ihde. Evanston: Northwestern University Press, 1974.

—————. *Freud and Philosophy: An Essay on Interpretation*. Tr. Denis Savage. New Haven: Yale University Press, 1970.

—————. *Interpretation Theory: Discourse and the Surplus of Meaning*. Fort Worth: Texas Christian University Press, 1976.

—————. "The Narrative Function." *Semeia* 13, part 2:177–202.

—————. "Philosophy and Religious Language." *Journal of Religion* 54:71–85.

—————. *The Philosophy of Paul Ricoeur: An Anthology of His Work*. Eds. Charles E. Reagan and David Steward. Boston: Beacon Press, 1978.

—————. *The Rule of Metaphor: Multidisciplinary Studies of the Creation of Meaning in Language*. Tr. Robert Czerny with Kathleen McLaughlin and John Costello. Toronto and Buffalo: University of Toronto Press, 1977.

Righter, Charles. *Myth and Literature*. London and Boston: Routledge and Kegan Paul, 1975.

Robertson, David. *The Old Testament and the Literary Critic*. Philadelphia: Fortress Press, 1977.

Rosenfeld, Alvin H. and Irving Greenberg, eds. *Confronting the Holocaust: The Impact of Elie Wiesel*. Bloomington: Indiana University Press, 1978.

Rothenberg, Jerome and George Quasha, eds. *America, A Prophecy: A New Reading of American Poetry from Pre-Columbian Times to the Present*. New York: Random House, 1973.

Rubenstein, Richard L. *Power Struggle: An Autobiographical Confession*. New York: Charles Scribner's Sons, 1974.

—————. "The Unmastered Trauma: Interpreting the Holocaust." *Humanities in Society* 2:417–33.

Ruland, Vernon. *Horizons of Criticism: An Assessment of Religious-Literary Options*. Chicago: American Library Association, 1975.

—————. "Understanding the Rhetoric of Theologians." *Semeia* 13, part 2:203–24.

Said, Edward W. *Beginnings: Intention and Method*. New York: Basic Books, 1975.

Saliers, Don E. *The Soul in Paraphrase: Prayer and the Religious Affections*. New York: Seabury Press, 1980.

Scafella, Frank. "Models of the Soul: Authorship as Moral Action in Four American Novels." *Journal of the American Academy of Religion* 44:459–75.

Schillaci, Anthony. *Movies and Morals.* Notre Dame: Fides Press, 1970.

Schneidau, Herbert. *Sacred Discontent: The Bible and Western Tradition.* Baton Rouge: Louisiana State University Press, 1976.

Scholes, Robert. *Structural Fabulation: An Essay on Fiction of the Future.* Notre Dame: University of Notre Dame Press, 1975.

—————. *Structuralism in Literature: An Introduction.* New Haven: Yale University Press, 1974.

Schorsch, Anita and Martin Greif. *The Morning Stars Sang: The Bible in Popular and Folk Art.* New York: Universe Books, 1978.

Schrader, Paul. *Transcendental Style in Film: Ozu, Bresson, Dreyer.* Berkeley: University of California Press, 1972.

Scott, Nathan A., Jr. "Arnold's Version of Transcendence—the *Via Poetica.*" *Journal of Religion* 59:261–84.

—————. "Criticism and the Religious Prospect." *Semeia* 13, part 2:225–40.

—————. *Mirrors of Man in Existentialism.* New York: Collins Press, 1978.

—————. *The Poetry of Civic Virtue: Eliot, Malraux, Auden.* Philadelphia: Fortress Press, 1976.

—————. *Three American Moralists: Mailer, Bellow, Trilling.* Notre Dame: University of Notre Dame Press, 1973.

—————. *The Wild Prayer of Longing: Poetry and the Sacred.* New Haven: Yale University Press, 1971.

Shea, John. *Stories of Faith.* Chicago: Thomas More Press, 1980.

—————. *Stories of God: An Unauthorized Biography.* Chicago: Thomas More Press, 1978.

Spencer, Richard A., ed. *Orientation by Disorientation: Studies in Literary Criticism and Biblical Literary Criticism.* Pittsburgh: Pickwick Press, 1980.

Steiner, George. *After Babel: Aspects of Language and Translation.* London and New York: Oxford University Press, 1975.

Steinmetz, David. "The Superiority of Pre-Critical Exegesis." *Theology Today* 37:27–38.

Tanner, Tony. *City of Words: American Fiction, 1950–1970.* New York: Harper and Row, 1971.

Tennyson, G. B. and Edward E. Ericson, eds. *Religion and Modern Literature: Essays in Theory and Criticism.* Grand Rapids, Michigan: William Eerdmans, 1975.

TeSelle, Sallie McFague. "The Experience of Coming to Belief." *Theology Today* 32:159–65.

—————. "Imaginary Gardens with Real Toads: Realism in Fiction and Theology." *Semeia* 13, part 2:241–61.

—————. *Speaking in Parables: A Study in Metaphor and Theology.* Philadelphia: Fortress Press, 1975.

Tolbert, Mary Ann. *Perspectives on the Parables: An Approach to Multiple Interpretations.* Philadelphia: Fortress Press, 1979.

Tracy, David. *The Analogical Imagination.* New York: Seabury, Crossroads, 1981.

Trilling, Lionel. *Sincerity and Authenticity.* Cambridge: Harvard University Press, 1972.

Turner, Geoffrey. "Pre-Understanding and New Testament Interpretation." *Scottish Journal of Theology* 28:227–42.

Via, Dan O. *Kerygma and Comedy in the New Testament: A Structuralist Approach to Hermeneutic.* Philadelphia: Fortress Press, 1975.

Warner, John M. "Literature and Religion: The Convergence of Approaches." *Journal of the American Academy of Religion* 47 Supplement: 215–19.

Washbourn, Penelope. *Seasons of Woman: Song, Poetry, Ritual, Prayer, Myth, Story.* San Francisco: Harper and Row, 1979.

Weinrich, Harald. "Narrative Theology." In *The Crisis of Religious Language.* Eds. Johann Baptist Metz and Jean-Pierre Jossua. New York: Herder and Herder, 1973, pp. 46–56.

White, Hayden. *Tropics of Discourse: Essays in Cultural Criticism*. Baltimore: Johns Hopkins University Press, 1978.

Wicker, Brian. *The Story-Shaped World: Fiction and Metaphysics*. Notre Dame: University of Notre Dame Press, 1975.

Wiggins, James B., ed. *Religion as Story*. Harper and Row, 1975.

Wilder, Amos. *Theopoetic: Theology and the Religious Imagination*. Philadelphia: Fortress Press, 1976.

Winquist, Charles E. "The Act of Storytelling and the Self's Homecoming." *Journal of the American Academy of Religion* 42:101–3.

Wolsterstorff, Nicholas. *Art in Action: Toward a Christian Aesthetic*. Grand Rapids, Michigan: William B. Eerdmans, 1980.

Yu, Anthony C. "The Editor's Bookshelf: Religion and Literature." *Journal of Religion* 55:492–98.

Ziolkowski, Theodore. *Disenchanted Images: A Literary Iconology*. Princeton: Princeton University Press, 1977.

_____. *Fictional Transfigurations of Jesus*. Princeton: Princeton University Press, 1972.

_____. "Religion and Literature in a Secular Age: The Critic's Dilemma." *Journal of Religion* 59:18–34.

NOTES ON CONTRIBUTORS

HUNTLEY BEYER is a composer who teaches music at Collins Academy in Seattle, Washington. He holds a D.M.A. in music composition from the University of Washington and an M.A. in religious studies from the School of Theology at Claremont. His compositions have been performed on the West Coast and toured in Europe. An article on Zen Buddhism and contemporary music is forthcoming in *Studia Mystica*.

REBECCA PARKER BEYER is the pastor of Wallingford United Methodist Church in Seattle, Washington. She holds a D.Min. degree from the School of Theology at Claremont, and studied music at the University of Washington. She has had writings published in *Perspective, Impact*, and *The Source*.

MARY GERHART is Associate Professor of religious studies at Hobart and William Smith Colleges and Editorial Chair of *Religious Studies Review*. She is the author of *The Question of Belief in Literary Criticism: An Introduction to the Hermeneutical Theory of Paul Ricoeur*, as well as articles in *The Journal of Religion*, the *Journal of the American Academy of Religion*, and *Cross Currents*.

PETER GROTZER is Privatdozent for French and comparative literature at the University of Zurich. He holds a Dr. Phil. from the University of Zurich and has also studied in Pisa, Perugia, and Paris. He is author and editor of books and essays on Béguin, Marcel, Poulet, and others. In 1981 he was Visiting Fellow at Princeton University.

GILES GUNN is Chairman of the Curriculum in American Studies and Professor of religion and American studies at the University of North Carolina at Chapel Hill. Author of *F. O. Matthiessen: The Critical Achievement* and *The Interpretation of Otherness*, his most recent book is *New World Metaphysics: Readings on the Religious Meaning of the American Experience*.

JANET VARNER GUNN is Assistant Professor of religious studies at the University of North Carolina at Greensboro. Her book *Autobiography: Toward a Poetics of Experience* was published by the University of Pennsylvania Press in 1982.

DAVID H. HESLA holds a Ph.D. in literature and theology from the University of Chicago and teaches in the Graduate Institute of the Liberal Arts at Emory University. He is the author of *The Shape of Chaos: An Interpretation of the Art of Samuel Beckett* and of numerous essays on literature and theology.

ERASMO LEIVA-MERIKAKIS holds his doctorate in comparative literature and theology from Emory University. He teaches these subjects in the Saint Ignatius

Institute of the University of San Francisco, where he has been Assistant Professor since 1977. He is translator of the multi-volume English version of Hans Urs von Balthasar's *Herrlichkeit: eine theologische Ästhetik.*

ROSEMARY M. MAGEE earned her Ph.D. in literature and theology from Emory University. She is currently Visiting Assistant Professor of English there. She is the author of essays and reviews on literature and religion.

JOHN R. MAY has a doctorate in literature and theology from Emory University. Presently Associate Professor of English at Louisiana State University, he is the author of *Toward a New Earth: Apocalypse in the American Novel* and *The Pruning Word: The Parables of Flannery O'Connor.* He is also co-author, with Ernest Ferlita, of *Film Odyssey: The Art of Film as Search for Meaning* and *The Parables of Lina Wertmuller.* His essays have appeared in journals such as *Renascence, Southern Review,* and *Twentieth Century Literature.*

DANIEL C. NOEL teaches religion and mythology in the Adult Degree Program of Vermont College at Norwich University. He is the editor of *Echoes of the Wordless 'Word'* and of *Seeing Castaneda* and is author of numerous essays on literature and religion. He is currently completing a book on the religio-cultural symbolism of the Space Age.

RICHARD L. RUBENSTEIN serves as Co-Director of the Humanities Institute of Florida State University. He is known for such books as *After Auschwitz, Power Struggle: An Autobiographical Confession,* and his latest, *The Cunning of History.* He is presently at work on a new book, *The Age of Triage.*

NATHAN A. SCOTT, JR. is William R. Kenan, Jr., Professor of Religious Studies and Professor of English at the University of Virginia, where he also serves as Chairman of the Department of Religious Studies. Among his numerous books are *The Broken Center: Studies in the Theological Horizon of Modern Literature* (1966), *Craters of the Spirit: Studies in the Modern Novel* (1968), *Negative Capability: Studies in the New Literature and the Religious Situation* (1969), *The Wild Prayer of Longing: Poetry and the Sacred* (1971), *Three American Moralists—Mailer, Bellow, Trilling* (1973), *The Poetry of Civic Virtue—Eliot, Malraux, Auden* (1976), and *Mirrors of Man in Existentialism* (1978). The present essay has been drawn from his Stone Lectures at Princeton Theological Seminary (February 1980) and his Hayward Lectures at The Divinity College of Acadia University, Nova Scotia (October 1980), on "Theology and the Imagination."

DAVID SEELEY attended Baldwin Wallace College and Methodist Theological School in Ohio. He is presently a doctoral student at the School of Theology at Claremont and a research assistant at the Institute for Antiquity and Christianity.

JOHN SHEA teaches systematic theology at St. Mary of the Lake Seminary in Mundelein, Illinois. He is the author of six books of theology. The latest is *Religious Language in a Secular Culture: A Study in the Theology of Langdon Gilkey.* He has also written two books of poetry—*The Hour of the Unexpected* and *The God Who Fell From Heaven.* His articles have appeared in *Concilium, Commonweal, The Ecumenist* and *Chicago Studies.*

THEODORE ZIOLKOWSKI (Ph.D. Yale) is Class of 1900 Professor of German and Comparative Literature and Dean of the Graduate School at Princeton University. His most recent books are *Disenchanted Images: A Literary Iconology* (1977), *Der Schriftsteller Hermann Hesse* (1979), and *The Classical German Elegy, 1795–1950* (1980). His essays on nineteenth- and twentieth-century literature have appeared in numerous American and European journals.

DATE DUE

DEMCO 38-297